Contents

Facebook updates throughout the Almanac have been taken from Richard DeDominici, Brian Lobel and Kira O'Reilly's walls between July 2008 and December 2009.

The Live Art Almanac Vol. 2

Introduction

Welcome to *The Live Art Almanac Vol. 2*, a collection of found writing from 2008 and 2009 about and around Live Art. Like the original *Almanac* (published in 2008), Volume 2 brings together texts from a variety of sources, which are representative of the most engaging, provocative and thoughtful writing about Live Art and its cultural landscape. Volume 2 expands its inquiry beyond Volume 1 to include writings published between July 2008 and December 2009 from not just the UK but also internationally. Volume 2 aims to continue a cultural dialogue started in the first volume and to be both a useful resource and a good read for artists, writers, students and others interested in Live Art.

The Live Art Almanac Vol. 2 is published by the Live Art Development Agency (London, UK) and produced in partnership with Live Art UK, Performance Space 122 (New York, USA) and Performance Space

(Sydney, Australia). All partner organizations act as advocates for the interdisciplinary and Live Art sectors – speaking out for artists and audiences and promoting the infrastructures and critical dialogues that support them.

The material for *The Live Art Almanac Vol. 2* was gathered through recommendations and submissions. The editors would like to thank everyone who submitted materials for consideration for the Almanac and we are sorry that we could not include them all. In late 2009, the open Call for Submissions announced:

The Live Art Almanac Vol. 2 will be published in 2010 and will draw together recent writings about and around Live Art – from reviews, interviews and news stories, to cultural commentaries and "private" communications. The material must be engaging, provocative, and thoughtful writing on and around the contemporary cultural landscape in which Live

Art practice sits and must shed light on the various debates and ideas in circulation within that landscape. The Live Art Almanac Vol. 2 will be published in English, but encourages international submissions as well as texts in translation previously published in other languages.

Over the next few months, the editorial team collected writing from across the globe including newspaper and journal articles, blog and wiki entries, transcripts of interviews, emails and other private correspondence, and even (by 2009, prolific) dialogic excretions via facebook and twitter feeds. In line with the broad aspirations of the Call for Submissions, we neither sought nor received many examples of academic writing as this tends to be admirably represented in a variety of other, often institutional, contexts, certainly within the UK. We received and collected far more material than we could possibly hope to publish, and made selections which we hope reflect the diversity of forms, topics, and geographic/cultural contexts of Live Art across, at very least, the English speaking world.

The Live Art Almanac is meant to shed light on the many different ways that the experimental processes and experiential practices of Live Art are critiqued, discussed and debated in writing. The *Almanac* intends to highlight certain discourses that fit within a catalogue of approaches to the

possibilities of liveness by artists who chose to work across, in between, and at the edges of more traditional artistic forms. Because of the nature of its temporal parameters, it also reflects some of the most significant performance events that took place over the 18-month period between July 2008 and December 2009, as well as the depressingly large number of singular artists who passed away in that period.

Our approach to editing has been to be as hands-off as possible and the majority of the texts are reproduced in the *Almanac* as they were originally published. We have given the texts a loose order and as you read you may find a number of recurring themes. These include the collection and re-production of live and therefore in some sense ephemeral "non-collectible" works of art, and the obituary both as writing form and as end-marker for the lives of a number of seminal artists.

One realization that came to us as we collected submissions was the lack of international material that shared both the aesthetic rigor and critical engagement of many of the UK submissions. We were also keenly aware that the submissions we received were primarily Euro-centric and very much "western" looking in their focus and discourse. There could be any number of reasons for these issues, such as not enough people getting to see the Call for Submissions; limited international contexts

for Live Art publishing and distribution; varying degrees of engagement with critical writing in international educational sectors; or inconsistent support for Live Art by international venues, festivals, and other promoters. We also asked ourselves whether there might be a generational refusal or disinterest in a critical engagement by artists in writing and thinking about their own work and the works of the generations that preceded them, and whether that has contributed to critical frameworks not being quite so advanced in some international contexts. Through the work of our own organizations in supporting Live Art practices, we know that there is a huge range of exceptional work across the world which either does not yet seem to be reflected in writing, or which we have failed to unearth.

We will continue to ponder these many challenges, and look forward to developing new strategies to address these issues in *The Live Art Almanac Vol. 3*.

The Live Art Almanac Vol. 2 has been made possible by the interest and engagement of all the people who made recommendations and offered their own writings for consideration; to all of them we are very grateful. It would not be possible without the continuing hard work of all the artists in our communities and their daily questioning and discussions of contemporary practices, concepts and Live Art frameworks. It would also not be possible without the generous permissions of those writers and publishers whose works are included.

We hope you enjoy reading *The Live Art Almanac Vol. 2*.

Sincerely,

Volume 2 Editors.

Lois Keidan, CJ Mitchell
and Andrew Mitchelson –
Live Art Development Agency, London

Daniel Brine – Performance Space, Sydney

Vallejo Gantner and Morgan von Prelle Pecelli – Performance Space 122,
New York City

The Live Art Development Agency offers Resources, Professional Development Initiatives, and Projects for the support and development of Live Art practices, and critical discourses in the UK and internationally. The Agency is committed to supporting the high risk artists, practices and ideas of contemporary culture and particularly the practices of emerging artists, and artists from culturally diverse backgrounds. The Agency's three key areas of activity - resources, professional development, and projects and initiatives - are informed by the guiding principles of working strategically, in partnership, and in consultation. www.thisisliveart.co.uk

Live Art UK is a consortium of venues, promoters and facilitators which explores new models and partnerships for the promotion of Live Art; develops new ways to increase the national and international visibility of Live Art; and initiates strategies for a more sustainable future for Live Art practitioners and promoters. www.liveartuk.org

Performance Space 122 has been a hub for contemporary performance in the heart of New York City's East Village for 30 years. The core of PS122's activities is the commissioning and presentation of New York, U.S. and international artists working in contemporary theater, dance, multi-disciplinary, new music, installation and live art practices. www.ps122.org

Performance Space is Australia's leading organisation for the development and presentation of interdisciplinary arts. Its artistic focus is on arts informed by performance, which draw their influences from across the performing and visual arts. Performance Space encourages art that explores the intersections between artforms, questions assumptions about the relationships between artist and audience, and engages with the concerns of the ever-evolving society in which we live. www.performancespace.com.au

Letter to New York

Rabih Mroué

Good evening,

My name is Rabih Mroué. I'm glad to be here with you tonight. This is my first visit to New York; as a matter of fact, this is the first time I've set foot in the Unites States.

To put it in a nutshell, this visit is quite important to me. It's true, I've only been here since yesterday, but I feel as if I've much to say about this city and about my journey from Beirut to New York.

When I received the invitation from the Performa Festival and PS122, I was very happy and anxious at the same time. I wasn't sure I would be able to obtain the American Visa, especially since one of my friends, who is a musician, was recently rejected. But I do know many other friends who received the Visa; maybe I have a tendency to see the negative side of things, and I assumed I would be rejected like this one friend.

I was staying in Brussels when I asked my managing agent to make an appointment on my behalf at the American Embassy in Lebanon, in order to apply for the Visa. Surprisingly enough, the date for my appointment turned out to be November 10, while I was supposed to be in New York on the 5th. I panicked and decided to send a letter to the Embassy, asking them to make an exception in my case, since I had a performance to attend to. I wrote to the Ambassador and told him the following:

"I've been told that the world of performance, theater and visual arts in New York needs me. My work, my voice and my perspective are very much desired and missing from the city's art scene. The city of New York wants me.

"A press announcement was made just a few days prior to hundreds of people, announcing my imminent arrival. PS122 started posting advertisements all over the city for my performance. Dedicated art magazines were promoting the

show. A number of New York curators and art dignitaries had expressed their enthusiasm at the prospect of my visit.

Moreover, Performa have been trying to fly me over to the United States since 2006, and would be greatly disappointed if I wasn't able to make it. Please consider my special circumstances, and provide me with an appointment at a more convenient date".

Two days after my return to Beirut from Brussels, I was sitting at the desk of the Visa clerk at the United States Embassy. He asked me about my work and theater, and wanted to know which performance I was planning to show in New York. I told him, Looking for a Missing Employee. He asked me about the number of actors that would be present on stage. I didn't know what to say. He asked me: "What's wrong? Why are you silent all of a sudden?"

"Well, there's no one on stage in this play," I answered.

At this point, he fell silent too. So I, in turn, asked him, "is something wrong?"

"Of course there's something wrong! How can there be a play with no actors on stage?" he snapped.

I tried to explain to him the proceedings of this particular performance, and the fact that the action takes place outside of the stage, among the audience. The spectators can only comprehend the play if they are looking at an empty stage, where the events are being broadcast live. I even tried to explain to him that my idea is that today

we have to look in an oblique manner at the events on stage in order to comprehend them, whether the events are taking place here or there, where the audience is seated, or on stage.

He was silent for a while then said: "This is a difficult concept to grasp. Honestly, this is the first time I've heard of theater without actors".

"Yes, maybe you're right. This is probably the reason why they've sent after me," I said.

"Indeed, you should definitely go there," was his reply, and he proceeded to hand me the Visa.

One of the reasons I've never come to the United States before, is my phobia of American airports; more specifically, of the security measures in these airports. I have heard many stories from Lebanese people about these measures, and how they were selected for 'random security checks'.

My friend Ziad told me that he was always selected for this random check, no matter where he was travelling from or to. I've also heard about endless delays, planes that were missed, long interrogations about one's personal life, luggage and personal effects scrutinized, laptop contents examined, and so on and so forth.

Yesterday, however, something entirely different happened at Kennedy Airport. When I arrived at the Security booth, I was ready. I gave my passport to the Customs officer. He started examining it; looked at the picture on it; looked at me; looked

back at the picture; hesitated for a moment, then looked at the picture again. At this point, I knew something was wrong, and got anxious. Pointing at the picture on the passport, he asked me: 'Do you know this person?'

Immediately, and out of sheer fear, I answered: "No Sir, I have no idea. I don't know him; I don't know who that is".

"Don't you know his name, by any chance?" he asked me again...

"No sir, I don't know. How could I know his name, since I've never seen him before?" I said.

"Are you certain of what you're saying?" he insisted.

At this point, I was totally confused and didn't know how to answer. I wanted to be as honest as I could, as they advised me to do back in Beirut: be honest, don't lie, whatever the question. Tell the truth.

I wanted to be truthful, so I collected myself and told him: "I can't be sure. Maybe I have met him before, but I'm not certain. He looks kind of familiar to me. I don't know. Sometimes I don't even know who I am, myself. I'm sorry, Sir, this is the truth".

A friendly smile appeared on his face, he stamped my passport and handed it back to me, saying: "It's fine. If you don't know who you are and if you don't know what to do and where to go, I can ensure that your stay in the United States will be a pleasant one. Something to remember for a lifetime.

Welcome to New York".

I went out of the Customs Hall. A man in his fifties was waiting for me, holding a sign with a name I did not recognize. How did I know he was waiting for me? I don't know, but my luggage ended between his hands, and I found myself trying to catch up with him. A few seconds later, I was sitting in a white Stretch Limousine as this man drove towards New York City. Not a word was exchanged between us, except for "Where you wanna go, Mister?" This question made me realize I was the wrong person in the wrong car. Along the way the driver started telling me stories, but I wasn't really listening; I was focusing on the fee I would have to pay for this luxurious ride, and estimating in my head how many dollar bills there were in my pocket.

For some reason, this car ride was a very long one, and seemed never to end. I wasn't able to let myself rest, although the car was very comfortable. All I could think about was my physical presence in this car, a car supposedly meant for Hollywood stars; here I was, drowning in my seat, not being able to look at the buildings, the roads and the scenery outside. Were there any trees? I couldn't really tell. All I could see was my own body, slowly becoming smaller in this huge car.

If it's true that New York gives you the opportunity to be a star, then the one thing that really saddened me was that I was not

able to be one and enjoy the moment; being in this fancy Limousine as any star in a movie.

When we reached the hotel, the driver told me, as if he was reading my mind: "New York is not like the movies. It's more like a television screen, displaying various shows all the time, filled with distinctive choices, filled with everything you wish to watch and hear. It's the city where the show is going on 24/7, without a single moment of boredom; and we are all part of the show".

At this point, I was so tired that I decided to head straight to my room, and collapsed on the bed from exhaustion.

Recently I've been travelling non-stop, going from one festival to the other, from one invitation to the other; it seems to me that with such invitations we ease ourselves into a certain situation, go with the flow, and accept new conditions with no sense of control. And all of a sudden, we feel deprived of strength and vitality, drained by travel. This is in fact our body alerting us of the risks of following the stream, forcing us to slow down, to stop and eventually retire. Yes, it's our body that halts us at the peak of our activity and orders us to take a break, so that we can think and reflect upon our manner of living.

Earlier this morning, I was scheduled for an appointment with a journalist. He asked me about my opinion of New York and I told him, "it's too early to tell".

He insisted, and I found myself telling him that "New York is similar to a Microsoft Windows program, where you are allowed to Do, Undo, and Redo, and so on and so forth. You can commit mistakes without anyone paying attention, since the program will correct them automatically, sometimes without you noticing, and of course without blaming. You can delete anything you want to, easily, with a simple push of a button". I fell silent for a moment and added, "or be deleted".

"What are you presenting tonight? What are you up to? What is the concept behind this evening's performance? What kind of reaction do you expect from our New York audience?" the journalist asked me.

I spoke, he wrote, and I now read:

"I, Rabih Mroué from Beirut, stand in front of you today in New York. The stage will be empty; there will be no actors tonight, no lights, no music. Just an empty stage and a white screen. I look at the emptiness of the stage and the whiteness of the screen, and I know that something is going to happen. Will the performance take place tonight? Or is it already over? Am I waiting for what's going to happen afterwards? The empty stage announces the unexpected. The empty stage is a space for work, for battle, for thought.

Theater is presently away on vacation, but will return. There's no need to wait, though. Today, I will look at the emptiness. Let me try to turn down the lights on stage, without fear. Let me try to become enveloped

Richard DeDomenici
has gone beef jerky
cold turkey: http://tinyurl.
com/84h9hp

by darkness, without dread. Let me try to
turn off traffic lights, street lamps, neon
signs, television signals, skyscrapers; let me
try to turn off the Internet and satellite
beams. Let me try to turn off America for
an instant, for I am coming from Beirut, and
will not be able to know New York, unless it's
plunged in darkness.

Before leaving for Beirut, I would like to
remind you to turn off your mobile phones;
this theater disposes of two exits located at
(please provide theater information here).
Enjoy tonight's program".

Rabih Mroué's Letter to New York was originally
written by Rabih Mroué and delivered at
Performa, 2009, New York. Translated from
Arabic by Ziad Nawfal.

Brian Lobel is not sure if the sample size is large enough to make such a bold statement, but after running into three amazing artists on the street today, is convinced that Church Street is an epicentre of something awesome.

The Great Unknown: A talk for the RSA

Andy Field

So for this panel we've been asked to try and predict what new forms of art might emerge in the next decade and where they might be found.

I've really got to be honest and say I definitely, definitely have no idea.

But then, I don't think I'd want it any other way. I wouldn't want to try and predict what's coming next because fundamentally I'd never want art to be that predictable. I wouldn't want things to slide in and out of fashion like heels or shoulder pads or French windows. I wouldn't want art to inevitably follow advancements in technology, in the internet, in iphone applications, in video games and social networking sites. I don't want art to evolve elegantly, sensibly, with neat, traceable legacies. I don't want to be able to walk smugly back in here in a decade's time and say 'I told you so'.

Instead, I want to be amazed.

I want to be shocked.
I want to be confused.
I want art to be messy.
I want it to be unpredictable.
I want some group of people who've been working away in obscurity for the last ten years to finally make it.

I want the National Theatre to go bankrupt and be squatted by people who really don't know what they're doing.

I want all the GPS satellites to fall gently out of orbit, ushering in a renaissance in old fashioned mapmaking.

I want someone to invent something as good as the internet.

I want us to be shaken roughly into acknowledgement of our own crushing decadence.

I want all the artists to sit down on our new seafront just outside Peterborough and wonder what the fuck we're going to do

Richard DeDomenici
has anyone thought
of any bad taste jokes
about Cockermouth?

about all of this.

From out of nowhere I want someone to discover something completely new.

I want someone to rediscover something really old.

I want ideas to be borrowed, pillaged, repurposed, re-imagined.

Where will this art take place?

A theatre?

A gallery.

A warehouse.

A factory.

A dusty church hall in Edinburgh.

Second Life.

On a train between London and Birmingham.

Or an aeroplane over the Atlantic.

On a boat in international waters.

In a flooded village hall.

In the rented corridors of royal palaces.

In the abandoned skyscrapers of the docklands.

Illegally, in prison cells.

Wrestling rings.

Peep show booths.

In your own home.

Or in a movement in a window

Or in an unseen touch, lingering on the back of your hand.

Or in a phone call.

Or in the way someone asks you to look at someone.

Or what they whisper to you as you walk along.

Or what they simply ask you to imagine.

Who knows? All these places and more, hopefully.

The less we try and predict, the better. The more exciting the spaces will be and the more exciting the art will be.

Spaces are never empty, despite what Peter Brook says. They are never a blank canvas. They are always already full. Full of conventions and prohibitions. Choked with history. Noisy with politics. Give artist a space and you are giving them a way of working, a way of being. Often I feel people should try harder to let the artist decide where they go, rather than encouraging them to use the spaces we keep designing without ever really asking them.

Let's stop building new theatres and new galleries. We need less cathedrals and more homes. Let's just wait and see what's needed. Let's think harder about how we can make use of what we've got – how that can be shaped to the needs of the artist.

So that's what and where dealt with, leaving enough time to answer a question I think is equally if not more important – not what or where but how? How will this new art be made in the next decade?

How can you make a new form of art, a really new form of art, when so many of the institutions that are there to support it limit themselves through narrow categorisations and proscriptive paths of development?

Specialisms quickly become suffocating.

Institutions rightly celebrate their area of expertise but in doing so they also ring fence it, inhibiting people from experimenting with new ways of working. Where do you go if you fall between the cracks? Where do you go if you know what you want to do but you can't find anywhere to do it? In theatre for example where do you go if you need space for developing and showing your work, but it doesn't fit a script or a scratch night?

Where to find that elusive combination of creative freedom and constructive support?

I believe the answer will increasingly be that artists look to each other, forging new artist-led communities and organisations.

Look for example at Residence in Bristol. A community of artists working somewhere between theatre and live art, sharing space and resources. Encouraging each other and collectively engendering new opportunities for creating and presenting their work. Out of this miniature ecosystem is coming some of the most exciting performance work to be seen anywhere in the country. Companies like Action Hero and Tinned Fingers, creating work that is distinctive, thoughtful, daring and totally original.

Or look at Showflat. A group of visual artists based in London supporting each other to work outside of the constraints of the gallery system by using their own flats to curate a year-long series of exhibitions, events and happenings.

Or the SHUNT Lounge – a theatre come gallery come bar come club come music venue come chaotic subterranean universe where the performance collective SHUNT managed to create one of the most dynamic spaces anywhere in the country for artists to experiment with new ideas. A space unlike any other, constantly re-imagining itself each week as a new member of the company became its lead curator.

I hope to see more and more of these collective projects. A brilliant network of artist-led communities emerging across the length and breadth of the country.

I hope to see a giddily diverse range of artists working together, making new spaces for themselves determined only by their fascinations and desires. Artists supporting each other to make new work, encouraging each other. New forms emerging unexpectedly from shared space and shared ideas.

And once these artists have established themselves, once they have built that space, I hope to hear them speaking in unison to champion these new ways of making the new things being made.

The Great Unknown: A talk for the RSA written by Andy Field and first delivered at The RSA's State of the Arts conference, 2009, London.

2 Degrees : Arts, Activism &
The Global Climate Emergency

Caleb Klaces

Programmed by Judith Knight and Mark Godber at Artsadmin, *2 Degrees* is a full-on mini-festival of artworks and events created by over 20 "radical and politically engaged'" artists taking place between 16 – 21 June 2009 in East London. *2 Degrees* is one of the events featured in Respond! How do you transform engagement into art and entertainment? Caleb Klaces takes a look at what is coming up in the festival this June for RSA Arts & Ecology.

After attending a *TippingPoint* meeting of scientists, artists and arts administrators to discuss imaginative responses to climate change, Judith Knight co-director of Artsadmin, felt both despair and excitement. THERE ARE PEOPLE SAYING "OH NOT CLIMATE CHANGE AGAIN," BUT YOU HAVE TO IGNORE THAT - Judith Knight, ArtsAdmin. The scientists had explained

that according to the best current climate models, a rise in global temperatures of 2°C above pre-industrial levels (very likely without significant worldwide cuts in CO2 emissions very soon), will start dangerous changes in the global climate systems which it would be difficult, if not impossible, to stop: past 2°C and it's in the lap of the Gods. But the meeting also showed Knight and her colleagues at ArtsAdmin that they were far from the only ones wanting to do something about it.

It will take a global, collaborative effort in order to avoid a 2°C rise. Shortly after the *TippingPoint* event, Artsadmin became a founding member of the 2020 Network 2020 Network of European arts organisations "working together to encourage artists and audiences to engage with the subject of climate change". The 2020 Network, funded by the European Union, currently includes

organisations in Slovenia, France, Britain and Belgium. Thin Ice is the name for a two-year programme of partners' activities, taking place in their respective countries; *2 Degrees* is one of the first events of the Thin Ice programme.

The festival is also part of the *RSA Arts & Ecology's Respond!* month and therefore part of a whole network of artists and organisers in the UK and abroad who are worrying creatively about these issues. With all these layers of involvement, I asked Knight whether she feels any backlash against climate change as a subject for artists – whether anyone thinks it's merely fashionable. "There are people saying Oh not that again, but you have to ignore that because it's just too important not to do. It's not a subject where you can think, We've done that". For Knight, the variety and growing number of artists' responses is only beginning to reflect the urgency of the problem, as expressed in the festival's subtitle, *Art, Activism & The Global Climate Emergency*. ArtsAdmin have deliberately shifted the definition of how we are affecting the earth's climate systems from clinical "climate change" to campaigner George Monbiot's much more alarming phrase.

A "climate emergency" requires artists' responses because "artists have a way of communicating that is so much more imaginative and interesting that just reading this stuff in the papers". It also requires artists and administrators to be responsible about the environmental impacts of making and showing work. The collaboration across borders that helped produce the festival, for example, raises environmental questions that Knight is keen for the sector to discuss. Over 18-19 June, the *Slow Boat* event organised with the British Council will bring together in London 100 British performing arts companies, venues representatives and technicians to ask how we should continue to work internationally while minimising environmental impacts. Many artists' livelihoods (including Knight's jazz musician husband's) currently depend on air travel, and it is hoped that the Slow Boat discussions will lead to some practical ideas for alternatives.

The artists in the festival are mainly locally sourced, and the events all situated in or close to Artsadmin's Toynbee Studios, East London. However, Knight "would hate to think" that they at ArtsAdmin are "preaching at people, because we're absolutely not the right people to do that". Rather, she hopes that *2 Degrees* will "not be a holier-than-thou thing", but looking at the present and future in a practical, honest and imaginative way – just as the scientists at the *TippingPoint* event were "devastating" and "inspiring" at the same time. The Peachy Coochy event on June 19 at Toynbee studios (a regular monthly feature there, but this themed evening for the festival is running in

Richard DeDomenici
What happens when you see what you think is a piece of Unattended Baggage, but actually the baggage is being attended, except the person who's attending it is doing so from inside the baggage? http://www.youtube.com/watch?v=meXXjmVI07w

association with *TippingPoint*), is typical in tone and purpose of the festival as a whole. "Coocheurs" (or presenters) must accompany 20 climate change-themed images, each projected for 20 seconds at a time, with precisely 20 seconds of live spoken text. The brevity and spontaneity of the exercise should provide some new ways of grasping sometimes tired subjects.

At Peachy Coochy nights, "randomness is discouraged but narrative linearity is not automatically esteemed", which is a good way of describing the ethos of the performances, interventions and sometimes confrontations that will form *2 Degrees*. The artists have varying focuses, including food and drink, urban environments, family and guilt, with varyingly abstract approaches, but none strays too far from the urgency of the central theme. "I don't think that artists can be so precious that they can't engage at all with the world", Knight explains, "nor would I sit in the camp that says you're an artist, you have a responsibility: you have to make work about A/B/C/D…you can't do that either." "The activism was important" to Knight and Godber and the artists that they approached to be involved were mostly people who already "really live it – they don't just make work about it".

It is also purposeful that *2 Degrees* is a festival not simply to attend. Whether it's sharing an organic picnic, recreating a lost river or buying a woman, almost all of the

events will ask the audience to do something, and think while they're doing it.

Knight agrees that "artists have to have a good sense of humour" when they are getting the audience involved. Richard DeDominici *Plane Food Café* Performance artist Richard DeDominici has said that "[i]f you can make a stranger laugh, then they're much more likely to engage with the underlying meaning of the work". From Tuesday 16th–Saturday 20th June DeDomenici will be serving genuine airline meals, delivered straight from an airport factory in a plastic tray, for £5 at his *Plane Food Café*, an immersive installation created out of fixtures and fittings procured from aircraft reclamation yards, complete with on-board entertainment on the wider subject of air travel. *Plane Food Café* responds to chef Marcus Wareing's recent statement that British pub food is so bad that "if you want a decent bite to eat, you'd be better off getting on a plane". If that's true then for five days in June people within walking and cycling distance of Toynbee Studios can sample better food than their local inn without emitting the 2 tonnes of CO_2 from an average long-haul return flight.

In 2005 DeDomenici stashed himself in a suitcase left outside Helsinki Railway Station for Unattended Baggage, drawing attention to a liminal space – and how official guardians of it react to its unwanted invasion; *Lossrail* is an ongoing project to

document buildings that will be demolished to make way for Crossrail – the planned trainline running East-West across London. As roads and rail carve out new routes and spaces across cities, many of the rivers and lakes that helped physically and culturally to shape them – giving places their names and providing food and other resources – are now concealed, submerged or gone. In artist Amy Sharrocks' 2007 *SWIM* project, 50 people swam across London from Tooting Bec Lido to Hampstead Heath Ponds. The swimmers were, in Sharrocks' words "exploring an idea of freedom" physically, putting their bodies through restricted and public waters, while also looking a cheering sight slopping through the streets of London together in swimming costumes. Sharrocks' *Walbrook* project takes the natural step from swimming in urban water to becoming it. On Friday, 19th June, 2pm-5pm, a large crowd dressed in blue and loosely tied together will trace and recreate the buried Walbrook River. One of London's oldest rivers, it has been tracked by Sharrocks and a dowser from its source in Islington to its mouth at the River Thames, through the heart of the City, indeed across the Bank of England.

At the Bank the blue walkers may well flow over one or several of the eight Postcapitalist interventions led by a number of artists under the *C.R.A.S.H Culture* banner (Wednesday 17th – Saturday 20th June). The *Café of Equivalent$* due to be opened for service in the City will price a dish according to its cost in the developing world that produced it, relative to an average developing world wage. Bankers will also be able to buy bowls of soup made from real gold in order, the artists say, "to discover what it feels like to be of real value".

Interview with Judith Knight

From June 16 to June 21 Artsadmin's *2 Degrees: Art Activism and the Global Emergency* will be challenging Londoners to think about their part in responding to the environmental challenge. Caleb Klaces talks to Judith Knight, co-director of Artsadmin about the story behind *2 Degrees*.

2 Degrees is one of the events featured in Respond!, highlighting the arts' response to environmental issues in the UK.

How did 2 Degrees come about?

Individuals were thinking about these issues in a personal way, but it began really when some of the Artsadmin team went to the second *TippingPoint* meeting (of artists and scientists) and it was quite devastating; an extraordinary event for me on the arts side. I don't come across scientists that often and they were very communicative. I walked out after two days in Oxford feeling 50% in despair, with another 50% of real positive energy because there were so many people doing so many amazing things, really engaging and doing stuff – scientists studying the weather on Mars, for example.

Richard DeDomenici is in shock after another 4 stars for the PFC http://edinburghfestival.list.co.uk/article/20228-plane-food-cafe and a big five for Plagiarismo! http://allthefestivals.wordpress.com/2009/08/20/review-plagiarismo-new-town-theatre

Worries in the arts community often just come out as just Oh isn't it terrible and it was encouraging to meet these science people. In general, the *TippingPoint* meetings have been a real inspiration, having a huge effect across the world.

The other thing was meeting people from across Europe and out of that came the idea to make a joint application to Culture 2000 (a 7-year European Union programme) from London, Brussels, Angers, Ljubljana, Montpellier. The idea was to form a network which would encourage artists to make or programme work about the subject because there wasn't a huge amount then (as there is now, which is a good thing). We're also working on a website which will include really practical thoughts on how we can collaborate internationally, which is really important to all of us – without just hopping on and off planes.

You say that more artists are engaging with the subject, but is there also a reaction from artists who think that it's becoming slightly fashionable…?

Some people are saying that it's just jumping on a bandwagon and of course there's the endless debate, particularly interesting in France, where it's taboo to tell artists to do anything. Of course you can't make artists do anything. We [Artsadmin] are 30 years old this year and all that time we've been trying to make happen what the artists want – we know that it has to come

from the artists first. And that's important because artists have a way of communicating that is so much more imaginative and interesting than just reading this stuff in the papers. If they can be encouraged, without telling them to do this or do that.

There are people saying Oh not that [climate change] again, but you have to ignore that because it's just too important to not do. It's not a subject where you can think We've done that (which, to some extent a subject like colonialism is) – the terrifying thing is that it's potentially bigger than all the other terrible things you can think of.

And you have very explicitly made that shift from "urgent issue" to "international emergency" (as George Monbiot put it). That seems a deliberately new way of talking about it…

It's because it's sort of invisible here, for people getting on the Underground every morning: we haven't had a hurricane Katrina, we haven't had disastrous flooding, so it's easy to put it out of your head and pretend it's not there. But lots of the artists involved in *2 Degrees* really live it [a sustainable life] as well – they don't just make work about it – they're very clear…

Running a climate change festival must put the focus on the sustainability of your own practice, too. Have you worked on making the venues etc. green?

Well we're totally not green through and through and we wouldn't attempt to say

we're like that, not like the Arcola Theatre in Dalston [London] or the National Theatre. We've done small, simple things – recycling, making sure windows can be opened and closed to save energy etc., but we'd never claim to be completely sustainable. *The Slow Boat* run as part of the festival by the British Council – which is about how we can continue to tour internationally, as often a huge element of theatre and dance company's livelihoods is touring, more than working in Britain, so there are good reasons to carry on, but we can't keep hopping on planes. The question is: how do you tell artists they can't do that any more? Back when Artsadmin started the geography was greener somehow because the flights were much more expensive and you tried to do tours within places you could get to. Now you can go all over with cheap flights. The British Council has identified the companies touring the most and is getting them together to discuss how their impact might be improved. It's also one of the things we're trying to do with the 2020 Network.

2 Degrees seems like quite a British line-up, is that intentional?

Yes, I think so. In future it would be nice to make more of an international link, but this lot are local.

And all interactive and interventionist artists. Was that a choice too?

That was a choice. The activism thing was important, it's the way many of these artists

work anyway, rather than getting people in just to watch something. I've heard great things about *The Contingency Plan* [play at the Bush Theatre in London, review on the RSA Arts & Ecology here], but so far I think that the artists that have really connected with this subject have been filmmakers and visual artists, or intervention/activism artists. It seems quite a difficult thing to write a play about.

There was a great play at the Arcola Theatre, One Nineteen [by Tim Stimpson, see here] a while ago, which was set in a flooded Britain, but that may be true; perhaps it's easier for visual artists to go at it from a slanted angle or something...

Yes, and this particular group of artists in *2 Degrees* are all getting the audience to participate in some way, whether that's just having a picnic or eating aeroplane food, or obviously through the education work. There's a big audience who like to get involved.

Were you tempted to include a specific goal or pledge for the audience associated with the festival?

We haven't thought about that. I'd hate to think that we were taking the moral high-ground. Somebody from Greenpeace said to me, when I said "does that mean I can never go to Greece again?", that "it's just doing something that's important". It doesn't mean we all have to beat ourselves over the head. We just have to really look at everything we

Richard DeDomenici's forthcoming project has received a 'mixed' review from the Observer's restaurant critic: http://www.guardian.co.uk/artanddesign/2009/jun/07/richard-dedomenici-in-flight-food

do and make informed choices. I would hate us at ArtsAdmin to feel we were preaching at people, because we're absolutely not the right people to do that.

And actually it's not just a question of telling people they can't do it like that anymore, but if there is no more oil, or very little, then on a practical level it'll be much more difficult to fly, for example, and we want to show how that might look. It's not a holier-than-though thing, but looking at the future in a practical way.

…and examining the past, too, as in Amy Sharrocks' piece, which looks at the layers of our environment…

That's a lovely project: it gets people's imaginations going. And the other thing is something that a friend of mine always says, which is that we should be trying to present an optimistic alternative future, rather than the doom and gloom. It could be a much nicer life for nearly everybody if we found a way of doing it. And that's what artists are so good at, getting across an imagination…

….so, for you, that's art's role in making social and environmental change: getting people to imagine other things?

There are those Arts Council tick boxes: education, community etc., and there is a reaction against that tick-box approach. I sit somewhere between the two: I don't think that artists can be so precious that they can't engage at all with the world, nor would I sit in the camp that says you're an artist,

you have a responsibility, you have to make work about A/B/C/D…you can't do that either. I think that artists are in the world like you and me and everybody else and it's good if they can deal with these subjects because they're better at it than us – they're imaginative, they get people thinking that's interesting, that's beautiful, That's terrible in a way that perhaps even Al Gore's film [*An Inconvenient Truth*] couldn't.

There's something to be said for having lots of different artists and artworks, because art is personal…some people might react better to Amy Sharrocks' piece and some to Richard DeDomenici…

Richard's piece will be very funny, and Amy's will be really imaginative, and it'll be a good balance.

Do you think you need to maintain a wit about these sorts of things?

Oh yeah, you've got to about everything. Artists have to. It brings people on board more. But there's levels of irony and wit, too. I'm particularly looking forward to the family picnic thing from this lot from Liverpool getting people to confess their eco-sins [Institute for the Art and Practice of Dissent at Home, 6th June, 7-10pm, Toynbee Studios], it'll be funny.

And the problem is that people will say that isn't everybody who's coming to this already on board…?

How would you respond to that?

It's a worry. But I like to think the

message spreads. It gets in the press, and people talk.

Are you deliberately trying to get along people who wouldn't normally be coming along?

There's a press campaign and we try to, although it tends to attract a certain, possibly younger, audience who are used to seeing work in strange environments.

Next year we hope it will expand. We're meeting all the European partners here during the week to look at the scale of what we're trying to do - we want to bring in other partners. Each country has its own approach, Ljubljana, for example, had a festival where every project was about recycling, and we're grappling with how we join up all these projects with a real connection.

Are you personally optimistic about the future?

I go up and down like a yo-yo. But I have children in their twenties and you can't sit around the dinner table being gloomy because it's their future more than mine. I veer between total optimism when I see what energy people are putting into projects and working in this way; then when I hear about ski runs in Dubai it feels pretty pessimistic, or Boris Johnson not extending the Congestion Charge. Stupid things make me cross. But then you have to have some optimism with Obama in charge.

Do you see American artists engaging with these issues in the same way?

I think so. The British Council in Washington have been doing some good work, and there

was a conference in New York last year about it. Probably a complete mixture, really.

Where do you think artists are engaging with it in the most interesting ways? Is it in the UK?

The [mainland] Europeans think it is. At a theatre conference in Bratislava people thought that the UK was miles ahead of everyone else. But we think that if we're the best then what must everyone else be like?... there's a long way to go.

A woman from The British Council said something interesting: an artist asked if they could be flown back to the UK from the US for only a few days between events and she said no, not even if they had the budget, because of the environmental impacts, which the artist hadn't even thought about.

My husband's a jazz musician and almost all his work is abroad... it's a big question that affects our lives, how do you look at that?

2 Degrees: Arts, Activism & Global Climate Emergency Review and Interview with Judith Knight were both written by Caleb Kraces and published by RSA Arts & Ecology online. May 2009. http://www.artsandecology.org.uk

Caleb Klaces is a poet, and founding editor of www.likestarlings.com, a website which pairs poets to create new conversations in poems. He currently lives in Austin, Texas, where he is editor-in-chief of the Bat City Review. He has written for various environmental journals and is author, with Joanna Yarrow, of *Eco-Logical*, a guide to sustainability.

A rebel performance artist goes through his mid-life crisis

Guillermo Gómez-Peña

(While revising my unpublished literary archives I came across this highly personal text I wrote in 2005, immediately after turning 50. As I re-read it I find it a bit self-indulgent and whiney, but I recognize that it reflects my troubled feelings at the time. I have chosen to distribute it with a post-script as a tribute to all the aging rebel artists facing similar demons).

I just turned 50, which is quite dramatic if you consider that I am a "radical" performance artist who is well known for his transgressive aesthetics, political bravado and uncompromising irreverence. I am the guy who became notorious for speaking in border tongues and spending three-day periods inside a gilded cage as an "undiscovered Amerindian"; the very Vato who crucified himself dressed as a mariachi to protest immigration policy. Suddenly, I'm growing white hair and a belly, and my voice sounds reasonable and tempered by my experiences. A cruel curator friend of mine tells me that "(I am) no longer feared or desired but respected." Auch!! When young rebel artists call me "professor Gomez"" or "maestro," it pinche flips me out.

But let me elaborate a bit: I have spent a lifetime utilizing my body and my tongue as tools to express my opposition to mainstream culture and values, advocating anti-authoritarian artistic practices and supporting outsider communities. And I always thought of myself as age-less, or rather as permanently young. To remain young for me implied a relentless capability to reinvent myself, to constantly take risks, and to remain in touch with the cultural and political pulse of the times and the streets. It also meant not to think too much about the past or the future, to always operate in the "here" and the "now," the time and place of

performance art. My existential motto was "If I don't go crazy at least once a week, I will loose my mind," and I was loyal to it.

By the time I turned 40, my rebel contemporaries and partners in crime began to settle down. They got full-time jobs. They married and began to have children. They bought homes. And suddenly they had much less time to hang out in seedy bars and undertake daring art projects. I saw them, one by one, loosing their spunk and bravado, becoming cautious and moderate, talking about saving for the future (anathema for a radical artist), and dyeing their hair to hide the grey. They gave me all kinds of advice: "Gomez-Pena, you should write more accessible (and profitable) books; follow the example of Eric Bogosian and Anna Deavere-Smith and get a job in Hollywood or in a TV series or at least get a tenure job in academia. It gives you medical insurance and the certainty of a monthly check." Those kinds of comments made me depressed. The subtext was "aren't you a bit old to live as an outsider artist?" I hung out more and more with younger artists who were willing to jump into the abyss with me. I even perceived a generational fault line between people of my age and me.

I experienced my mid-life crisis by going out with someone 17 years younger than me, a Mexico City upper-class princess. Our generational differences in "lifestyle," taste in art and political beliefs made me even more conscious of my age. Once day, I realized I was definitely going through my climaterio (Spanish for male menopause) when I found myself disco dancing in a Mexico City nightclub surrounded by 20-year-old hipsters. 'Patético'- I thought. I excused myself, pretended to go to the restroom and escaped through the back door for good. Now in retrospect I realize that this escape was a spiritual relief and that I wouldn't give anything to be that age again.

In my mid 40s, I began to perceive the symptoms of aging as cruel. I wrote in my performance diary: "When I was younger I had visions, utopian visions; now, I have dreams. As a young artist, the streets were my laboratories of experimentation; as a "mature" artist, conversations and rehearsals, have replaced the streets. Taking physical, aesthetic or political risks was an integral part of my artwork. Today, I am more interested in the pedagogical dimension of my art. I even have stopped getting naked on stage. (Clearly, I did this to protect my audience from my growing love handles.) I used to always collaborate; suddenly I am thinking more and more of my solo work and of my personal voice. (Was I becoming more selfish or merely wiser?) I am becoming increasingly more conscious of my "artistic legacy," another anathema for a performance artist. But worse than anything, I am becoming more tolerant of political difference and cultural insensitivity: I no

longer have formidable intellectual fights with conservative critics and ethnocentric curators."

In my late 40s, I became increasingly aware of the fragility of my body. After a lifetime of abusing my body partying constantly and simply working very hard, one day I got gravely sick. While touring Brazil, I caught a tropical parasite with an unpronounceable Latin name and experienced a total liver crash. With my body connected to machines at a Mexico City hospital, I came face to face with Death. I looked like one of my Chicano cyborg performance personas. For eight months I faced the prospect of a life without touring, without performing: a life as a stationary intellectual forever meeting my inner demons in front of my laptop. I was inconsolable. During my slow recovery I wrote my first script ever that dealt with my past; a biographical reflection on what it meant to be a Latino artist facing the abyss of the end of the century and the dark clouds of middle age. I noticed that my poetic tone had changed. I was more somber, and self-critical; less outrageous. I was thinking about my place in the world, my relationship to family, friends, art, community and the universe at large. I had lost some of my sense of humor. I was obsessed with literary craft. That script was better literature, but denser and clearly less accessible to a live audience.

I eventually recuperated from my illness and went back on the road, thinking it all had been a temporary nightmare. But I was wrong, pinche wrong. Soon my memory began to betray me. I started forgetting names, conversations, incidents, and book and film titles. My recent memory, say of the past three to five years, was even worse. I first attributed this loss to Caribbean rum, tobacco and sleeplessness, but then I started talking to other artists my age, and they were all going through an identical experience. An Indian artist friend told me: "Don't worry ese; it's the Big Smoke. You are simply going through the Biiigg Smoke." My wise mother told me: "It's the German guy inside of you, Mr. Alzheimer. You have to start making peace with him. His going to be living with you for a long time." It wasn't funny. I began to consciously engage in memory exercises, in acceptance exercises. I became an involuntary Chicano Buddhist.

And then of course, there was the loneliness: Young people simple didn't look at you anymore.

I now wonder if as a 50-year old artist one can remain current, "hip," sexy and connected to the world, or if soon I should withdraw with dignity from the world, become a neighborhood drunk or commit ritual suicide as my last performance art piece. But when these thoughts begin to linger over my inner stage, my sense of humor and my love for life somehow redeem me once again. I think to myself: Perhaps

I can hang my weapons on the wall and still be a warrior, like my Colombian Brujo told me or perhaps I can become a hip elder loco artist like the late Marcel Duchamp or Burroughs or better yet, a sexy old rockero like Bowie or Jagger.

For the moment my only hope is to continue walking, not running, with style, lots of style; to remain open-minded and tolerant; to consciously continue taking risks and opposing authority whenever I smell it; and to exorcise any disconcerting thoughts about the future as much as I can. My blessing is that Carolina, my wife, also 50, is still gorgeous, hilarious and as much of a lunatic as she was when I met her eight years ago in New York City.

San Francisco
September 2005

Post-script/2009: I stand naked in front of a mirror for an extended period of time. I'm drinking a delicious single malt scotch, toasting with my self on the other side of the mirror and making peace with my 54-year old aching body full of performance scars and biographical tattoos. I toast to my panza (tummy), my dimming memory and libido. This aging scotch tastes better than ever. My flying Chihuahua Babalu is barking at his own image on the mirror. Tomorrow I go on the road again. Roberto, Violeta and I will perform the last version of Mapa/Corpo, a ritual performance involving "political acupuncture." I'm still a nomadic provocateur. Life is ok. Salud!

This bi-weekly literary project by Gómez-Peña is intended to both recapture his archival performance texts and provide new writing for online distribution. This exercise on virtual citizen literature includes weird performance chronicles, poetic journalistic pieces, activist epistolaries and brief theoretical reflections on art and other "related matters" such as politics, culture, identity, nationality, technology, sex and language. Editors and advisers include La Pocha's project coordinator, Emma Tramposch, and cultural anthropologist Gretchen Coombs. This is the second text of the series. Please forward it to colleagues who might be interested.

A rebel performance artist goes through his mid-life crisis by Guillermo Gómez-Peña first featured via the Guillermo Gómez-Peña email list. www.pochanostra.com

Richard DeDomenici's
ability to compartmentalise
rivals that of a sociopath.

Book Review *Out of Now: The Lifeworks of Tehching Hsieh*

David Williams (UK)

Let's start by revisiting the bare bones of the performance projects by Taiwanese-American artist Tehching Hsieh, realised between 1978 and 1999. Six projects in all, beginning with a series of five year-long performances. First, one year of solitary confinement in a sealed cell with no communication. Second, a year of punching a time clock on the hour every hour and photographing this action: 24 frames a day for 365 days. Third, a year living rough outside on the streets of New York, drifting and seeking shelter, never going inside. Fourth, one year tied at the waist with a rope to the performance artist Linda Montano, with a prohibition on touch. Fifth, a year spent abstaining wholly from art, its making and its spheres of influence. Finally, a 13-year project in which Hsieh proposed to make art without ever showing it in public, a project during which he effectively disappeared. On New Year's Eve 1999, at the cusp of the new millennium, in a brief event at the Judson Memorial Church to mark the project's ending, Hsieh simply told those who had gathered that he had succeeded in keeping himself alive …

The publication of this superb monograph is timely indeed. To date very little of substance has been published about this most remarkable artist and his profoundly unsettling body of work, despite the fact that its contours and challenges are etched indelibly into the psyches of so many involved in contemporary art and performance. We know these deceptively simple shapes, the sculptural forms of the bare bones outlined above, and they are as honed as the shapes of some of Beckett's most economical work. Or rather we *think* we know them, for they linger on in unresolved reverberant forms within us. In reality, individually and collectively these works

confront and resist claims to knowledge: about art and its parameters; about the passage of time, meaning, identity, freedom; and ultimately about what really happened in the seconds and minutes and hours and days and months and years of these extraordinary 'lifeworks'.

In a brilliant opening essay, 'Impress of Time', Adrian Heathfield contextualises and unfolds the implications of Hsieh's 'life lived at limits' (58) with consummate sensitivity and thoughtfulness. He treads lightly and respectfully throughout, refusing to explain this work away in any singular and inevitably reductive 'reading', instead approaching each work in turn not as a referential or symbolic narrative structure but in terms of what it *does*. In this way, he seeks to articulate something of the affective 'force' of this body of work as a 'constellation of *enduring ideas*, echoing in the present' (58).

As well as providing detailed descriptions of each of the projects in turn, Heathfield explores a wide range of such ideas, including: Hsieh's conception of art and life as simultaneous processes; his embodied instantiations of radical paradox, including the ambiguity of relations between constraint, solitude, freedom and thought in his work, and his deconstructive 'binding together of activity and negation, production and redundancy', public immersion and isolation, movement and stasis (45); the differing temporalities of photography

and film, and the unstable epistemological status of documentation; Hsieh's embodied stagings of an ethics of alterity, relationality and civility; his recurrent engagement with aspects and structures of 'the law' (he cites Kafka as a core stimulus), set alongside his vulnerable status as an illegal immigrant in the US; his decelerative 'wasting of time' in non-productive and uneventful works of extreme duration, and the critical frictions his 'use-less' slowness seem to propose within the accelerated temporalities of late capitalism. En route, Heathfield also traces relations with Conceptualism, Performance Art, Body Art in the West, and connections with a range of other artists including Bas Jan Ader, Harry Houdini, Hiroshi Sugimoto, Abramovic and Ulay, and, perhaps most startlingly as a deterritorialising line of flight, the tightrope walker Philippe Petit. These connective genealogies are invariably and finely attuned to differences, and Heathfield resists collapsing this relational cartography into any homogenising empire of the selfsame.

The bulk of the book (pp. 63-315) is given over to Hsieh's exhaustive documentation of each of his 'lifeworks'. Scores, flyers, maps, punch cards stamped and signed, legal documents attesting to Hsieh's own 'rules' having been respected (cells and ropes sealed and unbroken, punch cards stamped etc.), and thousands of photographs. Hsieh also includes calendars registering minor

Brian Lobel knows it's crass, or thinks it is, but is desperately in need of a translation of the British phrase 'up the duff.'

breakings of his strictures, such as hours missed in the punching of the time clock: 133 absences in the total of 8,760, each one catalogued in relation to one of three possible 'reasons' - 'sleeping', 'late', or 'early'.

Many of the beautifully reproduced images comprise lengthy series of stills cumulatively registering the passage of time, in dated punch cards, say, or gradual hair growth. It's intriguing to revisit the hourly photographs of 'Time Clock Piece' in this print context, laid out on 31 consecutive pages, each page containing 12 vertical columns / film strips of 24 images (i.e. one day per strip, 12 days per page). The lay-out produces an uncanny juddering temporality, and at the same time foregrounds the sheer enormity of the (t)ask. Its astonishing difficulty is somewhat elided in the high-speed, suppressed-hysteria energetics of the 6-minute stop-motion animated film version, within which each day – each column within the book - is condensed into a second[1]. On the page one can skim and flick, or endeavour to accept it as a kind of meditation exercise: an invitation to engage with the im/possibility of paying attention to each image, to the rare blank spaces when Hsieh failed to make it, and to the infinite blank spaces of the unimaginable 59 minutes or so *between* each image. The labour of attempting to 'read' it as a (ruptured) continuum takes time and real effort. Cumulatively it's incapacitating, one soon struggles with a kind of 'blindness'

and defaults to skimming; and in the end we come no closer to understanding what really happened. One recognises Hsieh's absolute clarity of purpose and will-ful integrity in the work, but 'he' is always elsew/here.

Ultimately, Heathfield locates Hsieh as 'a sentient witness of time' (11), engaged in practices of 'aesthetic duration', with each work *'a sense passage in which corporeal attention is drawn to (a) time reforming'* (22). Each of Hsieh's 'untimely' projects constructs a space of severe, self-imposed privation and constraint within which time passes and thinking happens. Each performance elaborates a rigorously precise architecture for the event of thought as art; but none of those thoughts are communicated. The internal life of the being in human being - Hsieh's lived experience of brutalising bare life *in extremis* - is forever withheld in an economy of denial that serves to create empty spaces for our own projections and dealings with incomprehension. As Tim Etchells puts it in his letter to Hsieh, the extensive documentary traces of the work that survive 'show everything but tell nothing' (357). Hsieh moves implacably towards the self-erasure of ever greater illegibility, invisibility and silence to leave us confronted with 'a sculpture of nothingness', and we are pulled back endlessly to 'a face off with the void' (360). Or, as Hsieh puts it with characteristic economy and lack of sentimentality: 'Living is nothing but consuming time until you die' (335).

The book draws to a reflexive end without closure in a long and engaging interview/ exchange between Hsieh and Heathfield ('I Just Go On In Life'), and a series of open letters to Hsieh by Peggy Phelan, Marina Abramovic, Tim Etchells, Santiago Sierra, and others from Hsieh's personal archive. The latter include a hand-written note from an irate and anonymous Chinese person – 'Artist? UGH!' (354); and a delightfully formal letter of support from a (real) estate agent in Michigan – 'I don't totally understand exactly what you are doing but I do think it is very important. Keep on with your good work…' (350). The letters allow different modalities of writing to open up other more intimate perspectives on and creative responses to the work, most effectively to my mind in the exquisitely performative contributions of Peggy Phelan and Tim Etchells. Finally, Carol Becker writes back into and out of the book in an elegant summative post-script, in which she applauds Heathfield's approach to the curation of these materials. His framing, she suggests perceptively, creates 'a safe holding environment where the work can rest … The intent of the pieces appears intact, allowed to exist in its emptiness and silence, still elusive even after so much has been said' (369).

Notes

1. Hsieh, Tehching (1999). *One Year Performance Art Documents, 1978-1999*. DVD-ROM. See http://www.one-year-performace.com. Also available through the Live Art Development Agency's online Unbound: http://www.thisisunbound.co.uk/

Book Review; Out of Now: The Lifeworks of Tehching Hsieh by David Williams was first published in *Performance Research*, volume #14, issue #2, pp. 130-131, 2009 by Taylor & Francis Ltd, http://www.informaworld.com. Reprinted with permission of the publisher.

Brian Lobel hopes that the jerkface kids who just threw rocks at his bike on Seven Sisters Road are not in the audience for his kids show at the Barbican. Or that they are not unaccompanied. (I'm fine).

Theatre for adults is child's play

Lyn Gardner

If you could only bottle what goes on in Once and For All We're Gonna Tell You Who We Are So Shut Up and Listen you'd make a mint. This 60 minutes of teenage kicks performed by 13 Flemish teenagers ranging in age from 14 to 18 is pure animal magnetism, a sweaty adrenaline rush that captures the restless energy of being a teenager and all the absurd, reckless abandon of being poised permanently on the brink of the high diving board. It makes you look back and try to pinpoint the divide, that moment when you ceased being a child and became an adult and life became much more manageable but also much more dull. It makes you feel joyful and sad in equal measure. It is an extraordinary piece of theatre, cunningly choreographed to feel completely unchoreographed and madly manipulative. But in all the right ways. It is a show that doesn't hold back. Everything

these kids do they do with total commitment, even though you know that they are acting being themselves. They just do it better than most actors could.

What's fascinating about it in a British context is that, as Shami Chakrabati recently commented at the Action on Children's Arts conference, we really seem to hate kids in this country. Many adults stumbling upon a group of 13 teenagers in the street would cross the road. Yet here they take centre stage. For the most part children are neither seen nor heard in the theatre unless they are cute little moppets appearing in Annie or The Sound of Music. But just at a time when parenting anxiety and fear of teenagers has reached epidemic proportions along come a slew of shows in which watching teenagers being teenagers has adults queuing up to watch.

Quarantine, one of the most ground-

Richard DeDomenici has just discovered that he can touch-type.

breaking and exciting UK companies has often included young people in its work including three teenage girls in its most recent show Old People, Children and Animals. In That Night Follows Day, a group of children arrange themselves as if on best behaviour in a school gym, gaze at the audience and tell us some home truths. It's an hour-long litany of accusation whose effect is to create a sense of how much of childhood is about being coerced and bullied into doing things that you don't want to do by adults. "You make us promises and sometimes hope you will not remember them. You tell us to sit still, to stay quiet. You tell us no."

What's interesting about all these shows, of course, is that they are shaped and mediated by an adult director. Richard Gregory directed Old People, Children and Animals. It is Tim Etchells (from Forced Entertainment) who is credited with writing and directing That Night Follows Day, and his distinctive voice is apparent behind that of the children. For Once and For All it is 31-year-old Alexander Devriendt who takes the credit. Is this a problem? Only if the pretence was otherwise, and in any case these shows are not made by teenagers for teenagers, but very much for adult audiences. The two 13-year-olds I took to Once and For All liked it, but much in the way they enjoy the illicit thrill of seeing an episode of Skins. In That Night Follows Day the children gaze out at us accusingly as they speak of love,

betrayal, selfless sacrifice and emotional manipulation. They may be standing on stage in the spotlight, but it is us - the adult audience - who are being interrogated. The show causes an extraordinary welter of emotions because you know that as a parent you are guilty of the behaviour you also recall from your own childhood. The cunning of this artful yet beautifully simple piece is that the adult audience has a foot in both camps.

There's a similar fascination in Once and For All which tumbles across the BAC stage and trashes it. After one scene in which the kids snog, touch each other up and hang out, they turn and look at us. Their gaze is so merciless you want to look away. "What are you looking at?" asks one and you can hear the scorn in her voice. We have been caught looking at the animals in the zoo. I'd be interested to know whether these shows work differently in other contexts and when performed in societies not as scared of their young as we are, and whether their fascination is in part based on a kind of nostalgia because they allow us to reconnect with our lost teenage selves. The kids, I think, will be alright; it's us adults watching who I worry about.

Comments (in chronological order)

- **AndrewCowie 27 October 2008 9:55PM**
 The show is not: 'a sweaty adrenaline rush that captures the restless energy of being a teenager'; it is, as you rightly go on to say, a grown man's sweaty memory, or fantasy, of being a teenager. I saw 'That Night Follows Day' in Birmingham and I assumed it was devised by the cast until I spoke to one of them afterwards and he said it was all written by Tim Echells. Neither of these shows is the authentic voice of young people; they consist of young people being used by adults to entertain other adults and, in this case, to tittilate them with scenes of under-age sex. Approach with caution.

- **lyngardner 28 October 2008 9:44AM**
 Andrew, hello. That's certainly a view and one with which I would partly agree. The shows would strike me as being doubtful if they tried to hide the fact of the adult imput. But they don't, they are completely upfront about it. They are shows by shows for adults featuring teenagers. Yes, there is mediation and there is undoubted manipulation, but I don't think anyone watching would be unaware of that. As to the titilation and under-age sex, I'm not sure I'm with you on that one. Teenagers can't keep their hands off of each other and to have that acknowledged on stage rather than repressed as we generally do in this country strikes me as healthy. All best, Lyn

- **Matt Trueman 28 October 2008 12:48PM**
 Having seen Alexander Devrient talk yesterday, he makes no bones about his own involvement. He insisted that his own role was to create the free space for the kids to play freely, to push and break boundaries and to shape the material into form. In that free space, the performer still takes responsibility for his/her own actions - it is real and owned. The teenagers are far more aware of that responsibilty than the young children in That Night Follows Day - they know and understand the piece, they can see its slant. Its clear that they are playing a version of themselves that they want to project as much as the version Devrient wants to show. Take the drug sequence - yes, some give accurate portrayals, but others (particularly the younger performers) play fantasies, imaginings of that behaviour, inauthentic pretences. Talk to Ontoroend's performers afterwards and they will give you interesting insight into the piece. Yes, it may mirror some of Devrient's words, but they are perfectly capable of being more than a mere mouthpiece.

• **HelenCuinn 28 October 2008 2:08PM**
I wondered what the significance of nationality was in this emerging strand of work. I have only seen That Night Follows Day but understand that Once and For All We're Gonna Tell You Who We Are So Shut Up and Listen also features Flemish performers. Obviously Quarantine are home grown, but where are the rest of our young people challanging us on our perceptions and rule making in Britain? Perhaps this is still to come? (In saying that, a local home grown company by the name of Junction 25 are challanging me on my understanding of society)

• **ETAYLOR 28 October 2008 4:38PM**
Lyn, I cross the road in certain situations if confronted with a gang of 14 year olds coming towards me. I have some sympathy with Shami Chakrabarti's comments and your interpretation of them but avoiding potential problems in inner city areas does not signify anything other than self preservation. If you live near Moss Side it just becomes second nature to act in such a way, in the same way kids wearing hoodies becomes a camouflage rather than an indicator of how aggressive they are. It's our attitude to young children and the increasing splintering of societal groups that is more significant. I'm just back from touring in Spain and have been delighted to

encounter late night situations where there is no trouble in the air and where young and old mix effortlessly . Of course there are problems in Spain and it does have a disturbing attitude to black people but the social cohesion is still far stronger than here. Haven't seen the 3 shows you reference but Ubung also by Victoria which toured here a few year's back mixed children mimicking adults behaving badly with the missing gaps of their understanding of the scenes they were miming to providing some interesting material. I enjoyed it a lot but wasn't sure whether it was more about the adults rather than the children.

• **alisoncroggon 28 October 2008 10:16PM**
I saw That Night Follows Day last week, by chance with my 18 year old daughter, who poked me once or twice (particularly on the statement about emptying their moneyboxes and promising to pay it back - I thought we were the only ones who did that. Mind you, we did pay them back...) I didn't think it was accusatory. There was a lot in it about play and jokes and the ambiguities and idiocies of adults. It was mapping out that shady area between imposing one's will on another and the kind of guidance and teaching that adults must provide and that children also need and desire. To my alarm, I had said a very high proportion

on those things to my kids - explanations about cosmology, shadow puppets, etc, as well as "no". (Not the stuff about blacks and poor people, good little liberal that I am). Both I and my daughter thought it was fine that it was scripted, like any other play. Not everything has to be devised to be "authentic". What counts is the quality of imagining, which in this case was wide, and, I thought, wisely honest.

- **AJHampton 29 October 2008 4:17AM**
Surely this is true documentary theatre? where the material itself, the performers, are non-fictional, even if what they say is scripted ie. the exact opposite of verbatim, or what has passed as documentary in this country so far. Dying to see a Quarantine show, their work sounds fantastic. HelenCuinn, you mention Junction 25 - any links to them? Another show on this list, also made this year, would be Stefan Kaegi (from Rimini Protokol) and Lola Arias's 'Airport Kids', about the children of Lausanne-based multinational executives. Nice video footage of preparation here. <http://www.riminiprotokoll.de/website/en/project_3479.html>

- **TimEtchells 29 October 2008 8:40AM**
Without getting into too long a thing about process, I can maybe add

something here about *That Night Follows Day* was made. The piece - which was produced by the Flemish theatre Victoria (Campo) - has a text by me, as noted by Lyn already and as I think anyone who knows my work (or reads the programme) can probably tell. The text was made in two stages – it started with writing by me, to which new material was added, developed, structured and refined in a workshop process with the 16 young people who perform the piece. It certainly wasn't a case of my arriving with a completed 'vision' and a script and dropping it onto the performers – instead, as is the case with more or less anything I've ever done with adult performers in Forced Entertainment or elsewhere– this piece grew from, in and around the performers as part of a long long process – a process that involved discussions, suggestions, trying things, changing things, collaborative rewrites in doing you could say. The whole question of if the performers understand and own what they are doing is a fair one. My experience working with and watching these young people doing the piece over the last two years is - that like a group of adults who have worked together on something - they know what they are doing and they own it very well. They're acting. Theyre finding a position within the piece from which

to speak and face the audience. They know what that means. I take the young performers in the making and doing of the piece seriously. They made, regard and play it intelligently. It's a structure, and they work to make it sing. Of course anyone that steps onto a stage is read in ways they can't predict, control or anticipate - performance always exceeds and escapes us. The young people in *That Night Follows Day* know that too, just as any performer has to know, live and work through this fact. This doesn't make them puppets or parrots. The performers understand that they inhabit and are visible in the piece in a lot of complicated ways. Discussions about acting and 'truth' and character and persona and self are ones you can have with any of the cast of *TNFD*, even the youngest of them, if you choose your moments, and take time to do so. *That Night Follows Day* is about the frames (societal, intellectual, educational, famillial, physical) that adults construct for young people. It's also, inevitably, an example of these processes. So far as I can work out there can be no interaction possible between adults and young people that escapes this. That's what the piece is about. You can see my projection in it, and as an audience you can see and feel your own. The children are 'in' that - caught and free at the same time - just as they are in the outside world. What's

great I think is that young people are also always exceeding and escaping these frames. They do that in the performance too. I'm glad to agree that *TNFD* is not "the authentic voice of young people" – ughhh. I wouldn't set out to make something so naive. I wouldn't claim to represent in that way. In any case I hardly believe in authentic voices fullstop. Voices are voices – they are complicated layerings of desire, fantasy, limit, projection, haunting, fiction. Authenticity is a particularly contemporary tyranny of sorts, and has become a fetish, sought everywhere, by the media especially and (to be frank) most often quickly devoured as spectacle before the circus moves on. In that sense it doesn't interest me - I'm interested in making something more complex in fact, and which knows very well that it is artifice. But maybe that's another discussion. What TNFD tries to make as a performance is an echo box, a space for reflection on how adults make and frame the world for young people. I think, from reactions over from audiences and critics in countries all over Europe over the last 18 months since we opened the piece, that it works pretty well in that respect. *That Night Follows Day* will be on the South Bank in London during Spill next year, I hope people take time to come along. Tim Etchells Notebook here. <http://www.timetchells.com/

blogsection/notebook/>
Victoria tour and other info here. <http://
www.victoria.be/>
Forced Entertainment currently on tour in
the UK with 'Spectacular', tour info here.
<http://www.forcedentertainment.com/>

- **justpassingthrough 29 October 2008
9:14AM** I enjoyed Once and for all...
but I feel there's been something crucial
lacking in criticism of the piece, and
that's its very clear referencing of Forced
Entertainment's work (I'd be interested to
know if Tim's seen it). The mismatched
second hand chairs, the line up, the
direct address, the repeats, the mess, the
disruptions and interruptions, the half-
heard conversations, the prowling at the
edge of the action. Essentially Bloody
Mess performed by Forced Ents Juniors.
Having talked with the company, I know
how much they loved Bloody Mess when
it was performed in Ghent. In a way that's
not to denigrate the success of the piece,
but when the show's getting awards for
experimentation and innovation I think
this should be noted. As Ant notes, a
truly original piece of work like Airport
Kids should be included in looking at
this new vein of work (performances by
children/young people ostensibly but not
exclusively targeted at adult audiences),
and That Night Follows Day is a much
more emotionally engaging work that

speaks more about children today rather
than of a nostalgic, simplistic view of lost
youth (which I know they state at the start
of Once and for all...). Perhaps I take more
from TNFD because it reflects on what it
means to be a parent as it does being
a child.

- **ogalexander 29 October 2008 11:25AM**
Hi everybody, As the director of 'Once
And For All..' there are a few comments
made here that I really want to react to.
But in short, let me first give an insight
on the purpose and process of the play.
As a teenager I've played a part in too
many performances in which I didn't
really understand what I was doing
and didn't feel I had a clue what the
play communicated, and plain simple:
I didn't have fun. As teenagers we had
fun behind the curtains and on the
bus trips. And as an adult I relived this
experience in seeing youth productions
now. It's not that they aren't any good,
and complex and beautiful. I think 'That
Night Follows Day' for example has a
beautiful text. But I really believe that
in making a production with teenagers
about teenagers (which TNFD didnt
want to off course) you can try more to
communicate what they are about. Of
course an actor is always a vessel but by
plainly accepting this as the whole truth,
a lot of directors just stop trying to react

to this. It's true that Forced Entertainment is a group we have a lot of respect for (I think "And On The Thousand Night" is one of the best pieces I've ever seen). But I remember Tim Etchells once saying that achieving reality on a stage is impossible. That made me sad at that time because its what we as a performance group try to achieve. And now I can happily say hes wrong. Of course you cant achieve the fullness of reality or authenticity in a performance (how do you do that in real life?) but the degree to which you try to achieve it can be amazing. And thats the truth you cant deny about 'Once And For All. This production is more theirs than many other plays. Every line they say, every movement they make. Its one of them. During the process I provided a free space where they could do what they want. And over a period of six months thats the only thing I tried to make possible. Only after that we worked towards the performance in fixing the movements. And for those who have seen the play I think you can feel that the structure is something the director/ writer provided but at the same time you can feel the structure is pure and simple enough for them to fully understand. And in that structure you see authenticity. For me thats not naive, its just a great way of making theatre if you try to achieve a truthfulness and create the opportunities in the play to make that possible. Not only in 'Once And For All but also in our individual performances 'The Smile Off Your Face and 'Internal we mess with the boundaries between reality and fiction, between actors and spectators. Because we believe that theatre has to reflect on reality, and 'the outside world itself is a constant mixture of fiction and reality. And of course there is no absoluteness in achieving that. But its so easy to state that because its not fully possible, you give up. And in the case of 'Once And For All we didnt. alexander devriendt <www.ontroerendgoed.be>

- **RichardGregory 29 October 2008 3:55PM**
Well, if we're all at it... As Lyn says, Quarantine has often included young people in our work - Gail's 3 children in *Butterfly*, our piece with made with a family at Tramway a few years back; about half of the lads in *White Trash* were 16, 17; a 2 year old in *Grace* and most recently a 3 year old and the 3 teenage girls in the band - the sadly now defunct Ripswitched - in *Old people, children and animals* (worryingly the second band to split up soon after they'd been in one of our shows..). There have been others. Depending on the project we work with either or both trained or untrained performers - to borrow Rimini

Brian Lobel was asked
if he was a dancer today
at John Lewis. "you have
that confident posture..."
sir, you have no idea.
Love John Lewis!

Protokoll's phrase "experts in everyday life"- of an age appropriate to what we're exploring. Our process mirrors what AJ (Ant?) Hampton describes: we start with the people in the room and develop material from there. When we've worked with very young children, we've tried to create conceptual frames that they feel comfortable to play within on stage, with no pre-prepared or constructed material (apart from those pesky frames of course). Of course, they sometimes jump outside or ignore the frame. When we've worked with older children or teenagers, the process has been remarkably similar to working with adults. We try to build open, honest, critical and creative relationships, where everyone involved understands what they're doing when they're performing. Sometimes we fail (see *Old people, children and animals* below..) Our work often gets positioned under an arch of 'authenticity' . My feeling is that if you accept that what you're seeing is your own view, that night, of that particular performance's version of a moment that's been shaped (by perhaps director, writer and/or choreographer, as well as the performer themself) out of what we've decided to select from what an individual performer chose to reveal of what they remember about something that might have happened to them, then authenticity becomes a distant and

troubled concept. Neither veracity nor verisimilitude hold much interest for me in performance. Darren Pritchard (one of our performers, alongside his mum, in our piece *Susan & Darren*) has a useful thing to say when audience (often) ask him during the show about how he feels about sharing his life with them: "What - you think this is my life?" What follows might seem to contradict the above but its more about complexity. We dont try to turn our performers into skilful actors. We work with neither fictional character nor fictional narrative. Were trying to present individual experience rather than represent it. When we first started with this approach, I think – with the benefit of hindsight – that we were trying to dramatise real experience. Wed take a lived experience and use it as a starting point, a seed to be planted and transformed into something other, something more obviously dramatic. Over time Ive become more interested in working with elements on stage – including performers – that I have no control over. I dont want to predict or dictate how performers will behave all of the time. I try to create frameworks, games, rules and tactics for them to play within – supported by a filigree structure of rehearsed words and choreographed movement. And Quarantines work is distinctly and unashamedly theatrical.

We begin with both banal and extraordinary truths (or at least what our performers remember as, or choose to tell us is true). But those structures that their accounts sit within, are scenographic, musical, choreographic or textual frames of our own invention. We always use the actual and the imagined, the heightened and the everyday, side by side. *Old people, children and animals* was, for many reasons, one of our least successful pieces of work. The reasons for this are multiple and not all relevant to this particular blog. But somehow we failed to make the kind of profound connections and complex relationships that we've managed to in other projects and what suffered was the quality of material. I ended up jumping in with devices to try to save the show at the last minute. I wasn't happy about this. The young people and the adults (myself included) never quite met. Richard Gregory <http://www.qtine.com>

• **ianghysels 29 October 2008 7:23PM**
Hi i am ian ghysels one of the acteurs of once and for al... i really disagree that you say this play is made by the director sexuel fantasy what you see on the stage is a part of us our smiles aint fake i don't fake the actions what we do on stage is made by us by us all he didn't said now do that be that personne you know how he made it our director went to the

supermarket let us buy intresting stuf he set us on a stage and said do whatever you want have fun and we did and some actions weren't always in the repetition if we had a break and we were playing he picked that out this is a really close group and we know everything about each other i love being in once and for all it is a big part of my life and i never did a performance like this we don't pretend being someone else we are just ourselves and alexander is not only our director he is our friend a really good friend if you saw what we do if were not performing we going to party's with each other have fun we don't do it for money we don't get paid we just do it for being with each other and if you don't like the show... SOW WHAT!!! i dont even know you youre proberly an old grumpy guy who is afraid of kids or is jealous you never did that when you were young youre only young once and it is the greatest time of you life we don't care what you think were having fun on the stage every time. sow the thing is we made it our director the acteurs the techian the manager by being ourselves and not someone else and love them all and i think that seperates us from al the other youth theathre groups it is our play from all of us and we al got allong sow good with the group with the director the manager we are really close and stuff the end.

- **AJHampton 29 October 2008 11:33PM**
 For anyone interested in this kind of
 thing beyond work with kids i'd really
 recommend reading this interview
 <http://www.archivotellas.com.ar/kid.
 html> with director Vivi Tellas. (Actually
 i'd recommend going to Buenos Aires and
 seeing her work, four examples of which
 are on right now <http://www.pagina12.
 com.ar/diario/suplementos/las12/13-
 3823-2008-01-09.html> but that's another
 matter!) I like how people's different
 concerns regarding documentary theatre
 overlaps, despite there being precious
 little forum or communication between
 practitioners. My work with Greg
 McLaren and Gemma Brockis as La Otra
 Gente / The Other People on a project
 looking at Live Portraiture may be of
 interest. Site needs updating to include
 the stuff we presented at the National
 Portrait Gallery... the other people in
 BA earlier work in spain <http://www.
 theotherpeople.org/home.html> /
 elsewhere (http://laotragente.blogspot.
 com/) Ant

- **nathalieverbeke29 October 2008
 11:49PM**
 I don't give a fuck what you think about
 it I really agree with Ian, once and for
 all is for me as well a big part of my life.
 this play feels really personal, because
 we made it together we improvised, get

free, in a kind wild, fucked up each other,
became crazy, made alexander crazy, .. I
could do whatever I wanted to do and I
still can

<http://www.youtube.com/watch?gl=NL
&hl=nl&v=uZRBKmcBERw>
<http://www.youtube.com/
watch?gl=NL&hl=nl&v=9PaJswgK_GM>
<http://www.youtube.com/watch?gl=NL
&hl=nl&v=EdMzSIVgbXM>
<http://www.youtube.com/watch?gl=NL
&hl=nl&v=FwjIBwe5G2s>

- **AndrewCowie 30 October 2008 9:55AM**
 Im a huge fan of Tim Echells and Forced
 Entertainment and re-reading my copy
 of 'Not Even A Game Anymore this
 morning I realise that complaining
 about a lack of authenticity is the worst
 thing I could have said! I work in youth
 drama which is probably why questions
 of ownership and responsibility were a
 large part of my response and I apologise
 if I failed to credit the sensitivity and
 care with which the works were made.
 But how fantastic to see three serious
 and thoughtful practitioners responding
 at length in a Guardian blog alongside
 a national critic and the cast members
 themselves!

- **lyngardner 30 October 2008 10:14AM**
 Andrew. The issues that you raised are really important ones and stimulated the discussion. Like you, I think it is brilliant that so many practitioners have taken part in this discussion and with such openess.

- **MattTrueman 30 October 2008 12:16PM**
 "In a way that's not to denigrate the success of the piece, but when the show's getting awards for experimentation and innovation I think this should be noted." This is interesting. Firstly, clarification: the Total Theatre award Once and For All won was in the category of experimentation and innovation, rather than solely for those qualities. Its an important clarification, I think, because the piece sits in a category (if categories must be placed on such work) of experimentation and well as having innovative qualities. Regardless: surely this loses sight of the continuous process of innovation. How novel must a performance (or indeed any artwork) be to qualify as innovative? Surely not absolutely so? The recognition (or even manifestation) of traditions and precursors in a work cannot disqualify it from the label innovative, and certainly not from that of experimentation. Once and For All owes a debt to Bloody Mess, of course, and more beyond that, but

you can't rule anything in and around constructed chaos as unadventurous or uninvestigative. In fact, to quote Once and For All itself: "Everything has been done before. But not by me. Not now." (In retrospect, that's quite a tacky way to finish a post, but I'll leave it in, nonetheless.)

- **bengridiron 30 October 2008 8:13PM**
 Once And For All. . .quite simply redefines the representation of teenagers onstage. I absolutely agree with Matt Trueman. As long as a work is pursuing an active line of enquiry outside the stale old traditional models of theatre making then it can be classed as both experimental and innovative. The scene would quickly become etoilated if experimentation and innovation at any cost dominated, ie just to be different from the last big show. Of course this classification becomes secondary anyway when the show is quite simply so blindingly successful at what it sets out to do. Ontroerend Goed do here exactly what they set out to do in the title (and this is quite rare). Thank God for the influx of Ghent-based and other Flemish theatre-makers to our stages- opening up for us the ways that we repress, fear and limit teenage expression in this country. 'Authenticity' is a value term constructed by the media. Authentic to

whom, or to what, or to what world view? I prefer to judge a piece of work in more old-fashioned terms: did it move me? did it excite me? did it excite the performers delivering it? did it stay emblazoned on the memory? Once And For All. . .did all these things. As an aside, I heard the other day that the Culture Minister in Belgium was formerly the General Manager of Victoria. I'm sure that must have had an impact on the fertility of the Flemish theatre scene- a place where innovation can truly flourish. An object lesson for us all.

- **ogalexander 31 October 2008 2:15PM**
Thx Matt & bengridiron for your comments. Just a little sidenote to what you said about the culture minister once being the manager of Victoria. I really don't think that's true. I think the fertility of the Flemish theatre scene is more due to the young cultural identity of Flemish speaking Belgium. Due to a lack of a broad heritage, the government promoted new artforms to promote our new culture. We have no Shakespeare or Molière to be indebted to. Our most famous writer Hugo Claus only died recently, and he himself was also responsible for some rebelliousness in theatre (he even had to go to prison for putting naked men on stage). So we have a lot of support from the government to be able to experiment

which I feel is more difficult in the UK.

- **laksolid 1 November 2008 11:59AM**
first my compliments to the high level of discussion here on this blog but wouldn't it be a great idea to have a discussion with the three theatre makers mentioned here (and maybe some of their cast) to have a truly deep talk about teenagers on stage?

- **obengridiron 1 November 2008 6:51PM**
Thanks Alexander for contextualising the Flemish situation so clearly. Makes perfect sense. I think that in Scotland too we are benefiting from being a relatively young theatre culture (pre-1950 there was really very little apart from James Bridie, David Lindsay, panto, the last days of variety and only the very beginnings of Glaswegian political theatre, plus the odd touring English Shakespeare). We have a way to go however in Scotland before reaching the consistent level of artistic experimentation and confidence that seems to be so prevalent in the Flemish scene

Theatre for adults is child's play by Lyn Gardner first
featured in The Guardian online. 27 October 2008.
Subsequent comments are from various individuals
in the public realm.
http://www.guardian.co.uk/stage/
theatreblog/2008/oct/27/children-teenagers-theatre

Labour Practices: Ethics of Service and Ideas of Labour in Performance
A public lecture as part of At Your Service

Mary Paterson

Playing with the ideas of labour and service, the Live Art Development Agency outsourced the research and writing of a paper for *Labour Practices* (a seminar for the exhibition *At Your Service*) to the writer Mary Paterson. In turn, Mary outsourced the presentation of the paper to the Agency's Projects Manager and practicing artist Andrew Mitchelson. Artists and writers concerned with labour and service, including Nick Ridout, Ana Laura Lopez de la Torre, Emma Leach and Natasha Vicars of *Position Unpaid*, responded to the paper and provoked further discussion. The text reprinted below was written to be read aloud.

At Your Service was a group exhibition curated by Cylena Simonds running from 17 April to 27 June 2009 at the David Roberts Art Foundation in London. *At Your Service* engaged with the concept and dynamics of the service and hospitality industries

in today's political and social climate and brought together a wide range of artworks from emerging international artists. *At Your Service* examined aspects of service industries such as building construction, cleaning and catering as a way of addressing concepts of belonging, patterns of migration and the less-than-distinct roles of host/guest and native/foreigner. The artworks investigated themes within service labour such as routine, invisibility and the mundane. Juxtaposed with these works were projects that explored the notion of contemporary art practice as a service to the public, asking us to examine the kinds of interactions, expectations and desires we take on as art audiences.

The work in *At Your Service* ranged from sculptural objects to photography and video, and featured specially commissioned performances taking place both within the gallery and in public locations, film

Richard DeDomenici
is a bit hurty after Dave
Gorman stagedived
onto his neck.

screenings, and talks.

Labour Practices was supported by Queen Mary, University of London.

Labour Practices: Ethics of Service and Ideas of Labour in Performance

There are two popular stereotypes of an artist's relationship to labour. On one hand, there is the artist who suffers for his art, struggling and penniless in a garret while he responds to the divine inspiration of the muse. For romantic figures like William Blake or Vincent Van Gogh, so the story goes, art is a labour of love and artistic fulfilment is both cause and consolation for material poverty. On the other hand, there is the stereotype of the financially successful artist who has sold out to the market system. Everyone groans as another Damien Hirst is sold for millions, and he is labelled an artist of self promotion.

It seems, the artist can't win. Either she's poor with integrity, or rich without. Both stereotypes circle round a definition of art as something that exceeds normal market forces and labour practices. Whether art is made by the struggling artist or the successful one, it is seen as more than a commodity. It may be bought and sold in a market, but it is not defined by market value alone; in fact, money often distracts from the issue. And art is apparently made as a matter of personal choice, rather than obligation. To practice and produce the 'work' of art, from this point of view, is not a job. It's a privilege.

But the practice of art is certainly work. Like other skilled workers, artists often have years of specialist training before they can practice their trade. And, like other workers, artists are always working for someone else. In 2007 Anna Laura Lopez de le Torre and Joshua Sofaer made this explicit when they produced 'We are here to help' for the In-presentable Festival in La Casa Encendida, Spain. Over the course of the festival, a group of artists sifted through requests for services that had come from members of the public, and attempted to solve some of them. As Lopez de le Torre says on her website, the project had a dual function: 'not only were we helping the festival organisers by fulfilling their needs for "socially engaged" work, but we would offer our well meaning help to the citizens of Madrid, in whatever capacity they might want us.'[1] The artwork was both a product for the curators of the festival and a service to the people of Madrid.

In 2003, Andrea Fraser made a video piece called 'Untitled', which also makes the connection between art and work – this time, with the oldest profession in the world. Fraser sold herself to a collector for $20,000, in order that the collector could have sex with her in a hotel room; the DVD of their hour-long encounter was exhibited and sold as a limited edition. This piece takes literally the notion that an artist must prostitute herself to the

Richard DeDomenici
Chicago is to the 2016
Olympics what the UK
is to the Eurovision
Song Contest. Discuss.

art market. Eliding her body with her work, Fraser draws a parallel between the bodily commodity of sex and the bodily commodity of talent. Is there also a parallel between the impersonal spaces used to sell this most personal of artefacts? The anonymous hotel room or the white cube gallery, the red light district or the circuit of international biennials?

But, unlike a prostitute, Fraser had a lot of control over the way her body was used. She stipulated that the collector must be heterosexual and unmarried. She decided how many DVDs to produce, and vetted their future owners. Despite the obvious similarities between 'Untitled' and other ways of selling sex, Fraser says 'I think it's sort of ridiculous to say that the piece was prostitution.' This is because, in her words, 'it was my idea, it was my scenario.'[2] Clearly, then, art is work. But it has a different kind of meaning to work carried out in other contexts. By declaring that her work is different because it's her idea, Fraser suggests that it's not the materials or the act of labour that defines its value. Instead, it's the relationships that support the practice.

In an essay she wrote in 1986, Fraser described the notion of 'surplus labour'.[3] According to Karl Marx, workers in a capitalist system don't just work for the efforts they are ostensibly paid for; they must also provide something more – something which gives their employers pure profit and

themselves the competitive advantage. Marx says, 'The labourer purchases the right to work for his own livelihood only by paying for it in surplus labour.' Art, however, is a choice and not a necessity. For this reason, says Fraser, art is *all* surplus labour. The difference is that while everyone else has to give it for free, in order to earn the privilege of working at all, artists get paid for surplus labour alone. And, as members of society who, uniquely, get paid for what they love, artists acquire the high status of a 'leisure class.'

In other words, the work of art (both as an artefact and as a process) is not just worth money, but also acquires a kind of cultural capital. This is why two women who do exactly the same thing can be treated so differently. The prostitute's proximity to the exploitation of labour is so degraded that it taints her, erroneously, with the stench of immoral acts. But the artist's association with the work-free echelons of upper society is so attractive it gets her a feature in the New York Times.

It is the artist's cultural capital that transforms the labour of a prostitute into the work of art. It is, in part, this cultural capital that Anna Laura Lopez de le Torre and Joshua Sofaer traded on in order to set up their service industry for the people of Madrid. And it's this cultural capital that dresses the labour of art in its cloak of privilege.

Like other types of power, this cultural privilege can be used to exploit workers elsewhere. In 'VB65' (2009) Vanessa Beecroft gathered 20 African immigrants to eat a meal of chicken, bread and water in a high end gallery in Milan. The immigrants were dressed in designer tuxedos, although many were missing shoes or shirts, as if they had been hastily dressed in someone else's clothes. They were forbidden from making eye contact or speaking to the audience, and they were not given any cutlery. Sitting along one side of a Perspex table the African men were gazed upon by members of the Milanese bourgeoisie. According to Beecroft, this was so the Milanese could, 'observe people widely seen as the violators of privacy, people that are seen as different.'[4]

But difference, like beauty, is in the eye of the beholder, and it is Beecroft that marks these men out as different at all. More to the point, she reduces them to an essential, racial other in order to polish her individual art star. At the end of the performance, she posed in front of her anonymous workforce for photos. White, fully dressed and with a well documented eating disorder that means she hates to eat in public, Beecroft struck a note of sharp contrast to the labour force in her employ. In effect, 'VB65' is a study in exploitation, carried out by and for the notion of art. Many critics and commentators praised the performance for looking a bit like Leonardo's *Last Supper*. The cultural value of the Italian Renaissance, it seems, is enough to cancel out the exploitative politics of the work itself.

Beecroft uses her cultural privilege as an artist to exploit another section of the labour force. The same could be said of the Chinese artist Zhu Yu, whose controversial and shocking work explores the boundaries between statutory and moral law. In 2002, he contracted a prostitute to sleep with him, become pregnant, have a termination, and give Yu the foetus so that he could feed it to his dog. It is hard to imagine a more invasive transaction, in which the privileged financial and cultural status of the artist rides so carelessly over the needs of the prostitute. But the art historian Meiling Cheng has said that this current trend in Chinese art is itself driven by forces of 'violent capital', spurred on by the rigours of Chinese censorship on one hand (which encourages artists to produce work that is more and more conceptually shocking in order to get noticed quickly abroad), and the Orientalism of the West on the other (which nurtures the idea of an exotic, dangerous, Chinese other).[5] In this situation, who is working for whom? Where does the chain of labour begin?

Despite its privileged cultural status, then, art is not free from labour practices and power wielded elsewhere. But it can highlight some of these practices at work. In 'Temporary Space' (2003), another Chinese artist, Wang Wei, employed bricklayers to

build and demolish a wall inside an enclosed space. The obvious futility of this building project put the craft and precision of the labour centre stage, as a displacement for capitalism's relentless march to progress. The Beijing-based dance group Living Dance Studio produced a performance for video called 'Dancing with Farmers' (2001), in which farmers were shown to exceed their working roles – by dancing – but simultaneously confined to them – in the description of the project itself. These two pieces explore the relationships between different types of labour force – between viewers, artists, and manual labourers – without subsuming them all into the cultural capital of the individual artist. In the credits for 'Dancing with Farmers', all the participants are listed as collaborators.

Similarly, when Fred Wilson represented the USA for the Venice Biennale in 2003, he took a group of street sellers to the US pavilion, to sell the same fake designer gear they sell elsewhere. Like Beecroft, Wilson's intervention, called 'Speak of me as I am', noticed the racial difference between the people who visit the Venice Biennale and the people, mostly immigrants from west Africa, who sell products on the Venetian streets. But unlike Beecroft, Wilson did not fix everyone in reactionary roles of similarity and difference. In fact, in an environment of exclusivity and privilege, Wilson implied that the art market is bound by the same

rules as any other. The knock-off goods being sold outside the US pavilion were an equivalent for the luxury goods and cultural prestige being traded inside. Visitors did not just observe the accompanying relationships of exclusion, but had to carry them out by choosing which market they preferred.

This use of 'ordinary people' or 'ordinary workers' still trades heavily on the cultural capital of art – it's the designation of art that makes us look at this kind of labour in another way. The danger is that it reifies the differences between types of labour even as it suggests they're not so different after all. In 'Cargo Sofia' (2006) by the theatre company Rimini Protokoll, two lorry drivers took art visitors on tours of their working lives, from the back of a specially converted articulated lorry. In an interview included at the end of the documentary footage, one of the guides says that his original response to being in the work was to refuse, because he's not an artist. Rimini Protokoll told him he would be playing himself. 'But this,' says the lorry driver, referring to the role he has in 'Cargo Sofia', 'is not myself.'

Whose version of himself is he playing? Whose gaze is this work for? Perhaps there is a risk that the myth of artistic authenticity, which sustains the cultural capital of art, is being transferred, without thought, to the romantic myth of more menial labour. How far away are these tours of unknown lives in 'Cargo Sofia' from the parade of African

immigrants in 'VB65'?

Ultimately, 'Cargo Sofia' avoided essentialising its participants by consciously mixing up what is real and what is artifice. Border controls, service stations and roundabouts were peppered with surprises – like a singer who appeared as if by magic – and the two guides included stories about their personal lives from photos and anecdotes. In other words, 'Cargo Sofia' did not pretend to tell an authentic tale about two men who drive lorries. It just told a story, using the tool of imagination, instead of Beecroft's more sinister use of bodily control.

Bodily control is, of course, where all labour practices meet. Whether it is the authentic touch of the artist or the degraded body of the prostitute, to be in service means to be physically known. In our digital age, this physical surveillance has become more, and not less, enforced.

In a series of extraordinary, one-year performances Tehching Hsieh explored the effects of this kind of control on his own body. In 1980-81, for example, he spent a year clocking in to a Time Clock in his gallery on the hour, every hour. In 1981-82, he spent a year outside, without shelter. In 1983-84, he spent a year tied to the artist Linda Montano by an eight-foot rope.

The writer and director Tim Etchells describes these routines as reactions to the mechanisation of time, engendered in capitalism since the industrial revolution. 'It's all about the clock, routine and submission,' says Etchells, 'about capitalism's relentless drive for ordering and marking time, place, space, action, interaction and inaction.'[6]
But by following these templates for time management so seriously, Hsieh is prevented from carrying out the productivity that is their purpose. A man who clocks in every hour, on the hour, never has time for sleep. His productivity is lowered. His 'excessive compliance' (to use Etchells' phrase) to the accountability of capitalist labour practices means that his actions slip out of possible control. The purpose of all this surveillance, as far as the labour market goes, is to make sure workers are fulfilling their potential, and to get them to adjust their behaviour in line with the desired results. So what is the desired result of Hsieh's work? If surplus labour is the oil that greases capitalism's wheels, then working so obstinately to rule must be a kind of protest. And these are not just any rules, but rules far beyond what most people could tolerate. As such, they expose the fallacy of this kind of control in the first place. Like words that are repeated until they dissolve into sound, Hsieh repeats these mechanisms of control until the human being slips irretrievably away. To watch the film of Hsieh's clocking in performance is to understand nothing about Hsieh the man. To see the photographs of him and Montano is to know nothing about their relationship.

The performance studies academic

Adrian Heathfield calls these pieces by Tehching Hsieh 'lifeworks' instead of 'artworks', because they 'are made from the very material and experiences of life'.[7] In this sense, the cultural position of art is not what makes Hsieh's work possible. The art does not play the role of cultural mediator, as it does in 'We are here to help', or in 'Speak of me as I am', where the difference in status between what is called art and what is called life underlines or interacts with existing social ties. Instead, the cultural position of art is what makes Hsieh's work visible. In 1986, he embarked on a 13-year lifework of voluntary self-exclusion from the artworld. The piece, which ended in 1999, was successful. Hsieh did not have any exhibitions during this time, he was not fêted by the artworld, and he was not told in most art histories. Of course, it is in keeping with his role as an artist – as someone who chooses his own field of work – that this exclusion was carried out as Hsieh's personal choice.

I have attempted to list some examples of the different ways that artists can approach the subject of labour practices. First, I tried to establish that labour itself is not valued according to its materials or even what it produces. Instead, these are mixed with the far more potent spice of symbolic value, or cultural capital. Next, I listed some artists that have used the cultural capital of art to comment on labour practices within the artworld and without, both consciously

and not, and both exploitatively and not. Lastly, I suggested that the real privilege of the work of art is not in gaining insight into relationships of labour, but simply making them visible.

Nevertheless, in any industry as complex and successful as the artworld, there are always going to be relationships that remain hidden. For example, while it's easy for me to condemn the stereotyped identities constructed by Beecroft in 'VB65', the performers themselves did not necessarily feel exploited. Kamil Garba, aged 18, from Niger, told a reporter from the New York Times 'It was very cool. I liked it. In any case, it was very different.'[8] Who am I to impose my interpretation of art history and political correctness onto what he thinks?

Indeed, who am I? The Live Art Development Agency was commissioned to curate this event, and they outsourced the writing of this keynote paper to me, Mary Paterson. As you can tell, the reading has also been outsourced to me, Andrew Mitchelson. Somewhere in between, was the swapping of ideas and artists' names. At least one of the people behind this paper has not seen all of the artworks described inside it. It's up to you to decide who got the best deal out of this hidden series of transactions – the writer, who gets a little money and a little prestige, without having to speak in public? The speaker, who has to read someone else's words? Or the Live Art Development Agency,

which earned the opportunity to speak and then relinquished control? Another way to put it is, that while the economics of the situation are clear, which party extracts the most cultural capital remains to be seen.

Lastly, in terms of labour practices, there is the elephant in the room of all art practice inside the UK: volunteers. Sometimes euphemistically called interns, volunteers are the legions of highly trained arts graduates who carry out years of menial, unpaid work before they reach the lofty heights of low-paid work in the artworld. In this country, the artworld survives on this vast, skilled and exploited labour force. It is what keeps funders happy and ensures the arts will remain middle class. Like bullying, it's a system that is universally condemned and universally carried out.

In 1998, Anna Laura Lopez de le Torre made a piece of work that commented on the labour practices internal to this part of the artworld. 'The Perfect Object' was a performance at the ICA, in which Lopez de le Torre peeled potatoes into perfect spheres in the ICA bar and rolled them along the floor. The rolling potatoes were like young artists fresh from art school. Compliant and carefully formed, they are kicked against the service industries of the artworld – gallery bars, restaurants and bookshops – where they work in order to support their practice; often, institutions like the ICA expect the lucky young artists whom they notice to donate

their work for free. What is the 'work' of art in this scenario? Is it the work spent toiling for minimum wage in the ICA kitchen? Or the work spent toiling for free in a studio?

To return to the concept of surplus labour, it seems here that, far from having the privilege to get paid for their surplus – that is, to get paid for doing extra work that feels like free choice – artists must currently supply excessive amounts of surplus up front, in order to get a job at all. The flip side of the notion of the work of art being a privilege, is that a privilege is very difficult to earn. At least one of the people behind this paper paid the price of her time, her training, and a large chunk of her twenties, for the privilege of being here today.

Notes

1. www.lopezdelatorre.org
 (accessed 27th May 2009)

2. 'Andrea Fraser in conversation with
 Praxis' *Brooklyn Rail*, October 2004
 http://www.brooklynrail.org/2004/10/art/
 andrea-fraser (accessed 10th June 2009)

3. 'Andrea Fraser in conversation with
 Praxis' *Brooklyn Rail*, October 2004
 http://www.brooklynrail.org/2004/10/art/
 andrea-fraser (accessed 10th June 2009)

4. Vanessa Beecroft, quoted in Elisabetta
 Povoledo 'Vanessa Beecroft's VB65
 attempts to force spectators to see Africans
 Differently' *New York Times*, www.nytimes.
 com (accessed 29th May 2009)

5. Meiling Cheng, 'Violent Capital –
 Zhu Yu on File' *The Drama Review*,
 Fall 2005 v. 49 i.3, pp. 58-77

6. Tim Etchells 'Time Served', in
 Adrian Heathfield and Technig Hsieh,
 Out of Now: The Lifeworks of Tehching Hsieh
 (Live Art Development Agency, London;
 MIT Press, Cambridge, Massachussetts),
 pp. 355 – 361, p. 357

7. Adrian Heathfield, 'Impress of Time', *Ibid.*,
 pp. 10 – 61, p. 12

8. Quoted in Elisabetta Povoledo.

Mary Paterson's paper *Labour Practices: Ethics
of Service and Ideas of Labour in Performance*
was a lecture presentation first delivered by
Andrew Mitchelson at the Pinter Studio, Queen
Mary - University of London, in June 2009 and
commissioned by the Live Art Development Agency
as part of the *At Your Service* programme which
was curated by Cylena Symonds.

Mary Paterson is a writer and producer based in
London. She is co-founder of Open Dialogues,
which explores writing on and as performance.
www.opendialogues.com

Augusto Boal

Aleks Sierz

Brian Lobel heard the most amazing post-Pina analysis, one after another, from Annette Braun and Simon Casson. There are some amazing and deliriously clever minds in London.

Augusto Boal, the visionary Brazilian theatre director and dramatist, who has died aged 78, spent his life proving that you didn't have to wait until "after the revolution" for worthwhile social improvements - you could use theatre to make radical changes in the here and now. Best known as the author of the 1974 classic Theatre of the Oppressed, which had grown out of his theatre movement of the same name, Boal was an inspirational and internationally recognised theatre guru.

Boal was born and grew up in Rio de Janeiro and trained as an industrial chemist, first graduating in 1952 and then researching at New York's Columbia University. Fascinated by theatre, he spent his time in the United States studying drama as well as chemical engineering. In 1955, he wrote and directed his first play - The House Across the Street - in New York.

When Boal returned to Brazil, he was invited to work at the tiny Arena theatre in São Paulo, and was its director between 1956 and 1971. At first, he ran writers' and actors' workshops, then - influenced by the revolutionary spirit of the 1960s - he took agitprop shows into the countryside and pioneered a radical kind of "living newspaper" in which the audience helped decide the subject of the play.

At one point, when Boal's agitprop group was preaching the necessity of taking up arms, a peasant in the audience stood up and suggested an armed raid on a local landlord. Embarrassed, the actors backed down. But the incident taught them to listen to the people.

Abandoning crude agitprop, Boal developed the idea of the "Theatre of the Oppressed". At first, this involved asking audience members for ideas for alternative

endings to plays about oppression. Then, after an angry woman was so dissatisfied with how his actors interpreted her suggestions that she came on stage and showed them what she meant, he developed shows with more audience participation.

Drama entered his life in a more dangerous way when, in 1971, Boal's activities came to the notice of Brazil's military junta. He was arrested and tortured, then released after three months. Exiled to Argentina, he continued to practise his ideas, developing for example a new form of theatre, image theatre - which uses physical theatre instead of the spoken word - during a literacy campaign in Peru in 1973.

In 1974, he published his first book, Theatre of the Oppressed, which argued that mainstream theatre was an instrument of ruling-class control, aimed at sedating the audience, but which also showed how the dramatic arts could be a weapon, turning the spectator into an actor, the oppressed into revolutionaries. The British playwright John Arden once said it was a book that "should be read by everyone in the world of theatre who has any pretensions at all to political commitment".

Based on the radical teaching of Paulo Freire, whose book Pedagogy of the Oppressed was a direct influence, Boal's ideas aimed to wake up the passive spectator, inviting members of the audience on to the stage to act out their real-life problems,

turning them into what he called "spect-actors", and empowering them to find strategies for personal and social change.

He also developed other kinds of participatory drama, including forum theatre, which aims to generate solutions to real-life problems. Boal's Theatre of the Oppressed was translated into 25 languages and his techniques were adapted in places as diverse as Estonia, India, Puerto Rico and Sweden. There has been a torrent of scholarly articles and books about him in French, Spanish and Portuguese, although he is less known in the English-speaking world.

In 1976, he settled in Lisbon before being appointed professor at the Sorbonne in Paris in 1978. There he taught his radical approach to theatre, setting up a Theatre of the Oppressed centre, and organising international Theatre of the Oppressed festivals from 1981 to 1985. In Europe, Boal became more aware of the subjective aspects of oppression, so in Paris he started workshops - with his psychoanalyst wife Cecilia - designed to tackle what he called "the cop in the head".

After the downfall of the military junta, Boal returned to Rio de Janeiro in 1986. He set up a major Theatre of the Oppressed centre and formed more than a dozen companies to develop community-based performances. He also experimented with other kinds of intervention, such as invisible theatre, where actors set up a situation in

a public place to stimulate debate among onlookers, or culture theatre, which involves members of one ethnic group performing a play from a culture antagonistic to their own - for example, Palestinians putting on a Jewish play.

In 1993-96, Boal was elected as a member of Rio de Janeiro's city council, and turned techniques first devised to encourage audience participation into a way of making popular laws, calling this technique legislative theatre.

"Unlike the dogmatic political theatre of the 1960s, which told people what to do," Boal said, when I met him in 1995, "we now ask them what they want." What excited him, he said, was the unexpected creativity of the process. "Many times we came up with a simple idea no one had thought of before."

More books followed, including Games for Actors and Non-Actors (1989), The Rainbow of Desire (1995) and Legislative Theatre (1998). In 2001, his autobiography, Hamlet and the Baker's Son, was published. In 1994 he was awarded Unesco's Pablo Picasso medal, and he had countless honorary doctorates, including from London University, Worcester College, Oxford, and the University of Nebraska.

He was slight of build, modest, but always full of energy and quiet hope; Boal's terrific energy came from his faith in the creativity, spontaneity and ability of all people, however underprivileged, to change their situation. In

London, for example, he often worked with Cardboard Citizens, a homeless people's theatre company, and he continued until recently working on projects both in the developing world and in the US, which he visited every year.

Boal was married twice. He is survived by his wife and collaborator, Cecilia, and two children, Fabian and Julian.

• Augusto Boal, writer, director and teacher, born 16 March 1931; died 2 May 2009

Augusto Boal by Aleks Sierz first featured in The Guardian online. 6 May 2009. http://www.guardian.co.uk/world/2009/may/06/augusto-boal-obituary

In search of the art of insurrection

Brigitte Istim

Richard DeDomenici has just been to the Post Office, and was heartened by all the groups of protesters covertly readying themselves on street corners.

"We are driving very, very fast towards a very big cliff," says Isa Fremeaux. Sitting in the cafe at Hackney City Farm it is hard to grasp the full import of her words. To one side is a lush grassy bank sprinkled with flowers. Birds sing in the trees and the gentle hiss of bike tyres mutes the sound of lorries and cars as cyclists whizz along London's city farms cycle route. It is a place to relax and perhaps vow to do something about the world's social and ecological problems - tomorrow.

Tomorrow ceased being an option for Fremeaux several years ago when she discovered the book *We Are Everywhere: The Irresistible Rise Of Global Anti-Capitalism*. It was a life-changing moment, coming at a time when she was "intensely frustrated with being an armchair activist, getting angry at the world and not knowing quite what to do." Fremeaux abandoned her chair and tracked down John Jordan, one of the

book's editors and previously a lecturer in fine art at Sheffield Hallam University. Fremeaux and Jordan are now activists with the flamboyantly named Laboratory of Insurrectionary Imagination - "John doesn't do short and snappy when it comes to titles," says Fremeaux.

The Lab, founded in 2004, is at the heart of this month's Two Degrees festival, a series of events and performances in and around Toynbee Studios in London's East End. The aim is to get artists to "create work that confronts climate change head on." The Lab's contributions include a field kitchen that will tour the City, foraging for and sharing wild food, and a cataclysmic final closing down sale, offering bargain-hunters a last chance to buy a real woman. It all sounds like an apt comment on the recent financial meltdown. But what does the Lab hope to achieve through its "art activism?" Jordan

says pleasure is the Lab's main purpose. It is a succinct and interesting definition of activism, a deliberate rejection of the hair-shirt philosophy, which says that change can only come through suffering, or at least being very serious. Jordan explains: "Capitalism is so good at creating a kind of inauthentic pleasure and beauty, we have to fight that war of desire. Our actions need to be desirable - no radical social change can happen without creating moments that are pleasurable and accessible and beautiful."

For a moment the ghost of William Morris and his remark about not giving house room to objects that are neither useful nor beautiful hovers in the air. Morris is actually one of the inspirations behind a current Lab project, a book and film entitled Paths Through Utopias.

The film echoes Morris's book News From Nowhere, first published in 1890, in that it is set in the future, after the collapse of our present economic and political structures. The EU is no more and life in Europe revolves round a network of decentralised, self-managed communities.

To create Utopias, Lab members spent seven months travelling and visiting communities in Europe and Britain which could be seen as having a utopian element or rationale. They include an anarchist school in Spain, a pharmaceutical factory in Serbia which was taken over by its workers in 2006 and a "low impact living collective"

in Totnes, Devon. Jordan describes these communities as "living the future in the present." Fremeaux explains in more detail how Utopias interweaves present and future: "In the film everything was shot in the present, documentary-style. Fictionalised elements were introduced afterwards, mostly through the editing. Some characters are recognisable in both the book and the film. We hope to create a sense of intrigue for readers and viewers - all this is not just a figment of the imagination."

Utopias obviously reflects two of Jordan and Fremeaux's major interests: the idea of being on the edge and the philosophy of Mexico's Zapatista movement with its emphasis on diversity - one No to international capitalism and many Yeses to a whole range of alternatives. While the communities they visited could be viewed as too tiny and off-beat ever to affect mainstream society, change often does come from the periphery, where the need to adapt and innovate is greatest.

The Lab itself is in a constant state of flux and evolution. Fremeaux says it has a "variable geometry" as activists come and go, according to what projects are in hand. These flexible, permeable borders are crucial to its central aim of connecting art to mass social movements, a union which Jordan thinks is often overlooked and neglected. He says: "Getting artists to desert the capitalist world to bring optimism and energy to other

visions is important. The green movement isn't very good at doing this." The Lab may seem to have ambitious ideas of what art can achieve but then both Jordan and Fremeaux have an extremely broad definition of what art is. Jordan simply describes it as a "process of paying attention to something, whether you are writing, painting or cooking beans on toast."

In many respects the Lab is a contradictory organism. Its members worry about our addiction to instant material gratification, yet their performances are almost entirely rooted in the present, relying on a particular time and place and group of people. Their fascination with edges is set against a desire to be embedded in society as participants not observers. But this ambiguity is seen by Jordan as strength rather than weakness. "We don't need to be place-able. I want people to ask: is this art, is this activism, is it a riot, is it a carnival?" If art is about making people think, it is a pretty safe bet that the Lab will engage your brain 24-7.

Two Degrees runs from June 16-21, 2009. For more details, visit www.artsadmin.co.uk or call (020) 7247-5102. Lab events are free but you may need to book your place ahead.

In search of the art of insurrection was written by Brigitte Istim and published in the Morning Star online. 1 June 2009. http://www.morningstaronline. co.uk/index.php/news/content/view/full/76105

Making Art Out of an Encounter

Arthur Lubow

I first encountered Tino Sehgal's work under ideal conditions: total ignorance. Happening to be in Berlin in 2006 at the time of the city's art biennial, I heard from an art-dealer friend that there was one exhibition not to miss. "I won't tell you anything more," he said, as he walked me to the site and bid me farewell. I trod up a creaking staircase in a building from the turn of the last century and entered a decayed ballroom, its ornate moldings and gilt mirrors testifying to a more glorious past. Lying on the floor, a man and a woman, fully dressed, were embracing languidly. There was no one else in the room. My presence went unacknowledged. In a state of mounting confusion and embarrassment, I stayed until I could stand it no longer, and then I retreated down the staircase. Out on the street, I sighed with relief, because I once again knew where I was.

Had I remained longer, I might have recognized that the two were re-enacting the curved-arm caressing gesture of Rodin's marble statue "The Kiss," as well as poses from other osculatory works, some less widely known but in their own way iconic, like Jeff Koons's ceramic sculpture series "Made in Heaven." And eventually I would have heard one member of the intertwined couple speak these words: "Tino Sehgal. 'Kiss.' 2002." But I didn't need that information for the piece to linger in my memory and arouse my curiosity.

I knew the name of the artist, and I watched for him. Although Sehgal was very busy, thriving in the incubation culture of art fairs and international exhibitions, he did not surface in New York until his inaugural show at the Marian Goodman Gallery in November 2007. This time when I walked into the exhibition space, I had more of an idea of what to expect, but once again

I was knocked off-balance. "Welcome to this situation," a group of six people said in unison to greet me, ending with the auditory flourish of a sharp intake of breath; then they slowly backed off, all the while facing me, and froze into unnatural positions. At which point one of the group recited a quotation: "In 1958, somebody said, 'The income that men derive producing things of slight consequence is of great consequence.' " Jumping off from that statement, the conversationalists — Sehgal refers to them as "interpreters" — began a lively back and forth. Occasionally one of the six might turn to a gallery visitor and utter a compliment or say, "Or what do you think?" and then incorporate that person's comment into the exchange of words. Mostly they seemed content to natter at high velocity among themselves. It all continued until the moment when a new visitor arrived, an event that acted as a sort of rewind button. "Welcome to this situation," they chanted again, breathing in and backing off as they had done before and then assuming another stylized stance. A new quotation was dropped and another discussion commenced. Just as in Berlin, I felt a battleground developing in my mind, between a fascinated desire to stay and a disquieted urge to flee.

If you are not a devotee of the cult of contemporary art, especially its Conceptualist cadre, you may feel a whirring sensation beneath your eyelids starting up right about now. Your skepticism isn't, or shouldn't be,

a matter of "Is this art?" Almost a century has elapsed since Marcel Duchamp aced that one by attaching titles to everyday objects (a urinal, a bicycle wheel) and demonstrating that anything can be art if the artist says it is. Nevertheless, the ineffaceable critical question remains: "Is it good art?" Later this month, when Sehgal's one-man show takes over the Guggenheim Museum's rotunda for a six-week run, thousands of noninitiates, many no doubt having come to see the Frank Lloyd Wright building without any advance notification of what art exhibitions are on, will be able to decide for themselves.

If the overall response to "This Situation" at the Marian Goodman Gallery is any guide, even some who expect to hate Sehgal's work will leave enthralled. "I often see shows I don't like, but this was the only show I've ever seen that didn't like me," wrote New York magazine's art critic, Jerry Saltz, judging "This Situation" to be the best exhibition he encountered in 2008. Unlike so much of contemporary art, Sehgal's art evokes passionate reactions among the unschooled as well as the cognoscenti. Anyone who has seen the onlookers trudging passively through an art museum (all too often the Guggenheim ramp resembles the humane cattle slaughterhouses designed by Temple Grandin) can appreciate the achievement. What fascinates me about Sehgal is that working only with human clay, he can call forth thoughtful and visceral responses

from people who remain unmoved by more conventional paintings and sculptures. When I expressed this to him, he laughed at me. "I'm more ambitious than that," he said. "That's too little of a game."

At any time of day, Sehgal, who is 33, looks as if he has just tumbled out of bed. His tousled hair is innocent of exposure to a brush. His overcoat long ago parted company with its lining. In the six months since we first met, I have usually seen him in the same black jeans, black one-button pullover and white sneakers. My initial impression was that this was a man who was completely careless about his appearance, but I eventually concluded that the scrupulous inattention to wardrobe and grooming was of a piece with his refusal to fly on airplanes (visiting America from his home in Berlin, he travels by ship) or to carry a cellphone. More to the point, this conspicuous avoidance of unnecessary consumption conforms to the credo that underlies his work. Sehgal makes art that does not require the transformation of any materials. He refuses to add objects to a society that he says is overly encumbered with them.

It's his rigorous devotion to an art that vanishes instantly that Sehgal and his curators emphasize. "There's a purity to his approach," says Catherine Wood, the curator of contemporary art and performance at the Tate Modern in London. "There are a few artists who are making live action that is

based in sculpture, but what sets him apart is his purist insistence on the immateriality — or ephemeral materiality — of the work, so it crystallizes and disperses again, so there is no trace left at all." Fifty years ago, Yves Klein sold empty spaces in Paris in return for gold; the buyers received a certificate of ownership. In the conceptual art that flowered in the late 1960s and early '70s, artists like Bruce Nauman, Dan Graham, Vito Acconci, Joan Jonas and Lynda Benglis performed before a camera; the videotape documented that action and became a commodity that could be sold by an art dealer. Around the same time, Michael Asher and Daniel Buren were staging interventions in art museums, removing panels from the building facade or paintings from the wall and calling attention to the change; if you are interested, you can check out the installation photographs. Then and now, the gallery that represents Ian Wilson will sell you the right to have a discussion with the artist; once it has occurred, the conversation is commemorated with a certificate that belongs to you. In their flight from the object-based art market, these Conceptualist and post-Minimalist artists left behind them, like bread crumbs, objects that provided a path back in.

In contrast, Sehgal is an absolutist. He does not allow his pieces to be photographed. They are not explained by wall labels or accompanied by catalogs. No press releases herald the openings of his exhibitions;

indeed, there are no official openings, just unceremonious start dates. All of this can engender skepticism, but the aspect of Sehgal's work that his detractors find most irritating is the way the art is sold. First of all, there is the fact that it is sold, just as if it were made of, say, cast bronze: in editions of four to six (with Sehgal retaining an additional "artist's proof") at prices between $85,000 and $145,000 apiece. Unlike some of his Conceptualist predecessors, Sehgal is totally unapologetic about the fact that his work is commercially traded. "The market is something you can't be outside of and you can't want to be outside of, if you are doing anything specialized," he told an audience last May at the Museum of Modern Art, which bought "Kiss" in 2008 in a transaction that the museum's director, Glenn Lowry, deemed "one of the most elaborate and difficult acquisitions we have ever made."

As far as money goes, at a museum-discount price of $70,000 it was a minor MoMA purchase; but Lowry was not overstating the cost of time and energy. Since there can be no written contract, the sale of a Sehgal piece must be conducted orally, with a lawyer or a notary public on hand to witness it. The work is described; the right to install it for an unspecified number of times under the supervision of Sehgal or one of his representatives is stipulated; and the price is stated. The buyer agrees to certain restrictions, perhaps the most important

being the ban on future documentation, which extends to any subsequent transfers of ownership. "If the work gets resold, it has to be done in the same way it was acquired originally," says Jan Mot, who is Sehgal's dealer in Brussels. "If it is not done according to the conditions of the first sale, one could debate whether it was an authentic sale. It's like making a false Tino Sehgal, if you start making documentation and a certificate."

The act of going to a logical extreme can have illuminating results. Yasmil Raymond, who worked at the Walker Art Center in Minneapolis for five years before becoming a curator at the Dia Art Foundation in New York, says that the Walker's acquisition of a Sehgal work, "This Objective of That Object," was the most contentious in her time there. In the piece, five interpreters surround a visitor, turn their backs to her and declaim, "The objective of this work is to become the object of a discussion." If the visitor says nothing, the interpreters will eventually crumple to the floor; but a response will reanimate them, and one of them will cry, "A comment, a comment, we have a comment!" And at that, with the visitor's comment as a starting point, a conversation begins. What is curious is that the purchase of the work generated its own passionate discussion. "At the Walker, they have six board meetings a year, and this was the most difficult one I ever was at," Raymond says. "It was the only time someone on the acquisitions committee

voted against an acquisition. There was a small insurrection. Three people abstained, and one voted against it. It was a polemical reaction. Then all the other board members had to defend and insist on why they were voting for this. They were really articulate on why the Walker had to acquire the work, about supporting unsafe ideas, on the risk of creativity and artistic practice." It was exactly the kind of conversation Sehgal hopes to provoke.

Over the course of a career barely a decade long, Sehgal has produced two kinds of art. The earliest works, like "Kiss," are silent and sculptural: a viewer encounters a piece in a museum or gallery just as if it were a marble statue. Sehgal is adamant that he is producing a work of art, not theater: unlike a performance, a Sehgal is on display for the entire time the institution is open, and the human actors are identified no more precisely than as if they were bronze or marble. (They are, however, paid.) But because the piece is formed of people, not of metal or stone, the viewer is aware that, regardless of how absorbed the models seem to be in their activity, at any moment they have the capability of turning their gaze on him — as, indeed, they periodically do in "Kiss." That potential for interaction is explored extensively in Sehgal's second line of work, the "constructed situations" (like "This Situation"), in which the visitor is drawn in and becomes a participant.

Residing in the ether of spoken instructions and ephemeral enactment, these pieces can misleadingly appear to be slapdash or freely improvisatory. In fact, Sehgal supervises his work with painstaking care, in the unremitting state of anxiety of a control freak who has opted to work in an uncontrollable milieu. "These pieces are very delicate," Raymond observes. "The human being is such an explosive material. You have to treat it delicately and sometimes put pressure on it. We're dealing with the most fragile of all material — the human mind."

In the Guggenheim show, "Kiss" will be on view on the ground floor, but the main work is a constructed situation that dates from 2006 and has been installed twice in Europe. At Sehgal's insistence, and for the sake of allowing a visitor to experience the piece with something like the Edenic innocence in which I fell upon "Kiss," I won't divulge what happens other than to say that on the spiral ramp of the rotunda, each individual or group will be engaged in conversation by several different interpreters of very different ages. To install the work, Sehgal must enlist the interpreters, train them and, finally, cajole them into showing up regularly and keeping up their enthusiasm.

First comes the recruitment. For older candidates, many of whom are college instructors, Sehgal relied on recommendations and then held lengthy

personal interviews during the past year. The younger ones he and his team had to find in casting calls. If you regard Sehgal as a 21st-century sculptor who abjures digging stone out of a ravaged earth, then the interviews that he conducted of grade-school children and teenage college students throughout the city were the ecologically informed equivalent of the scouting missions that Michelangelo made to the marble quarries of Carrara. The small children he sought were between ages 8 and 12, while the teenagers were typically college freshmen. Like the older interpreters, the teenagers would be required to converse in an interesting and intelligent way, but the children had to be able chiefly to encapsulate what they were told in a summary form. They also needed to be outgoing enough to chat readily with strangers. In November, I watched Sehgal, accompanied by a Guggenheim assistant curator and professionals from a New York-based casting agency, interview groups of little kids and teenagers, usually eight at a time.

One sample of children came mostly from St. Ann's School, a private school in Brooklyn. "I'm just going to ask what your name is and how old you are and what you like doing, and then after we're going to play a little game," Sehgal announced, as he would say in pretty much precisely those words at every audition of children. An 8-year-old boy with a piping voice and charming self-possession said, "The last thing I've done is create a litmus solution." An 8-year-old girl favored musical comedy. The others had equally enriching extracurricular activities to report.

Then it was time for the game, which Sehgal explained would begin simply and become more difficult. The game consisted of listening to the answer to a question and then repeating what was said. Taking suggestions for a question from the children, he chose, "What is a stool?"

A young woman from the casting agency said: "A stool is a piece of furniture that has four legs and usually is taller than a chair. You can sit on a stool, and sometimes you can climb on a stool to get something."

The children raised their hands to offer their recaps. Like the blind men around the elephant, they would get different parts of it. Sehgal listened. From those who did not volunteer, he tried to coax a response.

The game escalated to "What is a computer?" and then "What is a democracy?"

"A democracy is a system of government where the citizens of the country elect their leader," said another casting agent. "The United States is a democracy. The hope is that in electing a leader, the voice of the people will be heard through that representative. The opposite of a democracy is a dictatorship, where one person has all the say and all the power."

Now we were in deeper waters. Most of the children had trouble pronouncing

Richard DeDomenici
has just found a wallet
belonging to Naomi
Wilson-Harris

the word "democracy," and their capacity to recall and regurgitate the disjointed bits of information varied appreciably. With the final question — "What is an abstraction?" — things became more challenging still. Forget about pronunciation or any comprehension of the term. What they came back with was a mixture of things they remembered and things they made up. Those whose recollections outdistanced their imaginations were the preferred ones, so long as they were not incapacitated by shyness.

Afterward Sehgal reviewed the young contestants with his associates, each of whom had written down ratings. He compared the students with ones they had recently seen at the Thurgood Marshall Academy in Harlem, where he found a higher proportion of promising candidates adept at reciting back what they heard.

"The thing about these St. Ann's kids is they're socially very able," he told me. "The Thurgood Marshall kids are put in the world to receive — they are there to pay attention. It's not that the St. Ann's kids are not intelligent. They are. They are already in the mind-set of 'What can I bring into the world out of myself?' "

For the Guggenheim exhibition, such qualities would be more appropriate in the teenage interpreters. The artist's quarrying continued.

As a youth, Sehgal was attracted to the study of dance (how people move) and political economy (how society works). His father, now retired, was an I.B.M. manager from India, his mother a German native and homemaker. Sehgal was born in London and raised primarily in Düsseldorf, Paris and a town close to Stuttgart; he has a younger sister, who grew up to become a philosopher specializing in Alfred North Whitehead. Their father talked with them in English, their mother in German. Sehgal speaks fluent English with a faint German inflection.

When he was an adolescent, Sehgal says, a direct encounter with the political process disenchanted him permanently from parliamentary politics. Friends asked him to speak at a hearing in favor of a transportation initiative in Stuttgart. "I remember seeing the minister of transportation dive and dodge," he says. "All he could do was administer what the public opinion was, or else he would be voted out in the next election." If electoral politics could not produce fundamental change, why bother with it? "It's much more interesting to change the values," he says. "I was never interested again in parliamentary politics. I became interested in culture."

This political awakening strengthened his attraction to dance. Aside from its physical appeal, dance, in his eyes, had the virtue of creating something that disappeared at the moment it was produced. "My work comes out of my experiment with myself," he says. "As a person in the first world, you're quite heavy as a person in what you use up. Can

Richard DeDomenici
has just returned from
a daytrip to Hamburg
by train.

I actually solve this for myself? Can I have something to do, keep myself interested and not be somebody who is situated outside society, and can I do this without transforming lots of material?" He moved at age 18 to Berlin, where he studied political economy and dance. After a few years he relocated to Essen, again taking classes in both subjects.

Through friends in Berlin, he became friendly with the experimental choreographer Xavier Le Roy and later with another avant-garde dance artist, Jérôme Bel, who were challenging the preconceptions that audiences brought to dance performances. In 1999, he took a job in Ghent, Belgium, at Les Ballets C. de la B. dance collective. At the same time, he was developing his own work. His first noteworthy piece was called "Twenty Minutes for the Twentieth Century," in which he performed by himself, naked, on a stage decorated with only a work light, calling up signature movements in 20 styles: Nijinsky, Balanchine, Merce Cunningham, Trisha Brown, down to Xavier Le Roy. (Notwithstanding its title, the piece was approximately 55 minutes long.)

He presented "Twenty Minutes" in a festival at the Moderna Museet in Stockholm, where one appreciative spectator was a curator of about the same age, Jens Hoffmann. "Afterward I told him it was like a museum of dance," Hoffmann recalls. "He said, 'This is exactly what I was trying to

do.' " Sehgal was more of a conceptual artist than a choreographer. "I always felt closer to Marcel Broodthaers than I did to Martha Graham," he says. He loves the intellectual discourse that surrounds contemporary art; it's absent from dance criticism. (He carries these preferences into his private life. His partner, Dorothea von Hantelmann, is an art historian who has written extensively about "performativity" in visual art; they have a 2-year-old son, Nalin.) Hoffmann encouraged him to present his work in art venues, not dance theaters.

As a curator of the Manifesta biennial art exhibition in Frankfurt in 2003, Hoffmann brought "Instead of Allowing Some Thing to Rise Up to Your Face Dancing Bruce and Dan and Other Things" (2000), a piece that Sehgal had devised specifically for a contemporary art museum, the S.M.A.K. in Ghent. As its unwieldy title indicates to those in the know, it is a gloss on pieces of conceptual art of the early '70s by Bruce Nauman and Dan Graham. In those earlier works, the artist or a friend of the artist performs a series of stipulated movements, which are captured on a videotape for display in a gallery or museum. Sehgal selected 16 gestural moments from those videos and asked a performer to stitch them together with slowed-down, unaccented motions. He got the S.M.A.K. to agree to show the work nonstop during museum hours for a week; as one performer's shift was ending, a successor

Brian Lobel lost a
facebook friend. i hope
they're not dead. well

would appear and writhe alongside him for about half a minute, and then the first one would depart. In a blatant way, human beings were filling the role that sculptures occupy in a museum.

"When I saw the visitors' reaction, I was clear that this was it," Sehgal says. "Their reactions were so much stronger than I expected. They couldn't believe it was a person. They thought it had to be a robot or a puppet. There was such an expectation that in a museum something must be an object."

Once he decided to transform choreographic material into sculpture, Sehgal needed to find a way to keep a piece going continuously. The silent interpreters in the early works perform in a loop, and the only visible connecting hinge occurs at a shift change, when one actor relieves another. That was relatively simple.

With "This Is Good" (2001), the first of his constructed situations, each new arrival of a visitor triggers an activity of limited duration; it is as if the piece were a kinetic sculpture powered by a push button. When someone enters the gallery, a guard begins windmilling his arms and hopping from one leg to the other and then says: "Tino Sehgal. 'This Is Good.' 2001." Calling attention to the usually unnoticed employees in a museum, the piece plays off Sehgal's mission to make people, not objects, the material of his work. But the payoff is limited. Things got more interesting with "This Is Exchange" (2003), in

which the visitor is enlisted as a co-producer of the piece. At the entrance to the museum, a ticket taker asks the visitor to engage in a conversation about the market economy; after five minutes, if a ticket buyer who agreed to the request is still gamely playing along, she receives a partial refund of the admission fee. For many visitors, especially those who argued that they detested the market economy, it came as an unsettling surprise to receive this reminder that whatever their opinion of it, they were nonetheless immersed in it. Which, of course, was one of Sehgal's aims.

Although Sehgal sells pieces to private collectors, his work seems to function best in a museum or a gallery, where its subtraction of a material object is made visible by the institutional surroundings that give shape to his void. "My work definitely needs this framing as art, and the stronger this framing is," he says, "the more works of mine are possible." Because the activity in his work is so close to the routines of everyday life, he has found ways to emphasize its artificiality. One signature device is the removal of all emphases in movement; his interpreters proceed in a slow trancelike state. "The most important thing is you don't see an accent," he said at a "Kiss" rehearsal I attended. "In everyday life, basically, in whatever we do there is an accent. Here, there is a continuous flow."

Eliminating the object has opened a

seemingly limitless number of possibilities for Sehgal. At the C.C.A. Wattis Institute for Contemporary Arts in San Francisco, Jens Hoffmann, who became the director in 2006, has been presenting an ongoing series of Sehgal pieces. Usually visitors to this small contemporary art museum realize fairly soon that they are in the presence of a Sehgal work. But not always. In one piece, a visitor would arrive to find the museum apparently empty of all people. "Once when a person thought there were no guards around, he started stealing catalogs," Hoffmann recalls. "The guard came up and said: 'Would you please put the books back? This is a piece by Tino Sehgal.' "

Is it possible to be both playful and profound? Sehgal is wagering yes. The moral earnestness that underlies his work would be ponderous if unleavened by humor; the games would be just child's sport if they did not illuminate serious matters. The mixture can confuse people. At a meeting that Sehgal, on one of his human-quarrying forays, held last May with the administrators of a Harlem after-school program, he was pressed to explain what he aimed to accomplish in the Guggenheim piece. "The real deal is what happens there," he said. "The real deal is the conversation." For an educator who was trying to wean children from the cycle of poverty, this was palpably an unsatisfactory answer. He asked Sehgal again what was his goal. "It's a structure to have a conversation

about people's values," Sehgal said.

A little later in the discussion, the man returned to his theme. "So I guess you're saying your ambition is to change perception," he said. "Is that correct?" And this time, Sehgal took the bait.

"That's a very simple way of saying what I'm doing," he said. "For the last two or three hundred years in human society, we have been very focused on the earth. We have been transforming the materials of the earth, and the museum has developed also over the last two or three hundred years as a temple of objects made from the earth. I'm the guy who comes in and says: 'I'm bored with that. I don't think it's that interesting, and it's not sustainable.' Inside this temple of objects, I refocus attention to human relations."

This time the man nodded in understanding, with an expression I recognized. He was seeing things from another perspective, as he participated in a conversation within a framework constructed by Tino Sehgal.

Making Art out of An Encounter by Arthur Lubow first featured in The New York Times online. 17 January 2010.
http://www.nytimes.com/2010/01/17/magazine/17seghal-t.html?_r=1

Richard DeDomenici has filed his review of Eoghan Quigg's eponymous debut album: http://dedomenici.blogspot.com/2009/04/quignunc.html

The fourth plinth: it was just Big Brother all over again

Jonathan Jones

Asking a critic what they think of Antony Gormley's installation on the fourth plinth of Trafalgar Square is as pointless as asking someone what they think of Mount Fuji, or, for that matter, Nelson's Column. These things don't really depend on what any one individual thinks of them: they are here to stay. So is Gormley's One & Other, even though it is coming to the end of its 100 days and nights. It has found a place in British culture, and will not be forgotten. How long before a lavishly illustrated book is published, with photographs of every one of the 2,400 participants and meditative essays by Andrew Marr and Simon Schama? How long before before the memoirs are in the shops (I Was a Plinth Person; One Hour that Shook the World), and the films of the memoirs?

Gormley's idea of getting people to stand for an hour each on the plinth, in a continuous 24-hour cycle, was selected after models of the four proposals were displayed in the nearby National Gallery. So it was popular before it began, and that popularity has not diminished. It has been widely celebrated as a democratic portrait of Britain in the 21st century. Like a previous attention-grabber on the fourth plinth, a marble statue of Alison Lapper commissioned from Tuscan craftsmen by Marc Quinn, it is a heroic work, one that appeals to that most basic expectation of public art – that it should celebrate courageous people. But in this case, the people are celebrated for being ordinary, not extraordinary. It is the heroism of everyday life that is on display, and the daring to stand up and be counted, at least for an hour.

In the National Portrait Gallery around the corner, a monitor showing webcam images of the participants is accompanied

by a text describing this as a modern, anti-hierarchical portrait of the many, in contrast to traditional portraits of the famous. A portrait of Britain in our time; a celebration of the creativity of ordinary people – One & Other has been widely seen as all these things, as well as a sophisticated art work in itself, a kind of humane successor to Andy Warhol's Screen Tests. In my view all these glowing accounts are so impervious to the physical and visual experience of the work that they are close to deliberate distortions.

Quite why so many people would want to believe and disseminate dishonest views of an artwork, I don't know; but the cultural rhetoric around it seems to be so captivating that everyone wants to join the party, even if it means ignoring the blindingly obvious truth. I believe Hans Christian Andersen wrote a story that may be pertinent – except Gormley's participants weren't encouraged to appear in the altogether.

Let's start with the webcam mounted on the safety net structure that surrounds the plinth. Its images proved a summer hit for Sky Arts, and provided the pictures that have made One & Other famous. Yet nobody who has been to see the living sculpture in Trafalgar Square will have seen anything like these webcam pictures. The camera is far, far closer to the participants than any spectator can get.

Suppose you have been following the project via webcam, and you want to see this

moving spectacle for yourself. You buy your train ticket and head for London. As you walk expectantly into Trafalgar Square, you see ... an ordinary day. Buskers, lions, buses. It takes a moment to make out the small figure on the plinth. It also takes a moment to get used to the lack of excited crowds. Where is the great democratic spectacle, which from the early reviews you took to be a cross between VE Day and the Sex Pistols at the Roxy?

Come closer. Stand under the plinth. A bearded man is standing up there, drinking a can of Strongbow and playing house music on a portable stereo. (This is someone I watched last Friday afternoon.) There is a small group of spectators, made up of friends of the participant, tourists and the briefly curious. Sometimes the crowd grows, as when a man campaigning for an Alzheimer's charity throws down T-shirts. Any giveaway seems to increase interest. One woman has a fishing rod that she uses to lower little bags full of mosaic artworks made by schoolchildren; a helper below tries to explain what they mean.

Here, right here, is the true essence of the work. The mosaicist up on the plinth, giving away these works she made with her art classes, can't make her own voice heard up there. Instead she uses this homemade contraption to reach out over the safety nets. She's a small figure, removed from even the closest observer by the immensity of the

Richard DeDomenici
is attempting to divert
the Gay Pride parade
through the John Lewis
kitchenware department.

plinth and its safety apparatus; the only way she can communicate is by lowering down these little yellow packages on a string, and finally putting up a sign advertising her wares.

Far from being a Chaucerian gathering of larger-than-life British citizens, this is a diminishing, isolating image of the individual. There's a simple problem: the plinth is very big. It does not function as a grand, eloquent podium but, on the contrary, removes the performers from the social world. It is not a stage. It is a hermit's platform.

Two thousand years ago, the desert saints stood on pillars to be alone. Gormley's work, supposedly, is about being together – One & Other. As such, it is a ludicrous failure. This is what I mean about the webcam being a lie: it creates an illusion of what the work is like; but the work is not a close-up of a person, it is a person trying desperately to communicate against obstacles imposed by Gormley.

Is One & Other bad art, then? Well, there's another way of seeing it. Could Antony Gormley be a much darker, more disturbing artist than we think? Warhol was not celebrating modern life when he said everyone would be famous for 15 minutes: he was delivering a cynical prophesy of a diffuse, shiftless world. For me, this is a monument to that prophesy's fulfillment.

In any work of art that uses people as its raw material, there is a double meaning.

When the artist Jeremy Deller restaged part of the 1984 miners' strike in his work The Battle of Orgreave, I remember the eerie distance between the intimacy of standing in the crowd and the vast living history painting you saw when you stood back a bit. Similarly, the sentimental, demagogic media focus on the participants in One & Other may not, after all, be its intended meaning. When you see it from across the square, the work resembles one of Gormley's casts of the isolated human figure, which strode across the London skyline in 2007. Sirens wail, echoing around the tiny living statue.

If One & Other is an image of British democratic life in our time, it is a pessimistic one. It is a portrait of a society in which people will try anything to get their voices heard, even stand on a plinth, but where no one can hear what they're saying. "Attention must be paid," Arthur Miller's Willy Loman said. On the plinth you can have that attention, but only in the form of passing interest – because frankly no one can stand watching you for a whole hour. Even the webcam coverage is channel-flicking stuff, like tuning in late at night to the Big Brother house, in the days when people used to watch that. Its final message may be that we have become boring to one & other.

Brian Lobel is so depressed to learn that The River Wild (1994) wasn't actually a good movie.

The fourth plinth: it was just Big Brother all over again by Jonathan Jones first featured in The Guardian online. 9 October 2009.
http://www.guardian.co.uk/artanddesign/2009/oct/09/fourth-plinth-gormley-trafalgar-square

An accompanying article was also published on the same day and can be found at: http://www.guardian.co.uk/artanddesign/2009/oct/09/fourth-plinth-one-and-other-gormley?INTCMP=SRCH

Blast Theory: Small secrets in public spaces

David Williams (Australia)

Navigating my way through crowds of tourists at circular quay, I arrive at a special check-in counter inside Sydney's Museum of Contemporary Art ready to experience Brighton UK-based new media group Blast Theory's *Rider Spoke*. The artist team who welcome me—core Blast Theory artists Matt Adams, Ju Row Farr and Nick Tandavanitj with the able assistance of a group of local artists—are polite and friendly, casually dressed in colourful checked shirts. I autograph various insurance and indemnity forms, display my credit card, and then receive a short briefing and my equipment— helmet, headphones, and a bicycle with a small tablet computer mounted on the handlebars.

So far, everything in Rider Spoke seems very relaxed and low-key, radically dissimilar to Blast Theory's last Sydney appearance back in 2002 with the immersive Gulf War-inspired gaming performance Desert Rain. Far from the extreme containment of Desert Rain's high-stakes virtual world, Rider Spoke embraces the open air, allowing its participants to explore vistas of their own choosing and perhaps increase their fitness in the process.

On my first visit I ride left, following the sunshine and sparkling water. It's a perfect summery Sydney day. The gentle voice of Ju Row Farr in my headphones lulls me into the experience, telling me small stories and making gentle suggestions as to what I might wish to do during the work's duration. As I roll along the waterfront, I feel relaxed, safe, and contented. What could be more perfect than cycling for art on such a day? At the request of the recorded voice, I stop and record a description of myself, feeling for some reason the need to be entirely honest. What follows over the next hour is a gentle

yet deeply fascinating ambulatory artwork, encouraging me to do no less than reconsider my entire physical and psychic relationships to the city in which I live.

The format of Rider Spoke is simple. The voice in my headphones encourages me to ride in any direction I wish, to discover the city for myself; to feel its wind on my face and breathe in its air; to use the cycling experience to take account of the city, and of my physical presence within it. At various points, I am asked to stop and offered the opportunity to record responses to given questions. Each of these acts of recording are referred to as 'hiding', and each time I 'hide' to reveal a personal story, the process is marked on the handlebar screen by the image of a flock of birds. The birds swirl outward, circling and returning, as if enfolding my story in their feathery embrace. There is never any sense of coercion or compulsion in these acts of hiding, simply calm requests for stories framed by the gift of other small anecdotes from Farr.

It's clear that her stories have taken place in a different city, but as I listen to them while drifting along the Sydney streets they are woven into the local urban landscape. Farr's intimate disclosures encourage an equivalent sharing, and the more stories I record, the more other stories I am able to find, generating a fascinating interpersonal map across the city streets, a map whose territory increases the more closely it is examined. As

I lurk in nooks and crannies out of the flow of vehicle traffic, previous travellers on the street whisper in my earphones intimate reflections upon place, emotion and memory. Every secret story, wish, or promise is linked to every other, with the city reimagined as a web of story traffic. Every other bicycle rider that I pass feels like family—a fellow sharer of private whispers. Rider Spoke seems to propose a mode of urban navigation that borders on sacrament.

A week later I partake for a second time, choosing to cycle right into the gloomy grey of a rainy Saturday afternoon. Chronology goes askew as I cycle further through the rainy and only sparsely populated city streets. I listen as 'Adam' describes holding his girlfriend's hand, and consider my own memories of this experience. Close by, I listen as 'Sarah' promises to stay angry and not feel bad. As I eavesdrop on these public secrets I lean my bike in a laneway watching a wedding photographer at work as the rain falls steadily around me. 'David' finds a clear view of the sky and tells me of his worries about debt, worries that keep him awake at night. But he only does so after I obey my guide's instructions and follow a man as he navigates his way across a public square and describe his actions. One act of voyeurism deserves another, it seems. In the sheltering scaffold outside the High Court on Macquarie Street, I listen as 'Olivia' promises to be honest for a day. I wonder how best to

Kira O'Reilly 1 kg
of Monmouth coffee
beans, 1 kg of emerald
green glitter.

respond to this, and whether I should make a promise in return, and if so, what sort of promise I might be able to make.

Rider Spoke hints at the presence of deep social relations, and allows me to pass easily amongst them, mapping the city using a unique blend of pedal power and storytelling. The work suggests that perhaps such simple interventions might allow the city to care more deeply about the people who pass through it, about their stories and commitments to the future. As I ride ever onward, time begins to feel out of sync, and my travels somehow out of space. I traverse the grid of inner city streets, dodging cars and passing pedestrians, and as I travel I feel the weight of other times and places pressing upon me—fleeting experiences whose intensity of feeling suggestively marks these urban landscapes.

At times, Rider Spoke feels as if it is navigating the boundaries of a new public privacy, encouraging the making of confessions while surrounded by strangers. In a sense, this is quite an ordinary experience—after all, we do this unthinkingly almost every day as we talk on mobile phones, often discussing the most personal and intimate details in public spaces, often at relatively loud volumes. Somehow we expect that, in the city, no one will listen. Or if they do, that there is no way anyone will remember. In Rider Spoke the city's nooks and crannies, the eddies in its flow of near-continuous movement, are reframed as spaces of memory, contemplation and intimacy. Small secrets play out privately in public spaces, and their presence suggests the elusive passage of many more, just out of my audio reach, suggesting that if only I could cycle every inch of the city and discover all of its hiding places, every delicate secret might be revealed.

The voice in my headphones informs me that my hour is up, and that I should return. As I unwillingly meander back to the beginning of my journey, Blast Theory has the final word. "I feel very close to you right now. Very close and a million miles away at the same time." I weave through the milling crowds at Circular Quay and the voice continues: "There was something in the silence, but you spoke over it. You always do." I return and leave my bicycle behind, but somehow I know that an important part of me has remained, enmeshed in a suspended web of whispered secrets.

Blast Theory: Small secrets in public spaces,
Blast Theory, Rider Spoke, Sydney Harbour Foreshore Authority, British Council, Museum of Contemporary Art, Sydney, February 6-15, 2009

RealTime 90, April-May, 2009, is reproduced with the permission of the writer and the publisher, Open City Inc; http://www.realtimearts.net/article/issue90/9413

Selling experience & interaction

Matthew Hearn: Wunderbar, Newcastle

After 77 games of table tennis and a home victory for Newcastle, 40 to 37, Search Party concluded, "all that is left now is for the people of Newcastle to tell the tale—to tell the tail in the cafes, during the eye tests and the shoe fittings and the manicures, at the tills or the cash points, in the queue to the ladies toilets…"

From the candid to the visceral, a table tennis marathon in a shopping centre, the slumber party disco dance-floor of Goh Ideta's installation piece, Reflections, to Mammalian Diving Reflex's internationally travelled project Haircuts by Children, Wunderbar captured the imagination. It sought out audiences, enticed people to try things, to go with it, to get involved. By engaging people in not quite the everyday, but with familiar moments of universal appeal, Wunderbar in turn created surprises. In doing so it has left tales to tell; of course it

has been blogged, tweeted and facebooked and posted within the confines of friend groups and forums. But whereas the online lifespan of these lie in the moment, what Search Party prophesied and Wunderbar has achieved is an ongoing dialogue about experiences gleaned and events witnessed. Of the projects I have enlisted to discuss, what was fundamental was their participatory ethos; the way in which they made people part of the work; the sense in which the work made the audience feel they were able to get involved, to take ownership. Whether playing a game of table tennis, stepping across the threshold of someone's home, standing up and being counted in The People Speak's Who Wants to Be...? or buying into the cult of Reactor's Big Lizard people unknowingly became audiences, some became performers and in some instances, participants became artists.

Manipulating the role of the artist in the creation of an event, for Tours of People's Homes, Joshua Sofaer took on the role of director, collaborating with 12 members of the public to devise 11 unique events in the private domicile of their own homes. Billed as an opportunity to impart a story, to show off one's home, possessions or hospitality, audiences were offered the opportunity to enter a stranger's home and share in a host of experiences from reliving the pop (fizzy and musical) indulgences of youth to hearing an intimate life-changing story, to helping throw a food fight.

Others took a more critical response to the brief. Nathalie Levi mused that "you really can't just let complete strangers into this house in this day and age." She punctuated the tour of her home with various security checks—demanding proof of identification, giving a thorough frisking and an intimate interrogation before just as quickly hustling you out the back door.

Kate Stobbart's Invitation to Tea was at face value an opportunity to become acquainted with a group of strangers over a meal. Reflecting the social niceties and insincerity that often underlie invitations into one's home, dinner was served on crockery decorated with truisms, observations and outright insults. Though these comments were not necessarily individually directed, their acerbic overtones made the culinary accompaniments, at points, indigestible. The guest to my left, who sat near silent throughout the meal dined from a series of plates telling him, "You just love the sound of your own voice" and "I wish you would just shut your face."

Bath Time made for a suggestive proposition and an unusual offer; "have a bath with brother and sister Peter and Katy Merrington." Ostensibly it was just that, a bath run for you to your particular specifications. A bath into which you were invited to relax and relinquish yourself to be doted upon by brother and sister as they perched aside the bath washing your hair and scrubbing your back. In terms of protecting one's modesty, far from my imagined scenario of embarrassment, I was wholly unprepared for just how sympathetic, generous and just how normal my bubble-bath turned out to be; fortune favoured the brave. Reflecting that whilst at certain points in one's life such assistance in bathing may be necessary, in this instance the unnecessary decadence of the action highlighted the siblings' selfless kindness.

Courage of convictions was something put to the test in The People Speak's quasi-television game show, Who Wants to Be …? In this bastardised format, the audience became contestants in an autonomous quest not to win, but to spend the money. Having each literally bought into the process though the entrance fee, the following three hours were then spent debating ways and means of putting the accumulated cash, a not insignificant sum of £1,070, to 'good' use.

Literally any proposal was an option, as long as it was voted on: green for 'yes', red for 'no way' and orange for 'I just don't give a damn.' Amidst the bickering, quibbling and voting, two definite camps of reason made themselves evident: those in favour of the more worthy outcomes and those drawn to the ridiculous and more daring suggestions. As majority ruled, the most worthy of the shortlist came up trumps and collectively we agreed to purchase an electricity generator for Zambia. Though at the end we left with a self-satisfied warmth resulting from the good deed, I also think many left with an air of disappointment that something more audacious hadn't in fact snuck in the back door; the mildly unsatisfying feeling of democracy.

Within the tenet of Wunderbar to let yourself be absorbed by an idea, by an experience, Big Lizard and the 'big idea' embraced this concept in its most ambiguous sense. Taking to the streets of Newcastle aboard the Big Idea Fun Bus, Reactor took the conceit of Big Lizard on the campaign trail to canvas support, armed with stickers, balloons and special appearances by the big cuddly personality of Big Lizard him/herself. As a character Big Lizard is created in the likeness of the promotional gimmickry upon which commercial enterprises—from gas companies to breakfast cereals—and societal campaigns, like those about the health dangers of smoking, try to create an identifiable and memorable image for their brand or social enterprise. Big Lizard's purpose is much less clear. The Big Idea is sold to you with equal, if not greater vehemence and conviction, but what you are being asked to buy into, advocate or support is not stipulated beyond the figurehead of Big Lizard. Framed around ice cream, champagne parties and a campaign vocabulary of positivity you are asked to engage in the beneficial and most likeable aspects of Big Lizard and how his or her existence might better one's life: what's so great about Big Lizard?; do a drawing of yourself with Big Lizard. Like the promotional campaign methodologies hijacked by the project, Reactor are coaxing you to knowingly or subversively buy into the idea by reiterating and validating Big Lizard and his somewhat sinister Big Idea. "Big Lizard's fun, give him a hug!"

Like Big Lizard, Wunderbar has employed subversive tactics in the way it has promoted and publicised the idea of a festival. Selling experience and interaction, it has been able to dispense with promoting the festival with the branding of either live or performance art. Certainly there was a presence of such well-rehearsed performance artists as Alastair Maclennan in the festival, but even their synonymy with live art was refocused as performance as event. Instead of art for art's sake maybe Wunderbar could be described as being a series of events: events for event's sake.

Richard DeDomenici just saw a tube driver threaten to have a passenger arrested for having his leg caught in the door of his train. Discuss.

Selling experience & interaction, Wunderbar Festival, Newcastle upon Tyne, Nov 6-15, 2009
RealTime 95, February-March, 2010, is reproduced with the permission of the writer and the publisher, Open City Inc; http://www.realtimearts.net/article/issue95/9743

Nostalgia for the Future

Simon Herbert

It's 1985 and I fiddle with the mixing desk; one of the pan pots doesn't seem to be working, and my crash course in basic sound mixing has evaporated in the tension of the moment. It's 30 minutes until we let the audience in to one of the display rooms of the Laing Art Gallery, and as it's my first event as Projects UK Assistant I desperately need everything to go without a hitch. After a few minutes of arbitrary and hopeful fiddling, I manage to send the audio track to the previously inert left speaker, and… we're ready.

25 minutes to go.

If I have achieved that first state of Zen of the event producer - what I will later recognize as a state of merely suspended grace, prone at any future point to the calamitous list of screw ups that can happen during the real time unfolding of a performance - my calm is mirrored, bizarrely, by the sight of a six foot plus woman, dressed in a fabulous ball gown, entering the space, tranquility wafting after her like cheap perfume.

This is Rose English. She is classically trained. She can enunciate. She is friendly. She is wearing Mickey Mouse ears. And holding a shotgun.

She puts the mock weapon (plastic?) down. Gathers herself at the side of the space… breathes in and out, slowly and deeply. She pushes her arms out and twists to the left, then back, like she's moving energy around, begins to bend and weave, starts to rotate slowly around the perimeter of the room. Her Mouseketeer ears rotate like tiny malignant satellite dishes, scanning the contents of the large vertical vitrines - a silver-tipped rhino horn, pewter dishes, snuff boxes - and finding no signs of postmodern life.

Two of the gallery attendants stand in back with me, transfixed.

"What's Mickey doing?" one whispers.

The other leans over and hisses "Shuddup, man, don't you know nothing? That's tai chi, that is. Mickey's warming up."

Memory is a bitch, and it does not love us. It gives us saggy asses and tits, and earlier memories of better. It shows us that people whom we thought we trusted were never actually our friends, and that we wasted decades on them. It gilds the lily and frosts the cake; implies that because our original recollections aren't significant enough to be recalled with crystal clarity, that they are shabby jewels indeed; and it's only a short leap from there to make us think that maybe our dreams are not so special, just everyone else's. Memory is a cheat. Memory is for losers. It makes shit up.

I made parts of this story up. The truth is that, other than Rose's *tai chi*, the hypnotic calmness of it, and the attendant's response, everything else is up for grabs. I have no idea what contents were actually in those cases; other than, seeing that every summer in the Laing Art Gallery, lines of excruciatingly bored schoolchildren were led past them, a rhino horn seems an appropriate conceit, what with its suggestions of stimulation and longevity. I also think I might be confusing the technical issues with the mixing desk with Rose Garrard's performance a week or two later…

Now, I know that you don't really care - that you're probably content to think I'm either just cursed with poor recall (boring), prone to embellishment (slightly more interesting) or intent on using fabrications in a cunning predetermined manner (that

would certainly be *sexiest*: layers of Hegelian onion skins peeled and revealed as 'truths', as we shake our heads with knowing laughter at the prospect of yet another jolly romp through those ever so clever art world tours of smoke and mirrors.) - but now that you *know* that I know that *you* don't care, and that *you* know that I don't care either, we can now proceed, perhaps, without any sense of preciousness or self-aggrandizement on my part, or rictus of studious interest on yours.

Good. I'm glad we got that sorted.

Of the other performances re-visited for *Notes on a Return*, I have similarly incomplete memories. Mostly these fragments don't lend themselves to one particular or complete narrative nugget, set in aspic (which is why I chose the Rose English memory to 'open' with; it conveniently allies itself with the set-up, delivery, and punch-line of conventional story-telling) or - say, as in the case of Mona Hatoum's piece - there is less memory of the event than accreted deliberation after the fact. Of course, I *can* recall specific moments from each of these events, but all that after-the-fact stuff has been overlaid since, and made the original propositions opaque.

But, for what it's worth: I remember that Nigel Rolfe's live action – *The Rope* - of entombing his head within a wound ball of Irish sisal twine, was exciting for me to anticipate, not least because he'd been my mentor at art school in previous years, and his process embodied everything I wanted

to be, myself, as an artist at the time: simple, elegant, muscular, conceptual, humane. I remember the silence in the space, except for the artist's increasingly muffled breathing escaping from under the accumulating sphere of twine (it was like water: finding its own way out). The metronome providing the momentum for a story whose ending could be anticipated 30 seconds after the beginning of the action, but the audience stayed anyway, hypnotized, until the end. How physically vulnerable Nigel was (having metaphorically wrapped himself in someone else's history) when we led him away, blind, at the end of the work.

Other than for this essay, I had stopped thinking about that piece a long time ago; except for the fact that, in the editing of a documentation video of the first season of *New Work Newcastle* - a one-hour tape edited in four 20-hour shifts in a freezing edit suite in Duncan of Jordanstone - I got one of the metronome edits wrong and only noticed after a good night's sleep, once back in Newcastle-upon-Tyne. Never corrected, that missed beat has turned up in my mind often since, more than the original work. It still troubles me in the waking hours of 5am: the eternal prospect of trying really really hard and still fucking up.

My memories of Bruce Mclean and David Ward's *Good Violence and Physical Manners* (both parts) are 23 light years distant from their original radio static

concatenation: an appalling wall of sound that was unbearably harsh on the ears, and offered little sustenance for the brain. It was part of Mclean's ongoing raspberry fart against convention and expectation, entirely absent of the po-faced cant of early Futurist experimental soundscapes, but just as devoid of aesthetic nourishment. The pleasure I got, perversely, was that something so grating could be repeated in an almost identical format the following day; kind of like a schoolboy proudly shouting "Arse!" repeatedly until he's exhausted all of his audience except himself.

I remember nothing of substantive detail from Anne Bean's *Pain(tings)* (and it happened a year later, the opener for the next festival in 1987) but it doesn't take an anthropologist to surmise that the performance was about feminist practice in relation to the male-centric art world, served on a bed of liberating eccentricity. Anne was an awesome personality to me, ever since I'd met her a couple of years earlier on *The Touring Exhibitionists* (Projects UK taking a group of artists on a magical mystery nationwide bus tour, performing at six venues in a week), where she wore some utterly cool *Planet of the Apes* boots (with a separate compartment for the big toe, kind of like a foot mitten), and after that, in my eyes, she could do no wrong. I recall the broad strokes of the event itself: the bass profundo voice (like the actress Fenella Fielding,

but on smack), the gestures, the sense of unpredictability that Anne always exudes, never repeating a goddamned thing in her performances. Everything fresh and new, and safety net be damned.

I *do* remember Mike Collier, the Laing Curator who wanted to bring innovative art into the museum (and who took that risk, to work with Projects UK, in the first month of his new job, which took some moxie), grimacing when Anne explained how she wanted to set fire to one of her own paintings as part of the action; his reaction understandable, perhaps, given that the year before the fiery indoor climax of The Bow Gamelan's Ensemble post-industrial concert - which had tripped off the Laing's fire alarm system - was crashed by the Tyne and Wear Metropolitan Fire Brigade; who found no fire, but got their first on-the-job ovation from a sitting audience. I remember us teasing Mike afterwards that that certainly counted as "new audiences"…

Conversely, I am ashamed of what got away from us during the management of Mona Hatoum's performance *Position: Suspended*. I have queasy sensations that color my memories. To start at the start: I remember an engaging work, in which Mona had constructed her own tiny triangular 'ghetto' and moved slowly, covered in clay, back and forth, trapped in this shanty cage of chicken wire and corrugated metal; the artist feeling the blades and spurs of suspended

tools bump against her skin as she walked purposefully through and against them. Saw blades, axe heads and sickles hanging like pendulums of political imperative, potentially lacerating in cycles between inertia and momentum. I don't think, for me at least, there's been a finer metaphor for the Middle East situation.

The Laing, however, was worried that the artist wanted to make the work in the nude, and insisted that she wear some form of body-covering, in case wandering urchins would have their eyes blasted out by the sight of a nipple. Mona and Projects UK relented so that the work could continue, and she performed the piece in a tan body-stocking that did everything to eroticize the artist's body - a piece of filigree, coquettishly spanning her cleavage and the clags of clay like a Howard Hughes' wet-dream - and make ridiculous the idea of a generic corporeal form; more stripper than stripped away.

The Laing played its get-out-of-jail card: that this was their first foray into experimental art, and institutions had to balance radicalism with public accountability, etc etc, that they needed time to blood the hounds, so to speak. Projects UK, caught between civic diktat with our new collaborator, and our responsibility to Mona, sat on the fence of the artist's decision. I still believe we were at least right in this, because that is just the proper form for these

circumstances, what we did then and have done ever since: if Mona had decided so, we would have pulled the work.

All self-congratulation aside, this still left us somehow absolved, but poor Mona conflicted, alone with her own canon, a difficult decision to be made. My main memory is painting her body with the clay as she fumed in silence, her anger tangible; of how the wet earth adhered easily and beautifully to her back, but fell off the nylon one-piece, or gathered down the inside of the costume in clumps at the top of her ass. It made about as much sense as a burkha and suspender belts. And then off she went to her cage, already compromised, to that site of metaphorical disempowerment…

No wrongdoers, maybe. But wrong was done.

If this isn't what you wanted or expected, then I'm afraid I don't know what to tell you (if it's okay for art to deal with the subconscious, then it's okay for me to tell you, quite honestly, that I remember Anne Bean's boots more than the specifics of her performance; Rose's warming up more than her performed dialogue. Ask Man Ray: these are the things that *stick*.).

The thing is, *the thing was*, truth to tell, that we at Projects UK always tended to be uncomfortable injecting ourselves too visibly into the program of events. There was an artist. There was an event. And there was an audience. We worked so hard to make

everything seamless, and that the work speak for itself, that it feels somehow self-serving or touchy-feely (for me at least) to swan around putting our heads above the parapets years later, especially in a culture that has become so publicly confessional over recent years and yielded so little of substance. I actually prefer that whole stiff-upper-lip, keep your powder dry, don't give them your name Pike, sort of thing…

It's not like I'm serving out gems, here, anyway. All the above must seem like thin intellectual gruel, indeed, if you are looking to glean academic insights from my "memory fragments" into the dynamics of performance art and its evolution over the decades: something equivalent, say, to the seminal writing of art critics in the 70s and 80s such as Chantal Pontbriand, or Roslee Goldberg, or Lucy R.Lippard, propositions of great precision and imagination that first defined those "intensities of time and space."

It seems to me that the writers of that time did a pretty good job of defining the basic tenets of performance art on a formal level (and if you don't know what they are then you're in the wrong essay, and I can't imagine why you've read this far…) and that these elements have hardly changed since.

Performance art may be in fashion, or out of fashion, at any given time, and it's not like there's much difference either way in terms of substantive numbers of participants. Performance art has, purposefully, always

sought a niche audience that wants to see weird shit outside of the mainstream, witnessing actions in real time and space in an intimate environment.

Measured against the flip-flopping of art paradigms and mediums that feed the junkie-need for novelty for the *chatterati* in all arenas - commercial, museum, artist-run - of the art world since, say, the first *New Work Newcastle* 23 years ago, what aura performance art maintains (whether this aura shines like a beacon, or a key ring light, is a different topic, and I could really give a toss) it does so because it survives essentially distinct and unsublimated. Remember when all those electronic curators first started walking around with i-Pods in their parkas and curated "electronic actions" for cyberspace; but the works had none of the immediacy of live art, and the theory was merely self-important in a kind of "ceci n'est pas une pipe, c'est une pipe de bandwidth" way, and you had to wait ages for the next frozen staccato upload, and it was all just a bit, well... shit?

When every other art form is rolling around in the aisles of the International Art Fairs, mixing styles and exchanging fluids like popper-sniffers at The Mineshaft – return to figuration, kitchen sink doodles, pan-global deadly dull photographs of construction sites, OCD flibbertigibbets, crystals, abstraction, anime, post-pornographic, lenticular, chewy, lowbrow,

highbrow, eyebrow – performance art has, wisely, tended to act like the vicar's daughter at the orgy; keeping her legs clamped together and her big bloomers hiked up ("No. I'm *only* into unmediated experience. Finite untrammeled intensity. Now please, go away.").

There's something contrary in me, however, that doesn't just want performance art, especially the events that we commissioned, to sit there all inviolate, and self–contained; illuminated just by historical anecdote, or the documentation, or theories formulated decades ago. I like to think that what we all did back then was important enough (not cancer cure important, for sure, or *Star Wars* digital remastering important, or Susan Boyle interprets James Galway Boxed Set Crimbo CD important) that it might resonate in the present, might have some import (and how very apt, in retrospect, that these events happened *in a museum*. I don't think we ever thought it through far enough to realize that, sexy value clashes aside, these performances would become artifacts of that institution, the equivalents of a silver-tipped rhino horn, captured and whittled at, *exotica redux*. I certainly didn't anticipate *Notes on a Return*, for instance…).

For what it's worth, I think it's both fair and accurate to recount that there were a broad series of principles back then - admittedly loose ones, context-specific, and by no means agreed upon by all – evinced by

most artists and curators (and audiences too), which tended to assume a consensus that live art was a radical art form that was anti-object, oppositional to commercial exchange, and propelled by a rocket fuel of intentionality to keep things *real*, in the moment. There was also that unmistakable sense of taboo: of proscenium arches exploded and bourgeois narrative structures shattered.

That hasn't changed since, unless I've missed something (entirely possible), but broader changes in culture have accreted subsequent layers of rider and perspective over the codas held at that time, and some of the labels we attached, *specifically about the collective memory of events and the ownership of them*, might actually be more fluid than we'd anticipated.

The performances at the Laing were experienced by those who turned up; and only thereafter in secondary formats as either still images, edited video compilations, or master material too fragile to be allowed to be viewed in their entirety by the casual or even obsessed student of the form (and it's sad that digitization funds still seem to be needed to finally preserve the entirety of the Locus+ archive). We recorded the performances on video machines the size of breeze-blocks that we lugged about back then, afraid to point the umbilical camera lens at a candle – and what did performance art have, if it did not have candles! – for fear of immolating our fragile BBC Old Grey Whistle Test tubes. The

evidence of these unique events that remains is murky and primitive in comparison with the lustrous terrapixels per nanometer that are captured on digital cameras smaller, now, than a packet of Benson & Hedges, or camera phones, and uploaded onto web sites for the potential purview of everyone. Everywhere.

"Intimate" space now means a different thing, when we can see the floss-thonged snatches of female pop singers playing peek-a-boo as they emerge onto the sidewalks of Hollywood Boulevard from their coal black Lake Tahoe SUVs (this is not an art action by Annie Sprinkle); homeless people paid in booze to fistfight each other under freeway overpasses (this is not a conceptual struggle between Iain Robertson or Stuart Brisley); or even spectators reacting to off-screen footage of two women eating shit from a cup (no, not even a Foucault essay disappearing up the fundament of its own gaze, or a Georges Bataille-inspired durational event).

And if you want to get *really* postmodern, you can log onto YouTube right now, put "Chris Burden" in your search engine, and in five seconds begin to watch a cocky youngster faux-recreating Chris Burden performances in order to take the piss, this lame pastiche seen by more casual surfers than ever turned up on Venice Beach for the original.

These frivolities are not, let's be clear, fuelled by the same impulse that made Mona Hatoum walk into a cage of objects

Richard DeDomenici
is listening to jazz
in an underground
gentlemen's toilet.

that prodded at the meniscus of her flesh, or why Nigel Rolfe suffocated himself, or why David Ward twiddled the knob of a radio receiver, a composer/vomiter of white noise, one eyebrow raised; but these memories and recordings do now exist in the same continuum, 23 years after we all sat around talking about abstract principles of cultural democratization and visceral unmediated communication.

We didn't know that "user content" so shabby and radical (and, okay, yes, let's be fair: wonderful and awesome, too, if you like that kind of thing; or just make a living, or beer money, from writing essays like this) would come down the pipeline of the Interweb; that a disposable and voracious collective memory would be constructed, grazed easily and compulsively, *existing in all points of time and space simultaneously and forever around all water coolers in all post-industrial builds every Monday morning* like a bad Damien Hirst title.

In retrospect, the performance artist's coach journey on the Rapide from King's Cross to Gallowgate, back in 1986, seems medieval in comparison now; a pre-Enlightenment pilgrimage, as undertaken by the Inquisitor Bernardo Gui in *The Name of the Rose*, all clattering hooves and inquisitorial desperation to keep the sacrosanct connections of live art within a circle of devotees, hidden and mysterious and wonderful, unsullied by those peasants who would get their hands on books and knowledge and mouse buttons, and animated smileys for their facebook pages.

The collective memory that surrounds the events of *New Work Newcastle* is tiny, minute, sub-atomic, infinitesimal in comparison to the exchanges built between colonies – nations - of strangers every second of every day in contemporary life. That may be an obvious observation, but it does make those of us who were there, audiences and curators and artists, trolling along to the Laing to see work which was intended to break down barriers and initiate a new communion... nothing less (in the academic sense) than *privileged.*

Now that we've all put our aqualungs on, and we're collectively engaged on a dive to the bottom *of everything*, the actions of performance artists in the 80s – often referred to at the time, by both supporters and declamators, as degradations – now exist in rose-tinted counterpoint to the casual debasements of the internet carnivale, the tribal hazing of outsiders via teenage cell phone Mafias, the twittering of fiercely-archived reports from people with nothing interesting to say.

The actions of *New Work, Newcastle* have been recast – fittingly, as the artists responsible for them did not then, or now, believe that art exists in an hermetically-sealed bell jar, untouched by a wider society – as far more precious than the original

freeform manner of their origination might have appeared. Their taboos and ironies, japes and rages, gestures and desires, are now quaint but radical, explicit but coy, horrified but tender. Not designed or marketed for the convenience of consumers.

In this context I can now rid myself of memory. I can see these events new in 2009, and clearly: shamanic acts for a society that was already beginning to leech itself of magic.

The title of this essay is with apologies to John Kippin. This essay is dedicated to the art critic Stuart Morgan: who knew everything important about art, and even more about honesty.

Nostalgia for the Future by Simon Herbert was first featured in *NOTES on a return* published by Art Editions North, edited by Sophia Yadong Hao and Matthew Hearn, on the occasion of the exhibition and symposium *NOTES on a return*, 9 May - 5 September 2009, at the Laing Art Gallery, Newcastle upon Tyne, UK, curated by Sophia Yadong Hao.

Performing Torture

Julian Stallabrass

The slap of a body thrown onto a floor, though 'slap' does not quite capture the quality of the sound, which is composed of the impact of something soft, viscous almost, bound in a skin with the unyielding concrete, and the crack that accompanied it, as something harder (a bone, a tendon?) broke with the impact. The body at first seems to lie still, but no, the shoulders lift and fall slightly with breath, and the floor is darkened with water, spilled from the barrel during the struggle, and spattered from the body itself. The torturer has left, a strip light starkly illuminates the small bare cellar with its barred window, and through the window faces crowd in to look down on the body.

So ended a performance, called *Confession*, by Regina José Galindo. She had travelled to Palma de Mallorca, a place which the CIA has used as a transit point for its kidnap ('extraordinary rendition') flights, where she

had hired a local bouncer, and instructed him to repeatedly force her head into a barrel of water. She would try to resist, and had told him not to be gentle. The performance would take place in September, during Palma's annual 'Night of Art', when its many galleries stay open late and hold parties for the many art-lovers that gather in the streets. It was an act to cut against the celebratory atmosphere of that event.

Galindo is a small Latina woman, strong but slight, and the bouncer a very large, very muscular black man who had the permanently pumped-up look of a habitual steroid user. Their physical struggle was entirely unequal, and while it the artist desperately used all her strength to work against him, again and again he forced her head into the dark waters. Their contest could be read as an allegory of the absurdly skewed power struggles played out between nations:

of the Iraq War, for example, in which the world's greatest military power, using the most advanced weaponry and with complete control of the air, destroyed an ill-equipped army of conscripts from a nation strangled by a decade of sanctions; but also of all those agreements on trade, privatization, 'regime change' and the law thrust on weak nations by the strong, and backed by the threat of poverty and devastation against those who say no.

A crowd of viewers gathered expectantly in the street outside. A few could look in through the cellar window but most had to be content with a large TV screen on which events in the room were relayed. The bouncer forced Galindo into the room, and their struggle began. The performance (if that is the right term, for it suggests that the artist is in charge of her actions rather than placing herself in a situation which has a structure but over which she has no control) was brief, intense and violent.

I have been struggling with words, trying to be accurate, to avoid newspaper cliché, and finding that the words that come to mind cannot do all the work that I want them to. Yet while the violence here was real, it also was artificially constrained, a pale imitation of what is conducted in similar cells across the globe by agents of our states and their allies. What is it to face such force, unbound in duration and severity, to be confined with no prospect of release, to have

no choice in when one eats, drinks or sleeps? If language alone seems inadequate to the task of sufficiently describing such situations, Galindo, with her bare, sparse actions, says something that words cannot.

Do photography and video fare any better? Galindo and her temporary torturer were not the only people in the small cell. A videographer was there to record the event, and I was there to take photographs. In most of my previous photography of performance, I had occupied the same space as the viewers, and it seemed strange to have been granted special access to the event because of the power of the lens. The purity of the event, its laudable simplicity and single-mindedness, it seemed at first, was compromised by our presence.

Yet in looking again at the Abu Ghraib photographs, or reading about the use of photographs in the interrogation sessions at Guantánamo Bay, cameras take up a darker and more sinister place than that of mere tools of documentation, held back from and not interfering with the scene. At Abu Ghraib, the torturers used cameras to document their acts, and to share their entertainment in them with other soldiers and even their relatives. The presence of the cameras also added to the humiliation of the prisoners as they were stripped, beaten, threatened by dogs or forced into sexual acts. At Guantánamo, prisoners were subjected to what their captors referred to as 'Extreme

Reaction Force' sessions in which they were severely beaten and otherwise abused by squads of guards, and these sessions were routinely videoed.[1] Printed photographs were often used as tools of interrogation, with images of scantily clad women or the victims of bombings or of the burning Twin Towers shown to and stuck to the bodies of the tortured.[2] So the privileged place of recording devices here was grimly appropriate.

Galindo has become well known for singular and what appear to be remarkably simple performances that bear directly on human rights abuses in her native Guatemala. In *Who Can Erase the Traces?* (2003), staged in the nation's capital, she walked from the Constitutional Court to the National Palace, leaving footprints in human blood, to object to the legal decision which had permitted former dictator and prominent architect of genocide, José Efrain Ríos Montt, to stand for election to president.[3] In response to government indifference to the routine murder and dismemberment of women in Guatemala and Mexico, she cut the word 'perra' (whore) into her thigh with a knife—that word being commonly found on the bodies of murdered women. She made further work about the murder of women in Guatemala by being confined in a cubicle and beating herself once for every such murder that had taken place in a six-month period (there were 279 of them), and, in another action, by having her naked body wrapped in plastic and dumped amid the garbage.

It may be that the very simplicity and apparent transparency of these actions, and their manifest connection to the grotesque political and social history of Guatemala, have both brought Galindo's work its renown and limited its resonance. Fredric Jameson, in a well known piece, argued that literature produced in Third World nations was unavoidably seen as national allegory, and some of Galindo's work seems to play knowingly to that condition.[4] So, while what is known of Guatemala's history and current condition (often dimly in the minds, for example, of Biennial goers) is brought to magnify the individual violence of each work, it is as a result too easy to put that work into a box that is labelled firmly 'Guatemala' or 'Latin America', and thus outside those places assign it to the category of the 'exotic' or 'other'. As such, its undoubted violence and power have nothing to do with us, comfortable Europeans or North Americans, just as (comments Galindo) the Guatemalan middle class were able to deny that they had anything to do with the long civil war which took place in areas of the country they did not visit, and affected people who bore the label 'indigenous'.[5]

The work in Palma had no explicit Guatemalan or Latin American reference, and, as we have seen, one site-specific element calls to mind state-sponsored kidnapping (as a prelude to torture) in

which so many states, including Spain, are implicated as accomplices. The 'war on terror' and the destruction of Iraq could not be far from the mind of those viewing the work. The barrel used in the performance had, appropriately, once been filled with oil. Yet the piece cannot be reduced to that context either, which is an implicit rather than explicit framing. After all, Galindo is simply having her head forced underwater; there is nothing so sophisticated, so delicate in conception as the current US forms of interrogation (including water-boarding) which, while undoubtedly painful and, when used over a long period, corrosive of the victim's very sense of self, are invented so as to look mild when described on paper, allowing the authorities to question the use of the term 'torture'.

Yet *Confession* seems to be more narrowly focused than merely being about power as such, about the naked force that the strong impose on the weak, men on women, and the wealthy on the poor. There is a more specific set of circumstances that links the war on terror to the situation in Guatemala and in many other places. In her extraordinary book, *The Shock Doctrine*, Naomi Klein lays out the long functional connection between neoliberal economics and torture. A policy that impoverishes the large majority of citizens while enriching a small elite can only be imposed by force, and the favoured method, certainly in large swathes of Latin America under the dictators who pioneered neoliberalism, was to murder and torture those that opposed them. Much in the treatment of detainees in the current wars would be familiar to those who have opposed the interests of the US worldwide—from Vietnam to Guatemala—for the techniques were researched and propagated by the CIA, and include hooding, stripping, beating and frequently electroshock.[6] What changed after 9-11 is that these techniques, rather than being hidden from public view, were openly defended.[7] No one in the inner circle seemed ashamed of kidnap, torture and murder, or of the bombardment of villages in the chance of killing some enemy of the state. Vice President Cheney continued to defend water-boarding in the last months of the Bush regime (after it had been outlawed by Congress).[8]

Galindo does not merely document or depict the abuse of power but repeatedly re-enacts it, in more or less mildly rendered versions, on her own body. In making such work, she stands in a tradition of art, in which political trauma is captured through work that marks the body or subjects it to pain. The US genocide in Vietnam brought about many and various acts of self-mutilation among artists, including Stuart Burden who had himself shot, and Gina Pane who, barefoot, climbed a ladder embedded with razor blades. The sign of the Communist tyrannies of Eastern Europe were inscribed

Richard DeDomenici
The 7-Eleven Extreme
Gulp is 50% larger than
the volume of the human
stomach.

by Marina Abramovic in the form of a bloody star cut into her skin (and this bears direct comparison to *Perra*, of course). André Stitt developed an art of physical hardship and self-harm amid the low-level civil war in Northern Ireland. To mark one's own body is the most evident way of expressing one's pain and sense of complicity in what is protested against: it is the clearest possible sign of internalisation. It is also the mark of the guilt of the privileged, protected by status, by exile and even by the status of art from the worst that the state can do. At the same time, such work points in two directions—towards a cathartic enclosure and control of the knowledge of oppression so that the individual can register, limit and handle it, and also outwards to a collective expression of what is hidden or downplayed in mainstream political discourse. [9]

Galindo is clearly continually haunted by the terrors undergone in her country, and particularly with the plight of lower-class women there, and once one begins to pull on that thread (as with so many others that appear to affect specific identities or classes of people) one finds that it is connected to a global web of oppression and calculations of profit-and-loss. Mark Wallinger remarked of the anti-war activist Brian Haw (whose protest installation he meticulously remade after it had been removed by police from Parliament Square) that an extraordinary thing about him was that he had chosen to live every moment with the pain of the Iraq War, waking each day surrounded by the hideous photographs that he had collected of the mutilated.[10] Wallinger, in his remaking, necessarily had to do the same for a while. Thomas Hirschhorn, in his work of the last few years, has lived in similar proximity to images of terror, working on, rearranging and composing the worst photographs of the effects of modern munitions on bodies. I remember, years ago, hearing Edward Said speak about the dreadful conditions of Palestinians living in Gaza, and confiding in his audience that, because of the invasive thoughts of all he had seen, he could no longer sleep. And surely, even more in these times, when so many of our governments are active or at least complicit in the panoply of techniques employed against 'terror' from the destruction of entire cities to the threats against children to extort cooperation from their parents, it must be a question for us all: how can you sleep?

Performance and photography share a number of affinities. Each regularly addresses the viewer through an insistence on the social and political importance of a person's presence and actions at a scene. Where performance may mark the body with traces of the action (scarring for example), the photographer's fascination with such marking is due to it being, like photography itself, a pattern caused by the direct action of a physical force on a surface.[11] The blade,

like focused light, traces its own shape. Scars, like photographs, are patterns that tie the process of mark-making to the stimulus of memory. Galindo's insistence on the importance of recovering memory in the face of the amnesiac forces of the dictators and of capitalism is shared by many Latin American writers and artists. When asked to comment through a work of art on the current condition of Guatemala, she graphically illustrated this concern by taking 10ml of valium, which rendered her unconscious. Photography and scars may stand on the side of memory against drugs, arbitrary violence and the enforcement of silence. Photography and video, aside from being the regular documentary tool of performance, have a fraught double alliance with the current regime of oppression and with resistance to it.

Yet lenses had another role to fulfil. The performance was arranged by a commercial gallery, La Caja Blanca, which at the same time staged an exhibition of Galindo's work on video and in photographic print. The photographs shown exhibited the conventional qualities of museum work. In their serene, seamless high-resolution surfaces, Galindo's often naked body underwent various abuses. One might think that there is a mismatch between performance and saleable product, in which the clean lines of the artist's body and the clarity of the print take on neoclassical connotations, in a measured and restrained beauty snatched from the flux of violence.

What are the wealthy buying in their materialized portions of light? Insofar as her work is not merely about Guatemala but about the neoliberal system as a whole, they buy a fragmentary reminder of their own place in that system and the structural conditions of exploitation that maintains them there. If the soft thrill of that realisation is permissible and saleable, it is because the forces of opposition seem so weak and threaten no substantial change. They can be framed physically and conceptually, parcelled up, and hung on a living-room wall—a comforting and sublime reminder, through contrast, of the safety and security of their owners, cosseted as they are from contingency by rolls of money.

Galindo, too, appears to think that her art has no power to change things: 'I do not believe that art can change the world. The problems that cause the injustice must be addressed.'[12] She is not alone in this, and we may compare similar statements from artists whose work has a similarly sharply cutting political edge (for example, Santiago Sierra).[13] Yet, there is an obvious puzzle about such statements. Why act out on your own body the violence done to others if you really expect it to have no outcome? What is it in the art world that makes such disavowals so common? The entire ethos of the art world is set against the idea that art should have

a use, least of all a political use. To suggest such a thing is to deprive artist and viewer of creative and interpretative freedom. It would amount to a declaration that what is looked at is not art. In addition, the constitutional individualism of the art world stands in plain opposition to the collective character of effective political action: Galindo may hope to make collective her internal trauma of living with the knowledge of the pain of others, but the art world celebrates above all the distinctiveness of her decisions as an individual to realise particular works of art, the way in which she occupies a position at least a little different from everybody else.

So is *Confession* condemned to remain merely the work of an exceptional individual, and a barbed piece of entertainment for the well-heeled art lovers of the 'Night of Art'? Compared to the torrent of propaganda that issues from the PR organisations of the state and the military, and which is for the most part faithfully reproduced in the media, the resources of any art are certainly feeble. Yet there comes a time (as even those administrations which are the boldest in their lies and glory in their shamelessness discover) when propaganda breaks up against reality, and when sustained oppression produces sustained opposition. An increasingly polarized and dangerous political situation has produced a reaction even in the art world, so that Galindo's work is not isolated but takes part in a broader

wave of 'political' art, in which some of the dearest held and most fundamental of art-world beliefs come under pressure, in particular in the identity struggles played out in the war on terror. That broad front of work has already helped to produce an effect over the cultural-political-economic elite to which the art world mostly speaks, which has turned against neoconservatism in foreign policy and neoliberalism in economics.

Galindo did an interview with the remarkable novelist Francisco Goldman, another ally of memory.[14] Goldman said that Guatemala, aside from its long history of political trauma, has also recently suffered a terrible hurricane, and asked what the nation had done to deserve so much misfortune. Galindo replied:

> Perhaps the proper questions would be: What *haven't* we done? Why have we been so afraid, and tolerated so much fear? Why have we not woken up and taken action? When are we going to stop being so submissive?[15]

This question, 'what haven't we done?' is one that Galindo's work keeps asking of its viewers, and it is a question that should be heard far beyond Guatemala, not least by the citizens of those states most involved in manufacturing neoliberalism and the war on terror, the US, the UK and even Spain.

Notes

1. David Rose, *Guantánamo: The War on Human Rights*, The New Press, New York 2004, p. 74.

2. See Philippe Sands, *Torture Team: Deception, Cruelty and the Compromise of Law*, Allen Lane, London 2008, pp. 8, 12-15. This book also contains extracts from the interrogation logs of Mohammed al-Qahtani, which make frequent reference to the use of photographs.

3. Montt had been found guilty of genocide by the UN-backed Historical Clarification Committee in 1999, Guatemala's version of a truth and reconciliation process. While he was permitted to stand for election, he lost. See http://shr.aaas.org/guatemala/ceh/mds/spanish/toc.html

4. Fredric Jameson 'Third-World Literature in the Era of Multinational Capitalism', Social Text, vol. 15, 1986, pp. 65–88.

5. Viviana Siviero, interview with Galindo, in Regina José Galindo, Vanilla Edizioni, Albissola Marina 2006, n.p.

6. Naomi Klein, *The Shock Doctrine: The Rise of Disaster Capitalism*, Allen Lane, London 2007, p. 41.

7. Klein, Shock Doctrine, p. 43. Electroshock is the exception here, for while it is certainly being used, it is not publicly defended.

8. Ed Pilkington, '"I think we've done pretty well." Cheney has no regrets about eight years in office', The Guardian, 17 December 2008.

9. Galindo has said that she tries to channel her own pain and energy in the work to make it something more collective. Francisco Goldman, interview with Regina José Galindo, BOMB Magazine, no. 94, Winter 2006. See http://www.bombsite.com/issues/94/articles/2780

10. Yves Alain-Bois, Guy Brett, Margaret Iversen and Julian Stallabrass, 'An Interview with Mark Wallinger', October, 123, Winter 2008, pp. 180-204.

11. See Patrick Maynard, *The Engine of Visualization: Thinking Through Photography*, Cornell University Press, Ithaca 1997.

12. Marjan Terpstra, "Guatemala is violent, and so is my art", interview with Regina José Galindo, The Power of Culture, May 2008: http://www.powerofculture.nl/en/current/2008/May/galindo

13. "There is no possibility that we can change anything with our artistic work… I don't believe in the possibility of change. Not in the art context, not in the reality context." Cited in Katya García-Antón, Santiago Sierra: Works 2002–1990 exhibition catalogue, Ikon Gallery, Birmingham, 2002.

14. See, for example, Francisco Goldman, *The Ordinary Seaman*, Faber and Faber, London 1997.

15. Francisco Goldman, interview with Regina José Galindo, BOMB Magazine, no. 94, Winter 2006. http://www.bombsite.com/issues/94/articles/2780

Performing Torture by Julian Stallabrass
was originally published by *La Caja Blanca* as part
of a monograph on *Confesión*, a performance by
Regina José Galindo commissioned by La Caja
Blanca gallery in 2007. The original book features
a text and photographs by Julian Stallabrass, and
was written in 2009.

The untimely, shady death of Michael Jackson

Paul Morley

As soon as he was gone, he was everywhere, regaining a flashy, bewitching agility he hadn't had since the early Eighties when he really was a kind of king. He was everywhere, and everyone had something to say, even if they didn't really know what to say. As soon as it was clear that he was really dead, and that it was now Michael Jackson 1958-2009, the instantly surreal truth being obtained and announced not by a traditional media outlet, but by a furtive, deadpan celebrity website, a whole host of Michael Jacksons was released into the air.

The loved Jackson, the gloved Jackson, the wealthy Jackson, the bankrupt Jackson, the Motown Jackson, the moonwalking Jackson, the MTV Jackson, the despised Jackson, the genius, the mutant, the addict, the oddball, the victim, the black, the white, the creepy, the glorious, the narcissist, the pathetic, the gentle, the monster.

You could take your pick as to which Jackson you want to remember, which version of the monster, or the genius, or the dissolving man behind the mask. He was everywhere, but now that death had returned his full transfixing powers as a spinning, gliding master of self-publicity, any truth about who he really was and what he'd been up to was shattered into a thousand glittering pieces. Once we stayed up late to watch the exciting premier of the Thriller video. Now we stayed up late to watch another form of extraordinary choreography intended to turn one fascinating, paranoid, fiendishly otherworldly entertainer into an immortal.

The crazed rush was on to try and fix just one Jackson in place; the trailblazing star, or the abused innocent, the loneliest man alive, or the greatest entertainer of all time. The uneasy combination of frantic web action and obsessive, hasty, flamboyantly superficial

news coverage meant it was possible to witness a certain sort of immortality start to take form. The tweeters, the websites, the pundits, the acquaintances, the impersonators, the colleagues, the hangers-on, the fan club members, the newsreaders, the correspondents, the international celebrities all performed their duties so obediently that the whole event seemed to follow a script with the full approval of Jackson. (Imagine how well he's planned the funeral.)

It was immediately clear that the nature and timing of this end had been coming for such a long time. Even while the whole thing was disconcerting and in the middle of it all someone had actually died, it was also the most obvious thing in the world. Now that it had arrived, this punchline to all the scintillating music and living, seedy chaos, everyone knew their place, as if Jackson's final mortal act as extreme self-obsessed entertainment illusionist was to ensure that the news of his death was itself a kind of glittering if slightly tawdry spectacle.

In those first remarkable moments, death had allowed the myth of Jackson to surge into life, and his career got the focused injection of publicity he had recently been unable to generate consistently without dangerous self-sacrifice. The 24-hour news channels couldn't believe their luck, all this archive, tension, scandal, revelation, mourning, scorning and gossip. Jackson played a massive, needy part

in shaping an entertainment universe which now largely consists of constant gossip about the antics and eccentricities of damaged celebrities, and his death was confirmation that the presentation of round-the-clock news certainly when it comes to popular culture is little more than formally presented, gravely delivered, hastily assembled tittle tattle.

Everything had been destined to lead to this untimely, shady death, and once that death arrived, a certain kind of natural order was established. Jackson was where he'd been heading all along - a sudden tragic end, a twist of mystery, a sad, final trip low across the LA sky to the coroner's, coverage that seemed in part pre-recorded ready for the big day.

The whole thing concluded the only way it could - in a resounding blast of grotesque but compelling publicity for a figure who had become all that he had become - the king and the imprisoned, the adored and the humiliated, the accused and the indulged - because of publicity. Jackson had been publicised to death. As soon as he died, the response came in the form of pure publicity, an almost relieved acceptance that finally the damned thing had at last been resolved.

He was no good to us alive, falling apart physically and mentally, making repeated attempts to repair his image and reputation, reminding us again and again that the neurotic energy, dangerous perfectionism and desperate ambition he'd turned into

Richard DeDomenici
anticipates that the
death of Michael
Jackson is going to
decimate London's
secondary concert
ticket market.

dazzling, video-age show business had eventually turned back on him and started to eat him up.

There was only one real way to rescue Jackson from the enduring pain of decline and reclusiveness. It wasn't going to involve taking on 50 dates at the O2 Arena, and no doubt revealing a poignant lack of wit, speed and power, and escaping to exile after a couple of disastrous shows.

When he was alive, it was never clear quite how to approach the perverse, shape-shifting, scandalous, ruined, faintly repulsive idea of Jackson, how to deal with the transformation from irresistible child star to weird, shattered, self-pitying, fallen idol. Dead, in acceptably mysterious and fairly dubious circumstances, he has joined those he loved and admired for their life-after-death adventures - Garland, Dean, Monroe, Presley, Lennon, Diana - and because one of the many Michael Jacksons seems to have had the kind of pointless, chaotic fame that we now think of as being the result of time spent on reality television, there's another chain of celebrity disaster he also belongs to that drops all the way down to Jade Goody.

It was the loony, minor celebrity element in late-period, now final-period, Jackson - a celebrity Big Brother appearance, even a pantomime, would have been more beneficial than all that demanding singing and dancing he was facing - that actually helped give his death something Presley's and Diana's

couldn't have. An element of the busy, hustling, hyper, self-aware 21st century, as reflected by TMZ, Fox, Perez Hilton and Google.

He'd hung on long after parts of his mind, business and body were falling off, but his sense of timing was in the end immaculate. He sprang to life in the Sixties, got himself into position in the Seventies, was anointed in the Eighties, started to disintegrate, and then hung on for dear life until the media and the web were in the right ever-vigilant, tabloid-minded, freakishly amoral, multi-channelled, search-saturated, tweetist state properly to cover his death with the correct combination of pomp and prurience.

The media had become as bizarre in its obsessions and anxieties as Jackson himself. The cultural stars were in alignment. Even as he lost ultimate control he somehow took absolute control of the coverage of his life and death, disappearing behind hundreds of versions of himself, now always in our lives whether we liked the idea or not. He had been disgraced as a living legend, but death had given him back, one way or another, the kind of grace he craved. The grace that comes when your fame, and your name, cannot be taken away.

The untimely, shady death of Michael Jackson by Paul Morley first featured in The Observer online. 28 June 2009. http://www.guardian.co.uk/ commentisfree/2009/jun/28/michael-jackson-death

The Disabled Avant-Garde

Aaron Williamson

Richard DeDomenici is monetising the outpouring of grief: http://dedomenici.blogspot.com/2009/06/touched-by-michael-jackson.html

THE DISABLED AVANT-GARDE TODAY!
Gasworks Gallery, London /
September – October 2006

Katherine Araniello and I were commissioned to make a collaborative exhibition at Gasworks Gallery in Vauxhall, London. We decided to form a fictitious organisation, of which we are only two members: the Disabled Avant-Garde (DAG). The title of this exhibition satirically suggested that the show would update the work of this organisation to 'Today!'. (The exclamation was added as a nod to all those disability art schemes, projects and shows that feel the need to stress their upbeat nature).

Whereas other 'oppressed/ minority' social categories have had avant-gardes (black art, gay and lesbian, transgender, feminism etc), an avant-garde made up of disability artists is difficult to historically identify or even conceive of. There have been individual artists who made work explicitly about their disability in dialogue with avant-gardeism (Frida Kahlo and Jo Spence being frequently cited examples), and a list of historic avant-garde artists with impairments would be lengthy, from Van Gogh on, and taking in many names on the firmament.

However, the disability art movement itself (i.e. of the last 30 years or so) would appear to be deeply resistant to avant-garde art. The intellectual argument for the social inclusion of disabled people in society, (with its stress on access), is institutionally acknowledged and reflected in political bills and legal acts which slowly crawl closer to being effective. Recognising the intellectual inarguability of the case for socially including disabled people (whilst not necessarily effectively answering it), the

main art institutions are politically beholden through a regime of tick-box quotas to represent this social caucus that includes one in every eight people in society.

Thus, disability politics and art are quite significantly institutionally-led and much public funding, since the 1990s, has been apportioned to arts/social agencies and organisations whose mission has been to build and maintain an infrastructure of workshops, event listings, gallery talks and so on. Because of this, disability politics and art have evolved a deeply symbiotic relation to the funding institutions that might be described as a 'top-down' structural relationship. Perhaps, as a consequence, the nearest disability politics has come, to date, to producing its own Suffrage, Stonewall, or Watts Riots, (in the UK at least) was a fracas at a protest against 1993's Telethon Charity Appeal outside the ITV studios on London's South bank.

Whilst Araniello and I are both passionate advocates for the social inclusion of disabled people through the provision of access, we are also enthusiasts of the historic avant-garde and identify ourselves with contemporary creative innovation and experiment. Thus, we felt that the very notion of a 'disabled avant-garde' would be both resonant and problematic. (Indeed, responding to our name, the artist Yinka Shonibare commented that a disabled avant-garde would also represent the *last avant*

garde, since disabled people are the minority that is furthest away from being included in all societies).

For our inaugural show then, Araniello and I decided to make work that purported to pay homage to our formative 'avant-garde' influences. We decided to do this through continuing the satirical note in our name and to identify an entirely fictional and ludicrous canon of 'avant-garde heroes' that included Tom & Jerry, Karlheinz Stockhausen, Simon & Garfunkel, Martin Kippenberger and Busby Berkeley. A slyly absurd gesture, our establishment of a 'disabled avant-garde' would be founded on homage to our canon in ways that would represent a satirical, intervention into avant-gardeism itself (a gesture that couldn't be more avant- garde anyway), but informed by a politicised disability perspective.

Over the course of a month or more, Araniello and I worked in a blue screen studio, building up performances to camera with our Personal Assistants Marja Commandeur and Chloe Edwards doing camera work, props and make up. The resulting films were then edited by Katherine using separately filmed backdrops to comically foreground the actions we'd developed.

Both the selection of the artists we paid homage to and the films themselves, humourously played up to stereotyped perceptions of disabled people by revealing

Richard DeDomenici is urgently appealing for everyone to donate their spare pornography to The Home Office, 2 Marsham Street, London, SW1P 4DF c/o Jacqui Smith.

a taste for childlike playfulness, raw primitivism and cod-pathos.

From the exhibition notes for 'The Disabled Avant Garde Today!':

Leigh Bowery's macabre and shocking creations – half human, half monster, half fashion mannequin – have become better known in recent years through Boy George's musical. The DAG relate to the monstrous element in Bowery's work and dress up in the style of their hero to spend an evening chez nous, watching videos of Leigh whilst swilling champagne, smoking fags and staying up really late. Part of the formal design of this piece was to incorporate a couch manner and to grunt and hiss whilst watching, (and sometimes mimicking) Bowery on a TV while the walls of the room explode with spinning patterns.

Tom and Jerry: in this piece the DAG's frequent use of 'blue screen' filming and technology reaches its apogee in a cartoonish, slapstick homage to their 'cat-and- mouse' heroes. Traditionally, cartoons and animation are considered to be very accessible to both children and disabled people. Here, the DAG perform a hilarious chase through their 'Mama's' house, bumping into cartoon furniture and whacking each other with pots and pans. The anthropomorphic appeal of cartoon characters, again, takes on new resonance through the 'filter' of disability: compare this knockabout, no-holds-barred romp with the careful tiptoeing around disabled people in real life, treating them with kid-gloves and avoiding at all costs, causing any offence.

Busby Berkeley: the DAG lacked the kind of budget that would have seen us pay full and worthy homage to Berkeley's florid mass choreography. However, we were filmed performing a would-be intricate choreographic piece around the Busby-ish fountains in Trafalgar Square (the site, at that time, of two statues of disabled people). The dance was carefully devised and structured so as not to be too obtrusive and, thus, detected by the Square's highly vigilant security guards. A plan to emulate Busby Berkeley's aerial shots of his dancers, by filming from the roof of the National Gallery had to be abandoned but the camera is still quite high up sometimes in this piece.

Simon and Garfunkel's most famous song 'Bridge Over Troubled Water' has given solace to many people who find themselves in traumatic circumstances, including disabled people. The song is a metaphor for the kind of support and help one discovers through friendship when surrounded by 'troubled water'. The DAG, having no time for bitter tears however, update the moral of the song by performing in the guise of Little Red Riding Hood and the Wolf serenading each other. This demonstrates a chin-up, 'disabled' optimistic outlook on life – a belief that unlikely alliances based on mutual trust

can be formed through the harmonising influence of music and creativity.

Karl-Heinz Stockhausen's 1956 piece *Gesang der Jünglinge* (Song of the Children) analysed song verses into their elementary phonetic components and deployed electronically generated aperiodic sound – more commonly known as 'white noise'. The DAG also generate white noise in this piece by varying the sync- waves produced by a loudly whistling boiling kettle. As with Stockhausen, a vocalist intones 'inside' the white noise (but using a different song – something by Roy Orbison). The total effect produced is to provide the listener with no idea whatsoever of what it must sound like to be profoundly deaf.

The Chapman Brothers have been exploring issues of body dysmorphia for many years, using shock tactics and confrontation in their work to effect an entirely 'physical' response to inert sculptures. They have also responded to disabled artists in the past, such as Goya. Here, the DAG re-imagine their own collaborative relationship through that of the famous brothers. Uncanny parallels are explored: why is one more dominant than the other? Why do they fall out so badly? Perhaps argumentativeness can be central to artistic creation as well as often being projected onto 'bitter' or 'ungrateful' disabled people. This construct of the 'twisted cripple' is given cathartic recognition in the disturbing physical impairments depicted by the Chapman Brothers.

Martin Kippenberger's late paintings developed a process in which crudely worked 'quotational' images (of products or famous people) are juxtaposed with seemingly random phrases and slogans. Similarly, the DAG quote freely from 'prize-winning' crayon drawings that were entered into competitions by disabled people that they discovered on the internet, re-drawing them and heavily treating them in ways that don't necessarily improve on the originals. The images were then juxtaposed with overlaid words and phrases lifted from internet porn sites.

The Arts Council of England funded this exhibition as part of the 'Adjustments' scheme in 2006.

ASSISTED PASSAGE
The Disabled Avant-Garde
Performance: 2 hours
Birkbeck College, SOAS, London /
November 2007

This was a collaboration with Katherine Araniello as the Disabled Avant-Garde in answer to a commission from The School of Oriental and Asian Studies (SOAS) and Birkbeck College's 'Diversity Week' to create a public performance. Katherine had previously made a short video piece titled *Suicide Message on Valentine's Day* in which

she pretended to be going to Zurich for an assisted death. Developing that piece into a public performance, we set out to deploy the cunning of Jonathan Swift's *A Modest Proposal*, 1729, (that satirised England's mistreatment of Ireland), by adopting its tactic of sustaining irony in order to draw out a response from the public and thereby reflect the depth of 'normal' prejudices about (or pity for) disabled people.

SOAS and Birkbeck College have a long tradition of student protest and petitioning; one spot between two trees, directly in front of the entrance, is staked out most lunch times by student activists distributing newspapers or collecting signatures for one cause or another. On the fringes of this activity lurk recruiters for religious cults such as the Hare Krishnas and evangelical Christian groups.

Here, in line with the other protestors we set up our table costumed as two 'charity beggars' (or 'medical-model cripples'), all biros, badges and drab-duds chic. Katherine was wrapped in blankets and a woolly hat while I wore a deadbeat anorak and peak cap, brandishing an inoperative megaphone. All around us we pinned up leaflets and posters rendered in a crude 1970's agitprop style that blared: 'BANNED FROM THE CLOUDS!' and 'SMASH THE BUDGET AIRLINES!!'

The performance took the form of me imploring the public to sign a petition while

Katherine mugged forlornly on, interspersing my shouting with pathetic mewlings to 'please help, please!'. Superficially, the petition seemed to be a protest against budget airlines such as Easyjet and Ryan Air. We had organised several candid cameras to capture the baffled-yet-concerned responses of passersby: was the protest something to do with the airlines' policies on flying disabled customers? Katherine and I systematically muddied the waters:

> Me: (shouting down the broken megaphone, thereby revealing my deafness): 'WHAT'S YOUR POSITION? SIGN THE PETITION! EVERYONE HAS THE RIGHT TO FLY!'
> Katherine: (much softer) I want to fly to Zurich to end my life.

The curious were drawn in to inspect the text on the table which fictionally recounted how the budget airlines have banned Araniello personally since she is on a list of people who are 'self-dangerous'; wanting to fly to Zurich to attend a clinic for an 'assisted death'. According to this text, she has been personally blacklisted by the airlines since she wishes to conduct an illegal activity (in the UK) and her passport number cannot be used to fly with.

Behind the fictional protest against the airlines' treatment of disabled people, then, the public was actually being asked

to support Araniello's right to purchase a flight to attend her assisted death. My role was to play devil's advocate/ angel of mercy, haranguing the public with ridiculous chants like 'What do we want?

Assisted Passage! When do we want it? NOW!'; whilst Katherine heart-rendingly posed as a pitiable outcast/ case for euthanasia.

The performance was conducted as an experiment: we had no idea whether or not the College's milieu would agree to sign the petition or take heated exception against us; or perhaps they would rumble that we were being satirical? Nonetheless, we achieved 37 signatories in support of our 'cause'. Since the petition sheets clearly stated that the 'assisted passage' referred not only to Katherine's right to fly but also to die an assisted death, presumably our supporters had read the text.

We were frankly shocked that a significant proportion of our audience took all of this 'protest' at face value, either missing the dark twist in our ostensible cause or choosing to agree with it anyway. The performance ended with us slipping into absurdity, singing verses of 'She's Got a Ticket to Die' and 'Somewhere over the Rainbow, Bluebirds fly / Birds fly over the rainbow, Why oh, why can't I?'

THE DISABLED AVANT-GARDE'S CHARITY STALL
Performance: 6 hours
The Art Car Boot Fair, London / June 2008

Billing ourselves as 'the World's Leading Disability Art Pranksters', Katherine Araniello and I managed to cadge a stall at London's main independent art-selling event of the year. The scrum for Peter Blake's prints, Gavin Turk's 'actual-car-boots' signed at a grand each, Edwina Ashton's ice-lollies and owls stall: the art car boot fair milieu has seen it all.

But they hadn't seen a 'disability charity stall' before. We tried to strike an atmospheric balance between the burlesque and that peculiar gloom that tends to descend upon philanthropy. A grim set of old hospital curtains (that must have shielded so many unspeakable sights before), formed the backdrop, emblazoned with Party-Shop lettering of our name.

A prominent sign claimed that the produce on the stall – school-pottery ashtrays, re-labelled jars of supermarket jam, minimalist embroidery and scribbled 'life drawings' – had resulted from a series of art-therapy classes and that we were raising funds to continue this much-needed programme. Faked documentary photos depicted us in a pottery class making the ashtrays, roughly sewing the acronym 'DAG' onto hankies, and 'making jam' together.

Brian Lobel thinks all
his friends are working
a bit too hard. That's
what you get when
you find hard-workers
attractive as friends.

The centre piece of this display was the 'life drawing' class' documentation. The artist Jordan MacKenzie, had modelled for us while we posed for photographs brandishing very large pencils, one strapped to my ear and the other to Katherine's chair in homage to the disabled 'foot-and-mouth' artists that create sentimental greeting-card pictures of kittens and snow-bound landscapes using those parts of their anatomy. Having posed for the important bit – the photos – we then spent an hour or two with another artist Oriana Fox, scribbling 200 drawings, each which would be for sale on the stall with an attached photograph of the drawing class.

Most visitors to the stall seemed to take the 'charity stall' at face value. Katherine had her Chihuahua dog – Lucy – and, since so many visitors to the stall requested to stroke the dog, we spotted an opportunity and charged 50p a time. I had my enormous pencil strapped to my ear as an illustration of my 'life drawing method', and greeted visitors to the stall, quite fruitily: 'Hello! Here is our information!' and pointing to a sign that spelt out the 'art therapy' premise/ nonsense.

The reactions to the stall – we decided – formed the gist of the work and it became more of a performance as the day went on and we garnered a rather baffling range of responses and sold a fair amount of product. Beforehand, Katherine and I had debated how obviously a sham the charity stall needed to be for people to 'get it' and in fact, we were curious to identify just how far we could stretch credulity. Posthumous documents – we had assistants candidly filming the stall – would evidently reveal the ruse, but over the course of the day, as hard as we pushed the absurdity (a mirror topped with fake cocaine and a credit card was strategically placed in full view), people seemed both mildly baffled, and yet also believing.

The history of art often consists in recounting a series of gestures that challenged the viewer to look closer than surface appearance: to analyse the actual image they're presented with. Clearly the critical faculties of many spectators from 'London's artworld' at the Art Car Boot Fair were stymied by the spectacle of two crips at a charity stall trying to push obviously re-labelled supermarket jam and other bogus ephemera.

The Disabled Avant-Garde written by Aaron Williamson concerns his collaborations with Katherine Araniello and first featured in *Aaron Williamson: Performance / Video / Collaboration* published by the Live Art Development Agency and KIOSK 2008.

Richard DeDomenici is walking in the footsteps of JG Ballard: http:// dedomenici.blogspot.com/2009/04/ walking-in-footsteps-of-jg-ballard.html

Pina Bausch's influence on the world of dance

Alistair Spalding

Earlier this month, from all over the world, the tributes and eulogies flooded in following the sudden death of the choreographer Pina Bausch, endorsing her position as one of the greatest and most important figures in the arts since the second world war. But the reality is that while she was alive and presenting her work at Sadler's Wells, over the past 10 years, the critical reaction here was often less than enthusiastic, and many of the British obituaries still qualified the importance of her art by defining it as dark and inaccessible.

The fact is that many commentators were philosophically against what she was doing to what they saw as "their art form". They railed against her allowing dancers to speak on stage, to carry out bizarre rituals between lovers, to create work that didn't follow the normal rules of narrative and sometimes involved very little actual dancing. This can

best be exemplified by the wildly differing reactions to her double bill of Café Müller and The Rite of Spring at Sadler's Wells in February 2008. The Rite of Spring, Bausch's pure dance interpretation of the Stravinsky score, was universally praised, whereas Café Müller, the work that was one of the first manifestations of her Tanztheater aesthetic, was damned as "tiresomely obscure". Café Müller is indeed a dark piece, but its ghost-like figures, inhabiting a bar long after the last customers have left, touch parts of the subconscious that you find yourself processing well after you have left the theatre.

This tendency towards conservatism in the UK is nothing new, of course. Last century, the innovative impresario Diaghilev was reluctant to bring either of the great Ballets Russes "shocks of the new" — The Rite of Spring and L'Après-midi d'un faune —

to London, but rather kept them for the much more adventurous Paris scene; and it is no coincidence that the work of Bausch has been shown in Paris annually for the past 30 years, as opposed to its relatively rare sightings in London. The bottom line is that what can be broadly described as European-based dance theatre has always struggled to find acceptance in the UK, the critics preferring on the whole the less controversial minimalism of the Americans.

This is a pity, as Bausch and others who have followed in her tradition have shown the world what can be achieved in dance, and have provided new narratives to replace those of the outdated 19th-century ballets. Her inclusion of techniques from other disciplines — predominantly the use of speech — has opened up the art form and boosted audiences; and it is because of her that dance is uniquely placed to articulate some of the complex issues that surround us right now. If not for Bausch, we wouldn't have the poignant and moving duet Zero Degrees that Akram Khan and Sidi Larbi Cherkaoui premiered at Sadler's Wells in the summer of 2005. This short piece of dance theatre spoke to us eloquently about the displacement so many second- or third-generation immigrants feel, both in this country and when they return to their ancestral cultures. Could these issues have been dealt with so directly in a play, opera or novel? I would say not.

Without Bausch's influential love of unsettling decor, the Sadler's Wells stage would certainly have been a less interesting place over the past 10 years — we would not have seen 14 dogs roaming free in Alain Platel's Wolf, the bricks would not have been flying precariously over the heads of the dancers in Wim Vandekeybus's company, and we wouldn't have seen Sasha Waltz's dancers swimming so beautifully in giant tanks at the beginning of her version of Dido and Aeneas.

Interestingly, this negativity towards Bausch and some who have followed in her tradition has not stopped audiences flocking to Sadler's Wells to see the work. I believe dance theatre is one of the main reasons we are seeing the current rise in the popularity of the art form.

Dance has always been the discipline most willing to open itself up to collaboration and has positively benefited from it. The sculptor Antony Gormley's involvement in Zero Degrees, and more recently in Cherkaoui's Sutra, went much further than providing a setting or sculptural backdrop. The devices he created on both occasions (life-size dummies of Khan and Cherkaoui in Zero Degrees, and 21 wooden boxes for the dynamic Shaolin monks in Sutra) provided the perfect vehicle for the narrative to flow in those pieces.

This fertile fusion of approaches is the reason for the huge growth in interest in dance, and you can find it on all fronts, from

Wayne McGregor's collaborations with the artist Julian Opie and the architect/designer John Pawson to much of the work being staged currently at Manchester's International Festival, where theatre has joined forces with television, architecture and classical music. As part of Sadler's Wells' year-long focus on the choreographer William Forsythe, we recently staged Decreation, a complex and multilayered work that showed not only what is possible in dance, but what can be achieved on any stage, being at the same time a dance, a contemporary opera, a piece of theatre and an art installation.

Here, in the form of contemporary dance, we are experiencing the future of art. Its practitioners, in particular, seem not to be weighed down by the history that paralyses classical ballet, for example, which is struggling to find a way of making narrative that speaks to audiences now. So I salute you, Pina, and I thank you for being the catalyst for change that is so needed in the development of any art form, even though it may not always have gone down so well. But then no artists who really caused a revolution of this kind were ever truly appreciated in their lifetime. Perhaps you will be now.

Pina Bausch's influence on the world of dance by Alistair Spalding first featured in the Sunday Times online. 19 July 2009. http://entertainment.timesonline. co.uk/tol/arts_and_entertainment/stage/dance/ article6716233.ece

The tears of things (for Pina)

David Williams (UK)

'I'm not interested in how people move, but in what moves them ... We are very transparent. The way somebody walks or the way people carry their necks tells you something about the way they live or about the things that have happened to them. Somehow everything is visible - even when we cling to certain things ... Everything I do is about relationships, childhood, fear of death, and how much we all want to be loved' (Pina Bausch).

In no particular order, some images, culled from a reservoir that has coloured and buoyed my imagination for 20 years or more. These (and others) are indelibly etched into my psyche, and they proliferate and animate still: in my 20s and 30s, this work changed everything for me ...

A group of women scurry across a leaf-strewn floor in pursuit of a man who plays the same short extract from Bartok's *Bluebeard* on tape. Rewind, replay, shuffle. Later, a slow somnambulist dance of partners, the women bowed and passive, their faces hidden, the almost-naked men masquerading their bodies - performing body-building poses to the audience, displaying them to both comic and alarming excess.[1]

A woman in her underpants walks through a field of carnations playing an accordion. Around the edge of the field, guards patrol with alsatians on leashes. Later, Lutz Forster 'signs' the Gershwin song *The man I love*. Comedy and pathos in this overlaying of nostalgic heterosexual song and signing. The overlay doubles and re-doubles the song's lyrics, making them un-familiar and re-writing them. The male body mimes and 'tells' - through an iconic corporeal discourse of a possible love to which a dominant ideology is metaphorically 'deaf'. Forster himself is both source and site of the narrative, and detached from it, consciously

Richard DeDomenici
to Bus Driver: 'Do you
go to the University of
Essex?' Bus Driver:
'Nah, I'm too thick to
go there'. Discuss.

showing/displaying it to us. [2]

A group of besuited men repeatedly touch a solitary woman (Meryl Tankard) like a child - pinch her cheek, tousle her hair, pat her. Cumulatively over time, their actions constitute a kind of rape; intimate, patronising 'affection' is defamiliarised through repetition to reveal the shadows this infantilising tactile economy suppresses.[3]

Two dinner-suited men, smug, self-congratulatory, mask-like smiles, posturing an image of suave gentility, wealth, sophistication. Then they squirt or dribble little fountains of champagne from their mouths - straight up, splashing down over their faces and suits, 'wetting themselves', like children. A kind of critical comic display of the infantile drives that underlie and inform their masquerade.[4]

An environment of towering, bristling cacti, peopled by a discontinuous dream-like array of figures. Couples waltz. Passers-by pass by. A woman in bra and pants hangs immobile and upside down, her body apparently suspended from a cactus's spikes. A man force-feeds a woman, like a goose, coercing and constructing her; she lies inert. A man in a balaclava wheels another woman around the space in a glass tank of water; it's uncertain whether she has drowned or is dreaming, her body literally floating through space. A man in a skirt, shades and a leather jacket dances alone. A woman with two black shoes in her mouth struggles repeatedly

to lift herself from the floor. A blindfolded man dances alone, a tea bag held over each eye by a red cloth, his partner a tea towel. Then there's a dancing pantomime walrus, and a group standing as if ready for a rather odd family portrait: a masked woman (one of those 2-dimensional Victorian paper cut-outs sometimes used for parties); two others beside her, their hats suspended above their heads, as they wriggle to fit inside them; and a slumped woman on a chair in front, her hair covering her face. [5]

A man struggles across a field with an enormous wardrobe balanced precariously on his back. A drunken woman with a bottle in her hand shouts and lurches at the centre of a flock of sheep; the sheep respond to her every move, instantly and collectively, her impulses rippling out through this animal *corps de ballet*. A man, gravity-bound, chases a flock of starlings as they swoop and soar. Dominique Mercy in a ball gown, pinned to the wall of a room by a model helicopter hovering in front of him, buzzing him, its whirring blades pushing an updraft under his skirt. [6]

A woman with impossibly long limbs and hair, a spectral somnambulist presence in a white night slip, dances through a maze of tables and chairs in a deserted cafe. A man clears her passage, his attention to his task all-consuming and selfless. [7]

The everyday defamiliarised. The image as aggregation: the conjunction of bodies,

objects, rhythms, music, space as psychic landscape. Even smell (the peaty earth in *Rights of Spring*). Bachelard's 'material imagination'. Brecht's *gestus* ablaze, signalling through the flames.[8] Accumulation and repetition (what repetition?) Masquerade. The voyeuristic economy of spectating: the 'display' of performing. Montage. E-motion: the continuous leak of affect. Excess. A corrosive theatricality. Irreducible ambiguity. Layers of fragmented narrative. Reversals. Ec-static exposures, uninsulated. Identities on the move. Possible worlds. The heart-land laid bare, in its resilience and fragility.

Love's work, its grain, its shapes. The tears of things.

Notes

1. *Bluebeard.*
2. *Nelken.*
3. *Kontakthof.*
4. *Two Cigarettes in the Dark.*
5. *Ahnen.*
6. *Die Klage der Kaiserin* ('The Lament of the Empress').
7. *Cafe Müller.*
8. '*Gestus* is at once gesture and gist, attitude and point: one aspect of the relation between two people, studied singly, cut to essentials and physically or verbally expressed. It excludes the psychological, the sub-conscious, the metaphysical unless they can be conveyed in concrete terms' (Bertolt Brecht).

The tears of things (for Pina) by David Williams appeared on the Skywritings blog at http://sky-writings.blogspot.com/2009/07/tears-of-things-for-pina.html on 2 July 2009.

Inbetweeness

Jason Maling

Kira O'Reilly succeded in reaching E.V. and is in the gravitational pull of the lab where there is chocolate shortcake, she is now appying herself to calling occupants of interplanetary craft.

I was talking about love the other day. It was with a stranger. We had veered into the territory via a discussion about cutting the fat.

We spoke about defrauding someone, about not giving over. Do we demand a sign of love before we surrender? Without a sign, do we remain calculated and reserved? She wanted to be carried beyond all calculation, to arrive somewhere having never considered the journey.

I thought about this conversation a lot afterwards and I believe it has something to do with art.

The conversation took place in a small office on the second floor of a convent. She was there because a friend had told her to come. She did not know who I was or what I did, but she was there anyway. I was there because she had asked me.

It sounds contrived and from my point of view it was. What isn't contrived is why I needed it to be that way.

It has occurred to me lately that I am no longer prepared to give myself away. I want a little of the big C(ommitment) before I subject myself to the big A (rt).

At what point did I become so demanding?

As an undergraduate painting student in New Zealand I was indoctrinated with modernist mythology. The artist functioned on the periphery of society, sending cryptic dispatches from frontier towns of the imagination. The act of presentation was sacred and a resolute nonchalance to audience dialogue was the preferred pose.

I tried very hard to be a believer. We joked about taking our vows with a prideful zeal and submitting to a life of impoverished isolation. I did my time in the studio and began developing a finely distorted vision

Richard DeDomenici is replicating the effects of being on a cocktail of mind-altering drugs by watching BBC Alba: http://www.bbc.co.uk/iplayer/episode/b00m0lps/Aifric_Series_1_The_Future_Tense

of my own self-importance. I had gallery shows with things that people looked at but increasingly I found myself hanging around watching how people engaged with the work.

I made notes but kept my distance.

Frustration at a lack of direct feedback was too articulate a description for my naiveté at the time but I can remember feeling severely contained by a model that others found endlessly liberating.

I flirted with performance, and I did feel a little bit closer. The thrill of the live moment made me feel special but my audience was still over there somewhere, boxed up, and named.

Back in the studio I began nullifying my self-importance with banal repetitive tasks and arbitrary reasoning. My days became exercises in accidental aesthetics and punitive process. Why couldn't just 'doing' be enough? My rules weren't playful, they were belligerent. I demanded meaning, as if by sheer persistence I could elevate private action to social commentary. It made complete sense to me that if people were going to 'get' what I was doing they had to do it too.

A lack of willing 'players', as I so benignly called them, simply reinforced my perception of a culturally ingrained passivity. A privilege of presentation over process.

I rationalised the conceptual sadism of my 'games' through my own subjugation – "look I'm going through it just like you". I wanted people to give over completely. Sure, I was functioning in the same system but there was mostly just using and not much listening.

A particular schizophrenia had begun to set in. On the one hand I wanted an elegance of composition born of sensitivity to the potential nuances and infinitely variable elements within a system. On the other I longed for complete immersive disregard.

The notion that a meaningful live exchange might be something a lot more subtle and complex took a while to filter through.

Attempting to position the work somewhere between theatre and the visual arts began to feel like an excruciating family function.

On one side were the visual artists, all post-situationist ideologues and 70s conceptualists. They were a sulky lot, totally prepared to get naked and dirty. They put on records nobody liked and stared down any objections. On the other side of the family were the theatre makers. This crew were charming but I was never sure what was for real especially when they were telling me stories about really real reality.

Gallery audiences frowned at humour, thought far too hard about everything and kept their distance. Theatre audiences expected a show, obsessed about the text and always needed to be told what to do.

I was trying too hard to please

disinterested parents. So I moved out, indignant about replacing a viewing box with some sort of magic circle of free play.

Of course nothing smells more like art than the anonymous public anomaly, especially if it has matching uniforms.

The idea that we can have unmediated artistic encounters may be a pretension but it is often our most incidental interactions that relate us directly to our world.

Finding oneself within a set of conditions that become artistically meaningful without a set of prior expectations or contextual associations can be disorientating. The sensation of having fallen into something can leave us feeling foolish and a little manipulated. But it is precisely this mental state that becomes the platform of exchange. The tricky thing is that the artist needs to fall in there too.

I was looking for a mutual space that was fluid, dynamic and responsive with a shared sense of vulnerability. It needed to be both presentation and process at the same time and it wasn't necessary to be aware of 'the work" or even consider it art.

It's messy and complicated. It's not you it's me. Didn't Saul Bellow say any artist should be grateful for a naive grace which puts him beyond the need to reason elaborately? It's an in-between space. Somewhere we are happy to be lost.

Having spent years making claims for my practice in the margins of visual art and theatre funding categories, I now find myself in the curious position of arguing its Inter, Hybrid, Community, or New Media worthiness. In-betweeness has become a category and categories require definition, hence the evolution of terms like participation, agency, and interactivity. These words outline an interdependent relationship between the artist, the work and for want of a better term, the audience. But what if by trying desperately to acknowledge and define in-betweeness we are making it harder for it to exist? Like too much personal information on a dating website.

The nature of being in-between requires us to step away from the edges that define it as one thing or another. The fear is that we no longer know where we are, yet that fear is vital for the development of new forms of artistic exchange.

I believe many of my contemporaries would argue that their work is determined by the conceptual necessities of generating this mysterious in-between space. They are tired of audience relationships that feel like one-night stands. Forgive us if we have evolved some convoluted strategies for falling in love. Gifts, games, tricks on trains, everybody hates audience participation yet we still love to play. Does creating an in-between space have something to do with how we enter it and negotiate a relationship rather than predetermining it with roles?

In the Japanese martial art of Aikido

there is the notion of blending. The energy of an attack is not countered, it is utilized. For an Aikido practitioner to successfully execute a technique they must receive a committed attack. An attack is the willing gift of energy that allows both practitioner and attacker to gain an understanding through mutual movement. If there is no energy given, there can be no blending. If that energy is hesitant or doubtful the practitioner has nothing from which to generate the movement and the art becomes meaningless.

So yes I am demanding. Perhaps I need to be.

If I'm going to be in this space I need you here with me and if it's going to matter it's got to be true love.

Inbetweeness by Jason Maling first featured in lala (live art list australia) online. 20 December 2009. http://liveartlistaustralia.wordpress. com/2009/12/20/inbetweeness/

IndigeLab Daily Diary

Wesley Enoch

IndigeLab 2009 was a residential workshop for Indigenous Australian artists working in interdisciplinary arts. Led by Wesley Enoch, currently Artistic Director of the Queensland Theatre Company, the laboratory provided a safe and supportive space for artists to explore artistic and cultural concerns. These extracts, taken from Enoch's daily diary, were written to share with the *IndigeLab* participants.

DAY 1

Okay I promised I would write a response to each day. It's hard to respond to a 90-minute flight, two hours of waiting, three hours of driving and then three meals in the space of four hours. But I did promise ...

My name is Wesley James Enoch. Wesley after the Methodist ministers, James after the Apostle and Enoch comes from Genesis 16 given to our family by missionaries. I should add that my father agreed to me being called Wesley because of Wesley Hall the West Indian cricket player. My family is a mix of many backgrounds. On my father's side of the family there are a number of Indigenous clans notably Noonuccal Nuggi from Minjerribah Stradbroke Island off the coast of Brisbane but also Filipino, South Sea Islander, and a splash of Spanish. On my mother's side of the family there's Danish, Spanish, and the usual British bits (Irish, English etc).

I work in theatre, telling stories and pursuing the idea of cultural recognition for Indigenous Australia.

DAY 2

I am amazed that we have so few Indigenous commentators in the mainstream media. Notions of Indigenous Australia have a significant place in discussions about national identity but this is not matched in our control

of these discussions. We are *used* to illustrate the uniqueness of the country, culture and sense of place. Yet, at the same time, the limited parameters of these discussions offer restricted definitions of us. It often feels like Australia has a vested interest in defining us – museum-like – in our pre-contact cultural manifestations rather than engaging in the complexities of our reality.

DAY 3
The word 'traditional' has come to mean 'things from long ago'. 'Traditional' has come to mean a safe distance from contemporary life and something that is other and somewhere else. However, 'traditional' should refer to a continuation of practices, which are age-old and passed down through generations and still relevant today.

It is traditional to be tapped on the shoulder by a community to be the expert storyteller of that community. It is traditional to respond to the world around us as Indigenous artists. We have always done so. But 'contemporary' has come to mean *not* 'traditional'. These terms require redefining. We should look at these terms and give them meanings reflecting the realities of our cultures and, in particular, the continuity and current relevance of our cultures.

DAY 4
Who has permission to innovate? Innovation is built into our cultures; dances and songs

evolve over thousands of years handed down through oral traditions. But what parts of our culture do we want to take forward? In what contexts should we be saying we wish to leave parts of our traditional cultures behind? As contemporary people we have accepted and benefited from international Human Rights obligations through treaties and changing social structures: the abolition of slavery, the rights to education and self determination, alongside the rights of women and democratic principles. But should we accept these social changes if they contradict our traditional cultural practices? At what point is there a need for a formal process in our communities to collectively accept and reject certain practices from our traditional cultures and our contemporary world? What happens when these choices contravene Australian Law and common sense?
It is important to bring these arguments to the fore. The role of the artist can be to help shine a light on some of these things and engage public debate, opening up discussion early, and hopefully outside the magnifying glass of the media, who always wish to demonise, dramatise and create moral outrage.

DAY 5
There is a great deal of interplay between the personal and the artistic. Our stories and our identity are very present in the work we create. This is not unusual in the

Brian Lobel had the
weirdest dream last night,
imagery courtesy of
Stacy Makishi.

art world but the dominant society dictates the readings of our work and readings of *our* identity are often overtly politicised. We are rarely seen solely for the work we are creating and our perspectives of the world. Instead our Aboriginality is read as being dominant, even if we have chosen not to make it the focus. Our work and our bodies are seen as being in service to the dominant cultural task of healing or defining *their* identity in this Land.

DAY 6 and 7
The joy of a couple of days off.

DAY 8
Who gives us permission to be an artist? Does the community give us permission or do we evolve into our positions in our community? The big issues arise when we work on contested ground – the crossover point between following our artistic aspirations and community expectations. What happens when the community doesn't want you to tell your story? Does this make it wrong or bad art, or is it the job of artists to explore the boundaries of acceptability and try to create a new vocabulary for a society? Societies are constantly changing and artists show the direction in which change can occur. No society should stay the same – no society ever does – but there can be a conservative energy where people have a vested interest in the status quo. Artists

create a vocabulary for the future, a language for change and/or can show the world as we would want it to be rather than the way we think it has to be. Artists are change agents. But what gives us that right? Are we there for the community? Or are we part of a community? Part of it, yet far enough away to see it for what it is? There are no hard and fast answers to these questions. Sometimes we must toe the line and get strength from our community and sometimes we need to fly in the face of conventional wisdom and say we don't agree.

DAY 9
Fact or fiction? I love the idea that some people believe that for a story to be 'authentic' it must be auto-biographical or at least 'the truth'. It's like we can't exist as artists or be capable of acts of fiction that are symbolic and contemporary manifestations of culture. Like all artists we are inspired by true stories or events that happen around us but are we to be enslaved by these stories? Why can't an Indigenous play *reflect* the world we live in but not *be* the world we live in? Metaphor and allegory have been embraced in all art-making yet when it comes to the reading of Indigenous art I doubt the greater audience fully appreciates the role of the artist in our society. We are like bower-birds – we borrow, steal, learn from and engage with traditions of art, techniques, form and content that fascinate us as artists.

DAY 10

We have to choose times when we are in the public eye and when we wish to be safe in our own world. We have to accept that – in the short term at least – we live in a world where we are not protected by a system of education or universal social engagement that allows us a forum free of ignorance. It has become beholden on us to know the environment in which we are speaking and prepare ourselves accordingly. When we are amongst our own it means the debate can be informed by our shared histories and cultural understandings (although, this is not always possible, of course, as we have diverse backgrounds) but when we are in public we have to be prepared to engage in any debate that comes our way. This is a tricky position to be in. We are encouraged to be calm and relaxed and articulate against a background of sometimes mind-numbing ignorance and aggressive personal attack. But I think engagement is better than shutting down discussion.

We have to know what world we are standing in and prepare ourselves for any outcome. This is not something our Non-Indigenous counterparts really have to consider. This is not to suggest that we have to be good Jackey Jackeys but more that we have to champion the ideas we are promulgating through our art. Being an artist is one thing but being an Indigenous artist is another. Being an Indigenous artist means we are taking on the Australian social, political and cultural environment in relation to our heritage.

DAY 11

Art is an inherent human need and each individual can create art. In pre-contact cultures I understand that everyone danced and sang and painted but a select few would be elevated in a clan to be the keeper of a story/dance/painting either through birthright or talent. It was then their responsibility to be the protector of that cultural material. I think all human beings are capable of making extraordinary art but very few of us are the keepers of that sensibility. It is a vocation like any other and we are the ones who keep it strong in a community. The major difference between the community artist and the artist as keeper is that the latter must be in a position to replicate the circumstances that support the making of their art. Being an Indigenous artist is not a passive description, rather it must be an active choice. It is a way of actively engaging in the cultural context of being Indigenous and taking control of our language and context.

IndigeLab Daily Diary by Wesley Enoch was written to share with the participants of *IndigeLab,* Performance Space's residential laboratory for Indigenous Australian artists, November 2009.

Merce Cunningham

David Vaughan

Merce Cunningham who has died aged 90, was one of the greatest choreographers of the 20th century, and the greatest American-born one. As a choreographer, he never abandoned the voyage of discovery that he embarked on at the beginning of his career. Like his life partner and frequent collaborator, the composer John Cage, he remained intransigent to the last. He continued to lead his dance company, founded in 1953, until his death, and presented a new work, Nearly Ninety, last April, at the Brooklyn Academy of Music, New York, to mark his 90th birthday.

In spite of what was often seen as his iconoclasm, his work was essentially classical in its formal qualities, its rigour, and its purity. Both Cunningham and Cage used chance processes, though in very different ways: Cage carried them through to the actual performance of his music, while Cunningham used them only in the creation of the choreography itself. As with any other compositional tool, what really matters is the quality of the imagination at work. Apart from Cunningham's sheer fecundity of invention, his choreography was notable for its strength of structure, even though that structure was organic rather than preconceived.

Merce never gave the impression that he was concerned with what happened to his work after he was gone. He was, like most creative artists, chiefly involved in the work he was doing now – or was going to do next. His interest in new technology was well known. His pioneering work in film and video, which began in the early 1970s, first with Charles Atlas and later with Elliot Caplan, proposed a grammar of dance on camera. In the 90s, his fascination with the computer program DanceForms led to

the formulation of a new choreographic complexity.

The most controversial of the innovations that he and Cage introduced was undoubtedly the separation of dance from music, prompted by their belief that the most important thing the two arts have in common is that they exist in time. It is possible that Cunningham would have achieved greater popularity if he had choreographed to recognisable music instead of the "live electronic music" composed by Cage, David Tudor, Takehisa Kosugi, and other musicians who worked with him. But of course his work would have been very different if he had.

Having worked with Merce since 1959 – first as a studio administrator, then, from 1976, as company archivist – I have had an unparalleled opportunity to observe his career from close up. I first met him in October 1950, when I left Britain to go to New York to study at George Balanchine's School of American Ballet, the associate school of the New York City Ballet. At that time, Cunningham was teaching a class in modern dance there once a week.

At the time, Lincoln Kirstein, the school's general director, was not as dismissive of modern dance as he later became: in 1947 he commissioned a ballet from Cunningham and Cage, The Seasons, with decor by Isamu Noguchi, for the second season of Ballet Society, forerunner of New York City Ballet. This was the first of what came to be known

as Cunningham's "chance ballets", Sixteen Dances for Soloist and Company of Three (1951). Cage played for Cunningham's class at the American school; he knew at most three tunes, among them Three Blind Mice.

Merce and John went off on tour after a few weeks, and never came back to the school. In the summer of 1953, at Black Mountain College, he founded the Merce Cunningham Dance Company (which included the young Paul Taylor, who had been in the Graham company with him). Sixteen Dances for Soloist and Company of Three – the first collaboration by Cage and Cunningham that I saw – was performed as part of a season of American dance at the Alvin Theatre, New York, sandwiched between works by Martha Graham and José Limón, whose supporters were united, if in nothing else, by their detestation of everything Merce and John did and stood for. The evening was not perhaps in the same league as the premiere of The Rite of Spring in 1913, but it was more of a scandal than often occurred in New York at the time. The choreographer Anna Sokolow hit the man sitting behind her to make him shut up.

The performance was striking for its wit and brilliant inventiveness, and from that time I never missed a Cunningham performance if I could help it. As it happened, I found myself in a uniquely favourable position not to do so: a few years later, I began to study with Cunningham

Brian Lobel is thankful to Sidi Larbi Cherkaoui for renewing his faith in spotlights, haze, normal-sized female performers, floppy blond hair and so much more.

again. In December 1959 Cunningham opened a studio in New York, on the top floor of a building on the corner of 14th Street and 6th Avenue occupied by the Living Theatre, and he invited me to come and work for him.

In June 1964 the company embarked on a tour that lasted six months and took us round the world. By the end, many things had changed. The artist Robert Rauschenberg was no longer its resident designer and technical director, having won the grand prize at the Venice Biennale and become world famous.

But Cunningham too had gained a kind of recognition that he had not received at home. In Paris and particularly in London, where a week's engagement at Sadler's Wells had been extended by the producer Michael White by a further two-and-a-half weeks at the Phoenix, the work of Cunningham and his collaborators was taken seriously by such critics as Dinah Maggie of the French newspaper Combat and, in London, by Alexander Bland, Richard Buckle, Wilfrid Mellers and John Percival, and by audiences that included artists and, especially, theatre people. Directors like George Devine, Lindsay Anderson, William Gaskill and Peter Brook, the designer Jocelyn Herbert and actors like Irene Worth and Harold Lang came night after night.

Word of this response found its way back to the United States, and the company returned to find there a new curiosity about its work. Not long afterwards, the National Endowment for the Arts and the New York State Council on the Arts were formed. Both sponsored touring programmes with residencies and performances, and Cunningham's company was among the first to be included. As the dance writer Nancy Dalva observed, it was not that Cunningham had gone establishment, but that the establishment had gone Cunningham.

In France, thanks to the advocacy of the late Michel Guy, director of the Paris Autumn festival and sometime minister of culture, and of Bénédicte Pesle, Cunningham's European representative, his work found even greater acceptance than at home.

Cunningham (his original given names were Mercier Philip) was born in Centralia, a small town in the state of Washington in the north-west United States. His father, Clifford D Cunningham, of Irish descent, was a lawyer and his mother, Mayme, was from a family whose origin was Slavic. Neither parent had any connection with the theatre, though Cunningham once said that his father had a certain histrionic talent in the courtroom. Cunningham was the second of their three sons; both his brothers followed their father into the legal profession. (Cunningham, being questioned once on jury duty, said: "I'm the criminal in the family.")

As a teenager, Cunningham studied tap and ballroom dance with a local teacher, Mrs Maude Barrett, who had a great influence on him. He began to perform in her school

Richard DeDomenici
invites you all to
'Anything You Can Do I
Can Do Batter'. Outside
the National Theatre.
Today. 12noon to 3pm.

recitals, and even went with her on what he described as "a short and intoxicating vaudeville tour" as far as California in the year before he graduated from high school, an experience that turned him into a trouper, which he remained throughout his career. After graduating, he went to George Washington University in Washington DC, but quit after a year and enrolled at the Cornish School in Seattle, originally with the intention of studying acting. But he soon changed his field of studies to dance. He also spent a summer at the Bennington School of Dance in Oakland, California.

Cunningham first met Cage in 1938 when Bonnie Bird, the dance instructor at Cornish, engaged him as the accompanist for her dance classes. A year later Cunningham left to join Martha Graham's company in New York, where he remained until 1945 taking leading roles as a soloist in El Penitente (1945), Letter to the World (1940), and Appalachian Spring (1944). Cage made his way to New York in 1942, and wrote the score for Credo in Us, jointly choreographed by Cunningham and Jean Erdman, and Totem Ancestor, which was a solo in Merce's first independent dance recital. Thus began a collaboration that was to last until Cage's death in August 1992.

Neither of them talked openly about the nature of their personal, as opposed to professional, relationship. When a young man who no doubt hoped to "out" them once

asked in a public forum about their domestic life, John said, after a pause, "Well, I do the cooking … and Merce does the dishes."

Anyone who knew Merce in the earlier years of struggle was familiar with those times when he would descend into a mood of black despair and anger (I often wondered how Cage dealt with those moods). The astonishing thing was that these did not recur when his dancing days were more or less over. Cunningham seemed to find ample satisfaction in creating choreography for the young dancers of his company that pushed them to ever greater heights of virtuosity. But he never wanted to stop performing – he was one of those performers who are most alive on stage. This remained true even in later years when, as he put it, he "appeared" rather than danced – every step caused him pain, but he still made himself walk out for his curtain call from the farthest upstage wing.

Judith Mackrell writes: It was only last month that Merce Cunningham and his company were announcing plans about how to safeguard the choreographer's work after his death. As Cunningham said to journalists at the time: "It's really a concern about how you preserve the elements of an art which is really evanescent, which is really like water."

It was obviously a prudent action to take, given that Cunningham had turned 90 this April. But it also seemed so abstract. Despite his age, despite being confined to

a wheelchair, Cunningham had shown no signs of giving up his work ("choreography is like knitting," he once told me, "I don't stop"). In his own inimitable and mild-mannered way, he had seemed immortal.

Cunningham's genius was not the storm-und-drang kind – he wasn't the type of man to take up all the oxygen. While his first employment was possibly the best job going in modern dance – it led to him performing with the great pioneer Martha Graham – he only stayed in it for six years, driven by an almost boffin-like curiosity to explore his own ideas.

During the late 1940s, Cunningham worked on developing his own choreographic language, based on a fusion of modern and classical dance, but also on his observations of how ordinary people and animals moved. It constantly delighted him to see how different steps and gestures could be put together – in one phrase a dancer might be executing a slow circle of a leg, while her bent arms rotated like propellers and her head turned this way and that like an anxious bird.

No one else made dance that looked remotely like this, and at the same time no one else had Cunningham's conceptual ambitions. It was at this time that he came under the influence of his long-term partner and artistic collaborator John Cage, and became fascinated by Cage's use of chance principles in composition – often throwing

dice or using techniques such as the I Ching to determine the sequence of movements or the number of dancers he might use. Cunningham also developed his now-famous method of creating choreography independently of his music and design, seeing what would happen when the three elements came together at a late rehearsal, or even at a first performance.

This was not some hippyish abnegation of control; rather he was using chance as a way of going beyond the limits of his own mind and imagination. The human body offered a constantly intriguing set of possibilities for Cunningham. And it was for this reason that he had no interest in telling stories or inventing characters with dance – there were already too many shapes, patterns and rhythms to discover and explore.

Throughout his career he continued to make those explorations. It was Cunningham who led the way in using computers as an aid to creating dances; he was later one of the first choreographers to use digital technology in staging his work. There was always a part of the dance world which regarded Cunningham as too cerebral, too weird, that resisted these preoccupations. Some of his early reviews were terrible. Yet for those of us who have loved and admired his works, they seemed the opposite of dry. For one thing Cunningham was a rare, instinctive showman. On stage he was mesmerizing.

Even in his 90s, when he was ravaged by

arthritis, his dancing contained a burnished intelligence. And the choreography he created was just as compelling, just as rich. Some of his works were very funny; some inexplicably moving. Watching a Cunningham dance could be as absorbing and overwhelming as observing a landscape, a starlit sky or a city crowd.

There was nothing godlike about Cunningham's ego, but something godlike in the works he created.

• Merce (Mercier Philip) Cunningham, dancer and choreographer, born 16 April 1919; died 26 July 2009

Merce Cunningham by David Vaughan first featured in The Guardian online. 27 July 2009. http://www.guardian.co.uk/stage/2009/jul/27/obituary-merce-cunningham

Kira O'Reilly: SUNN O))) - Alice (4) this really needs to be listened to on something proper. The album is my current thing to play obsessively to accompany studio movement experiments. This and Scott Walker's The Drift ... Both are gorgeous. LOUD.

Notes On Documenting Live:
Performance-Based Art and the Racialised Body

David A Bailey

These notes are specifically written to accompany the unique dvd that brings together for the first time roundtable interviews with three generations of artists from the diaspora who have worked within the genre of performance-based Live Art in Britain.

In the past I have written about the transformations in black British art over the last 40 years. However, this overview had a tendency to neglect the relationship and distinctiveness that performance and Live Art have played in this period. One also has to understand that in the context of the visual arts, which already suffers from under-documentation, in the case of the performance and Live Art this is even worse when we come to consider cultural diversity, which makes it very difficult for scholars, curators and artists to get a sense of a history and continuity of practice. In these

notes I will want to review this period in the light of this. Of course this will not be a complete survey nor an encyclopaedic view, but the beginnings of a map of this period. These notes have been informed by three areas in my life: my work as Co-Director of the African & Asian Visual Arts Archive (Aavaa), my work as a curator, and with discussions with artists who have worked in this genre from the 1960s to the present day. To examine this period we need to look at significant developments in the following areas: institutional developments and changes; differences and convergences which led to substantial paradigmatic shifts in artistic practices; independent organisations; globalisation and internationalism; the role of the curator; social and political events. There needs to be much more research and critical writing on black artists and black cultural practice in Britain. Although some work

has been done about black artists from the post-war period, much more archaeological work is required on the pre-1945 era. The point here is that one should not isolate the practices between the 1970s and 1990s without looking at this earlier period.

In the 1950s and 1960s, England was the place where artists came together from the newly formed "Commonwealth". One crucial gathering was the formation of the Caribbean Artists Movement (CAM) in London in 1966 - an important moment that influenced events in the 1970s, 1980s and 1990s. Formed by Kamau (Edward) Brathwaite, John La Rose and Andrew Salkey. Like the Harlem Renaissance that emerged in New York during the 1920s and 1930s, CAM was a diverse collection of writers, critics and artists who were interested in developing a modern Caribbean aesthetic - an aesthetic that explored colonial histories as well as defining a newly formed black British identity. It seems to me that during this period the question and practice of performance and the formation of a Live Art practice had its seeds in this movement and in this period of the CAM era. It was in this moment that where visual arts were in dialogue with performance poets and at the same time in dialogue with performance spectacularists. This is the period where poets from the Caribbean were beginning to find a new voice and a new signature in Britain through the use of language and dialect, where the

phrase patois and creolisation came into being in newly formed West Indian centres in London such as the Keskidee Centre in London. In this context we need to re-examine the documentary film work of the Trinidadian artist Horace Ove, whose films such as 'Baldwin's Nigger' captures the dialogue between James Baldwin and the Caribbean community in London, as well as other films such as 'Pressure', which documents the West London black community.

The 1970s was also a rapidly changing period for African and Asian artists in Britain, who were making important contributions to global art movements like modernism whilst at the same time beginning to demonstrate a move towards a Live Art practice. In this context we need to look at the performative works by artist such as Rasheed Aareen and David Medalla. David Medalla formed the Artists Liberation Front and Artists For Democracy in London with an international membership that included Rasheed Aareen, who performed 'Paki Bastard' (1977), one of the first critiques into the positive/negative imagery debate. Later in this decade, Aareen launched the art magazine Black Phoenix with an article entitled 'Black Manifesto'. The point here is that like the artists' group CAM here was a body of artists who were not only bringing their relationships to other global artists through their work but also introducing these

artist for the first time to a British audience. This is certainly the case of David Medalla, whose practice related to several different international artists such as Lygia Clark and Helio Oiticcica, whom he introduced the British artworld. The events of the 1970s led to the first major report on black arts in Britain or what was then termed Ethnic Minority Arts. With institutional support from the Community Relations Committee (CRC), the highly influential 'The Arts Britain Ignores' by Naseem Khan was published. This initiative marked the beginning of support for black art from organisations like the Arts Council of Great Britain and the Gulbenkian Foundation. The report recommends the funding and profiling of arts from a range of culturally diverse groups in Britain and enables the setting up of the Minority Arts Advisory Service in London, with regional bodies in the West Midlands, Manchester, Cardiff and CHROMA based in Nottingham. In this moment we can see the development of an artistic social policy and, parallel to this, a formation of an aesthetic practice. Also we can see the development of a definition of performance grounded within theatre in this moment, which locates performance based Live Art as marginal.

We cannot look at black art practice in the 1970s without seeing the bigger global picture and in this sense America and Africa become an important component. In the USA the black arts movement were forging alliances with the civil rights movement in an era where performance, the black body and language were fused together and contested in the churches, in the formation of choreographed marches, and in intimate halls and interior spaces where a narrative was being developed to mark the intervention of a new black American subject. This is clearly evident in work by artists such as Adrian Piper and David Hammons. In Africa places like Ethiopia were being seen as the new mecca for the Rastafarian movement, whereas places like Nigeria were where the now legendary 'Second World Black and African Festival of Arts and Culture' (Festac) was based. It was here where I argue that the first black diaspora biennale emerged bringing together visual artists with performers from around the world. It is here where we need to discuss the politics of canonisation within a form of afro-essentialism with the danger of re-writing art practice with a heavy-handed Afro-centric viewpoint. So for instance in this global context one might also consider groups like Fluxus and artists like Yoko Ono and Stanley Brouwn in Holland. In Britain there were also those that challenged the modernist paradigm with activities that took art out of the pristine "white cube" gallery space to alternative spaces and on to the streets with happenings, activism and conceptual art. The Drum Arts Centre was an alternative space, established to promote the art of black

people in Britain, and in London carnival begins to form a new sub genre in the form of the sound system with the rise of dub in the formation of dub performance poets such as Linton Kwesi Johnson.

The 1980s becomes a period of diverse activity from a new generation of artists, writers and critics. Civil disruptions across the country go hand in hand with the Thatcherite era, which in turn, has its influence on artistic production and policy. There is mass movement within the arena of black curatorial practice, independent publishing, forums, mainstream exhibitions, collaborative ventures, and organisational developments. One of the most influential bodies in the 1980s was the Greater London Council, and between 1982 -1986, through funding, institutional support, and changes in legislation, artists, writers, critics, and community groups were brought together to advise and shape local government initiatives, thus transforming the cultural landscape. For the arts some of the key events included the Ethnic Arts Conference in 1982, which established the Ethnic Arts Sub-committee, as well as the Anti-Racism Year Programme; the Black Visual Arts Forum; 'Black Artists-White Institutions' Conference, The Black Experience Programme. By 1986, the Arts Council had begun to adopt some of the initiatives developed by the GLC with a special remit to develop an international black arts centre at the Roundhouse in

London. For the first time in Britain there was a real and passionate push to develop policies that addressed the black subject within visual arts, film, writing and performance. It is in this context where we see the beginnings of a policy-led discussion on the question of performance, which leads to the formation of research and funding in the 1990s that opens up the question of inter-disciplinary practice and the exploration of performance and its relationship to the lens.

In the 'Black Experiences' issue of Ten.8, Stuart Hall made the point that in the 1980s we were entering "the Age of Innocence", which ensured that black subjectivities were visible and positioned at the centre of artistic discourses. If the 1970s was about a politicisation and mobilisation around blackness, then the 1980s was a period when the use of the term Black was at the forefront of exhibitions, events and publications. Then there were publications such as Making Myself Visible (Rasheed Aareen); conferences such as 'Black Artists –White Institutions'; artist-led groups such as The Blk Art Group. All gave the impression that the narrative theme and mode of address was one of confrontation and opposition. However, Hall concludes that within this moment of visibility and positioning there also was an "opening up" to the question of the complexity and heterogeneity of the black experience, an opening up that requires a critical framework that does not take for

Kira O'Reilly nothing was ever the same again, Virgin Prines, '79, The Late Late Show, Irish telly, the kind you watch with your granny (which I did). Virgin Prunes - Late Late Show www. youtube.com

granted that it is all good.

This idea of a radical critical framework took place within the multitude of voices and differing styles of writing around black art in Britain: from the art historical to questions of psychoanalysis centering/de-centering the subject; to the "other" and colonial discourses on the body. This was clearly the case in writings by Stuart Hall, Paul Gilroy, Pratibha Parmar, Homi Bhabha, Kobena Mercer, Eddie Chambers, Lubania Himid, Rasheed Aareen, Sarat Maharaj, Gilane Tawadros and Guy Brett. In the writings of people such as Guy Brett there is the exploration of visual art practice and performance. In addition to this there are other writers, artists and publishers who are also trying to critically bring together in a publishing arena the question of visual art practice and performance such as Kwesi Owusu's 'The Struggle For Black Arts In Britain', 'Storms of The Heart: An Anthology of Black Arts & Culture' (1988), 'FAN' (1988) by Sulter and Himid. This was also the period where independent journals and publications were established that were unique in bringing together interdisciplinary genres such as Artrage, Blackboard, Making Myself Visible (1984), Third Text (1987), BA.ZAAR (South Asian Arts Forum) (1987), Black Arts In London, Race Today Review, Urban Fox Press (Passion 1989) and Mukti. There were mainstream institutional interventions by organisations that published material which explored black

art practices such as CRE The Art of Ethnic Minorities (1985). The point here is that in the 1980s it becomes clear that there are policy initiatives, funding initiatives, the emergence of a critical and artistic groundswell that is focused around questions of the black body and autobiography, which become a 1980s intertextual debate amongst a range of artists from different generations leading to one-off debates, publications, exhibitions and the formation of groups. It is in this context that we see a distinctive narrative emerging which leads to the formation of radical experimental theatre groups such as Double Edge, the re-imagining of choreography and dance by Greta Mendez, the performance poetry of SuAndi, the televisual subversion of the black and white ministerial genre with Lenny Henry and the distinctive music performative success of Soul II Soul who reach number one in Britain and the USA. In this context we also see elements of performance and adornment in the work of visual artists such as Keith Piper, Ingrid Pollard, Sokari Douglas Camp and Rotimi Fani Kayode. By the 1990s this emerges into a distinctive Live Art practice.

In the 1990s we begin to experience for the first time en masse artists who are exploring performative live visual time-based projects whether it is in a gallery installation, in a studio theatre, or in the public realm - a unique body of work which is deeply rich in film culture, performance, theory and

the history of visual arts that makes direct relationship to the modern conditions that pre-occupy the arenas of race, sexuality, memory, history, fantasy and desire in our daily lives. This is the period where we see the Arts Council producing reports into the question of cultural diversity and Live Art practices, this is the period where we see new funding streams such as New Collaborations geared towards supporting interdisciplinary practices. This is the period of the launch of publishing and exhibition franchises to Sunil Gupta (OVA), Rasheed Aareen (Kala Press) and Eddie Chambers, and of new organisations such as inIVA whose output throughout this period is multifaceted: instigating and collaborating with a range of critics, curators, artists, art historians, galleries, museums and arts organisations on exhibition and publishing projects. This is also the period when performance, film and visual art practices begin to merge with artists such as Isaac Julien and Steve McQueen, and when Live Art came into its own through the approaches of artists such as Susan Lewis, Ronald Fraser Munro, and **moti**roti and through the curatorial work of Catherine Ugwu and Lois Keidan at the Institute of Contemporary Arts, who went on to establish the Live Art Development Agency in 1999.

Now that we are in the 21st century people tend to be obsessive with the form of practice and its relationship to new technologies rather than the object itself and its complex historical relations. This is clearly the case with Live Art where for the first time in Britain one can locate three generations of practice with artists who emerged in the 1960s and 1970s with artists from the 1980s and 1990s and artists from the 21st century. The question now is how do we (as curators, critics, policy makers, thinkers and artists) link the past with the present and the present with the past. The point is that in the 1950s in Britain there was no archival policy put in place which has meant that most of the work and practices I have discussed which dates back to the 1960s has been lost or destroyed. There are only fragments left in the form of photographs, reviews, diaries. By the 1990s this archival work improved but what now remains are vast gaps from the last half of the 20th century to now in the 21st century where in Britain it is very difficult to try and navigate a historical presence of race within the performance-art-based genre. The next question is how do we remedy this scenario. Do we re-create some of the land-making performances of the past? And document them? And if so, how do we interpret them? This was the question I was faced when working on this project and the only answer I could come to was to provide a forum where a small group of artists from the period of 1960 to the present day could discuss these issues in two roundtable discussions which were filmed alongside face-to-camera

statements about their practice. It was out of this moment where three remarkable things occurred - the first being a discussion about the work and the work in the context of the body and history. For artists who made work in the 60s, 70s and 80s there was a greater importance to the body not just for visibility but also for historical marking in the sense that here were a group of artists who were making and creating history through these performative moments. The second was the importance of personal biographies as statements of intent which were an important development for artists of the 1990s and 21st century. It was here where the question of influences was important. The third and most important was the need to keep these discussions living through continued meetings which the artists have organised themselves - what I would call keeping the archive of performance based art alive.

Notes on Documenting Live: Performance-Based Art and the Racialised Body by David A Bailey was originally published in *Documenting Live* commissioned and published by the Live Art Development Agency 2008.

The 'Re' - factor

Guy Brett

I want to begin with a little ceremony in which I participated myself. An obscure event probably, which took place on a piece of waste ground near the centre off the city of Rotterdam one cold and foggy morning in 1992. We brought with us a bag of dark earth and a small rectangular enclosure, or frame, made of wood, 80 x 80 x 10 centimetres. We poured our earth within the frame until it was filled, removed the frame so the square of earth remained on the earth, and left.

What we were doing was re-enacting a work of the Brazilian artist Hélio Oiticica which he first carried out in 1978, shortly before his death in 1980 at the age of 43. He enacted the ceremony in Rio de Janeiro, in Cajú, a forlorn piece of urban wasteland near the port. He called it *Counter-Bolide: returning earth to earth.*

This needs to be explained. In the mid-60s Oiticica created what he called his *Bolides.*

These were containers – glass or wood or plastic – containing earth or pigment and were an expression of the nucleic concept of form that he was developing at the time (*Bolide* means 'meteor', or 'fireball', in Portuguese). This involved a radicalisation of traditional genres. His own account goes as follows: "The *Glass Bolide* (and the *Box Bolide* too: the pigment colour applied or boxed in, was a way of turning effective the pigment mass in a new form extra-painting) which contained pigment, earth, etc., did not act as a mere 'container for the earth' but made manifest the presence of some earth as a piece of the earth: it gave it a first and contained concretion removing it from a naturalistic dispersed stage." [1]

By 1978, Oiticica felt that, given our commodity culture, the *Bolide*, with the passage of time, had begun to lose its efficacy as an act made in the living world and had

Richard DeDomenici
has had everything apart
from his teeth darkened.

taken on the inert, fixed quality of an object absorbed by the institution of art. Therefore the contradiction of the contradiction was to return earth removed from earth back to earth to re-animate the continuity. In contrast to many works of Oiticica – his *Penetrables*, or *Parangolé Capes* – which drew people in to participate, the *Counter-Bolide* was a sort of internal act of critical negation and affirmation within the logic of his own work to renew its relationship to the world at large. The material object was the minimum necessary to register it as a conceptual act. As the square of earth lay there, it gradually lost its 'concretion' signified in the form of the rectangle, part of human culture, and was absorbed back into the universal flux. The old *Bolide* was buried and a new one arose. The metaphor of renewal was amplified by the *Bolide* implicitly leaving the highly valued art gallery and museum and going back fruitfully to the earth in its most abandoned and least valued appearance.

That is what we were doing, in a neglected corner of Rotterdam, just a few metres from the Witte de With Centre for Contemporary Art where a large, posthumous retrospective of Oiticica'a work was about to open. He himself had said that the *Counter-Bolide* could be repeated anywhere and by anyone "when the proper occasion or necessity for it appears", in his own words. [2] Therefore it seemed absolutely correct to re-enact it in each city in which

the exhibition was held – Rotterdam, Paris, Barcelona, Lisbon and Minneapolis. This fact was imparted to the visitor by colour photographs hanging in the exhibition.

While the idea of renewing the vitality of a work of art appealed to me strongly, my feelings about the actual photographs were curiously ambivalent. The present moment (1992, that is), and the locations in different countries, are made very vivid. But in most cases it is obvious that the sites chosen are close to the museum and that the people carrying out the *Counter-Bolide* are museum staff. Are we assisting at a lugubrious burial in which something has died in the confines of the museum and is being laid to rest with institutional trappings? Or are we witnessing a renewal, in the very shadow of the museum, of Oiticica's view of art as a poetics of life? The *Counter-Bolide* was always either, or both, a burial and a resurrection. And Oiticica himself recommended an attitude of "critical ambivalence" (his phrase) in order to avoid being trapped in absolute and universal categories and values.

I think these ambivalent impressions remind one of what is actually involved in a genuine re-creation or renewal. Many such ceremonies of renewal in human cultures through history have a strong element of risk and trepidation accompanying them. This is the case, for example, with the archaic Aztec Fire Ceremony. This is one version of a very widespread ritual involving the crucial

human achievement of producing fire at will. In Aztec society, every cycle of 52 years was marked by the New Fire Ceremony, a time of great nervousness in which all fires were extinguished and replaced with a new fire ceremonially kindled using a fire-drill and board. One marvels at the Aztec conviction that it is necessary periodically to go right back to the beginning, to return to the time before the innovation was made, with all the anxieties involved in not knowing whether, this time around, the procedure would work.

In fact it is fascinating to consider further this little prefix 're-', as in 'return', the keyword of this conference, which is so commonplace and familiar. It seems, when one comes to think about it, that its use can be divided between a group of words which are more or less neutral and those that have a powerful charge of vitality. On one side we have return, repeat, record, report, relate, represent, and so on, and on the other side words like renew, re-create, regenerate, revitalise, reactivate, revivify, re-animate, replenish, refresh, etc. The words on one side challenge those on the other: there is always the question of whether a repetition is a renewal or just an empty, arid copy, and this bears on the efficacy of any recurring ceremony, such as those of the New Fire or the New Year. I would like to give an account of three recent, and I think brilliant, examples of the revitalisation of a form which is very ancient and always

returning: the procession. Of these three, two have been carried out and one still remains a project (this is not a problem since I have always considered that unrealised projects in contemporary art can be as meaningful as those that circumstances have allowed to happen).

I wasn't present, unfortunately, at Jeremy Deller's procession organised for the Manchester International Festival with the assistance of Sarah Perks and others, which took place on Sunday 5th July 2009. But I was captivated by a large photograph published the next day in The Guardian, a birds' eye view of the defile snaking its way through the streets of central Manchester. The core of Deller's light-hearted concept was to borrow a traditional popular form – to de-officialise it - to include representatives of contemporary cultures which would have never normally been given that approval. The result was that joyful sense of mental freedom when rigid thought-patterns are surpassed. The Guardian's chief arts writer, Charlotte Higgins, reported: "Deller likes the idea that there are people who, according to conventional wisdom, ought not to be celebrated – which is why, wandering gloomily into view, come the emos and Goths who hang out in Cathedral Gardens on a Saturday afternoon. Before and behind them putter local authority mobile libraries." She goes on: "Look, there's Britannia, and after her, a banner celebrating Ian Tomlinson, who

Richard DeDomenici
thinks he has just
seen the single most
intensely beautiful
piece of art ever

died during the G20 protests. Ed Hall, who often collaborates with Deller, has stitched beautiful banners, including one designed by David Hockney, depicting an ashtray, for a chain-puffing group, the Unrepentant Smokers. There's a Smoking Kills banner just behind, for balance." [3]

Obviously there is a strong sense of carnival here, reminders of the Notting Hill Carnival procession in England, and beyond that the carnivals of a country like Brazil, which Hélio Oiticica, to re-invoke him, called "the greatest public improvisation in the world"[4]. He was speaking of carnival before it began to rigidify and over-organise itself into a TV spectacular, which is the case of the Rio Carnival, impressive though that still remains. "Improvisation" and "public" are the key words Oiticica uses, and these are a characteristic of carnival which can be strongly felt in a book of photographs taken by Claudio Edinger of carnivals in several Brazilian cities. In his preface to the book the Brazilian anthropologist Roberto Damatta writes eloquently of – I quote – "the thousands of microscopic carnival dramas, these tiny plays of the people in which every citizen has the right to act and participate, once he or she is duly garbed in fancy-dress and steps into the streets revealing what they may have liked to have been, or could have been … this *fantasia* … the equality and liberty of the individual in a profoundly controlled, authoritarian and hierarchical society." [5]

Mikhail Bakhtin, the great Russian theorist of carnival, carnival being, as we know, a universal release-valve of human society, has given this description: "During carnival time life is subject only to its laws, that is, the laws of its own freedom. It has a universal spirit; it is a special condition of the entire world, of the world's revival and renewal, in which all take part. Such is the essence of carnival, vividly felt by all its participants." [6]

The Guardian report of the Manchester procession continues: "Suddenly, there are nodding black plumes as a horse-drawn hearse appears – inside the glass-sided carriage, the word HACIENDA picked out in cream chrysanthemums. It's the first of a fleet of hearses, each bringing a floral tribute to another lost, loved club of the north-west: Wigan Casino; Bolton's Burden Park. This last gets the local vote: "Very poignant", says Rachel Cook, 36."

I will now speak, with slightly more gravity, of another city, another appearance of horses, another funeral cortège, and another reversal of the official and established order. This is Rose English's project, *Beauty and Beau: a Requiem for the Horse who Knows History*. In the context of Rose English's own work, this is just one manifestation of an extraordinary, life-long interest in the great global tribe of equine beings, its past, its present, its breeds and its individuals.

One work, *My Mathematics*, centres round a dialogue between her and a horse on stage. In her Procession, which still remains a project, here is what we would witness, taken from her own project description:

"*Beauty and Beau* will be the funeral of an actual horse. The cortège will be a choir of mourners accompanied by musicians and the ceremonial presence of two black Fresian funeral horses, Beauty and Beau, will be used to honour a dead horse with the epithet 'the horse who knows history'. In an eloquent reversal of the usual practice *Beauty and Beau* will honour the remains of one of their own species. Like a vestige counterpoint of the symbolic ceremonials and traditions of the military (e.g. the grave of the 'unknown soldier') the presence of the horse who knows history will evoke a sense of what has been forgotten but awaits remembrance by the fluid substance we call history.

Solemn, mysterious, powerful and evocative, *Beauty and Beau* will be presented as a torch-lit progress with 'stations' through the streets of central London at dusk. Stopping at strategic points for particular songs written for that location and that moment, the cortège will follow a route featuring many equestrian statues and monuments. The proposed route will be from Jubilee Gardens, past the old site of Astley's Amphitheatre (the first circus, founded by equestrian and ex-cavalry officer Philip Astley), over Westminster Bridge, past the statue of Boadicea in her chariot (Boadicea is believed to be buried under St Pancras Station), round Parliament Square, up Whitehall, past the cenotaph, past Horse Guards to Trafalgar Square with the statue of Wellington on his horse Copenhagen. Pausing also at the empty plinth (the absent monument) in Trafalgar Square the cortège will travel up Regents Street to Portland Place (with other equestrian monuments) through Regents Park and on to Primrose Hill for the symbolic interment of the horse." [7]

Now, the third recent return of the Procession I want to mention took place in 2005 at Tijuana, by the sea, on the frontier between Mexico and the United States, a border which Mexicans frequently risk their lives to cross in order to find jobs in the USA. This was the project of a young Venezuelan artist, Javier Téllez, who also has a recurrent theme in his work. The son of a psychiatrist father and a psychiatrist mother, he grew up in close contact with the mentally ill. His subsequent work as an artist has revolved round collaborations with the inmates of asylums, in various countries, in specific works that answer to the local context. As part of *One flew over the void*, as the Tijuana event was called, inmates of the Baja California Mental Health Center in Mexicali formed a parade, part circus, part carnival, part political demonstration, drawing a parallel between the geopolitical border and the demarcation confining

Richard DeDomenici
wishes Facebook a
happy fifth birthday, but
honestly, what a brat

them to the mental institution. As the noisy procession arrived at the border area, a human cannonball was about to be shot in a high arc across the frontier (certainly a novel form of immigration! One can imagine the police exhaustively checking his papers before allowing him inside his canon – in fact in the clip I'm going to show you we can see him waving his passport as he enters the gigantic cannon-barrel). [CLIPS] So, Téllez contrived a carnivalesque border-crossing, or a carnivalisation of the official seriousness of political and mental borderlines. And in fact in the event the work had a further extension perfectly in keeping with the spirit of carnival. While the large crowd that had gathered to witness the spectacle – local people, art world types, media crews, police and immigration officials – stared into the sky expectantly, a Mexican worker took the opportunity to slip through the fence and cross undetected to the US.

Coming back again now to this two-faced 're-' prefix – as in record, return / revive, revitalise, and so on – we can see Anne Bean's extraordinary Matts Gallery Publication, *Autobituary*, *Shadow Deeds*, produced in 2006 by the artist, with the designer Phil Baines, and with the support of Matt's Gallery director Robin Klassnik, as a heroic struggle with the implications of this lexicon of re-words. It is reflected in the layout itself – a sober little breviary of interpretive essays surrounded by a wild

profusion of images of Anne Bean's bodily interferences in established patterns and conventional assumptions: a little breviary with perforated edges so that, when pressed out, it can be read in conjunction with several pages of overlaid images simultaneously. To rescue, re-stage, and record actions from a particularly rich period of the artist's ideas between 1969 and 1974, without making them into a funerary monument: that was the task of the event Autobituary. How – and I quote her own words - to provide information when "photographs seemed as questionable as memory, and truth danced to its own tune." [8]

Her procedure really was to continue to experiment with what had originally been an experiment, and experimentally, at least once, to dispense with documentation altogether. This work, *Yearning*, as it was revealingly called, went as follows: At the beginning of one year, at the Scout Hut, Jamaica Road, Bermondsey in London, she did a performance in front of an audience of five women, of which no records were made. On the same night, in the same place, a year later, she asked each of them to re-perform the piece according to their memories of it. They did so in turn, without seeing each other's versions. Then the piece was re-made as a public performance which Anne herself took part in and performed her own memory of the original. Not only were all their memories of what happened very individual

and different – as was to be expected – but sometimes the five witnesses remembered things the artist had done that even she had forgotten, or given little importance to ….

The conclusion drawn from this event can only be as open as possible: that there is no remembering without forgetting, that there is no single truth, and that we need the Other.

Apart from the word 'return', I calculate there are 33 different 're'-words in the text I have just read. Here they are, in no particular order:

remove	regenerate
re-enact	revitalise
reanimate	reactivate
renew	revivify
relate	replenish
register	refresh
retrospective	recur
repeat	remain
resurrect	realise
recommend	reveal
remind	release
recreate	reverse
replace	remember
record	revolve
report	reflect
represent	rescue
revive	

I leave you to draw the line where such words begin to be infused with that extra charge which connects them with the myth of return and renewal.

Notes

1. Hélio Oiticica, 'Account on TO RETURN EARTH TO THE EARTH in the first URBAN-POETIC EVENT: KLEEMANIA at CAJU/Rio de Janeiro, Dec. 18th, 1979', Hélio Oiticica, Rotterdam: Witte de With, 1992, p. 202.

2. Ibid.

3. Charlotte Higgins, 'First came the scouts' band – then Goths, smokers and a lament for lost clubs', The Guardian, London, Monday, July 6, 2009, p. 9.

4. Hélio Oiticica, op. cit., p. 228.

5. Roberto Damatta, in Claudio Edinger, Carnaval, São Paulo, Dórea Books and Art, 1996. UK Edition, Dewi Lewis Publishing, 1996.

6. Mikhail Bakhtin, Rabelais and his world, trans. Hélène Iswolsky. Bloomington: Indiana University Press, 1984, p. 7.

7. Rose English, Beauty and Beau project notes (unpublished). Quoted with the artist's kind permission.

8. Anne Bean, Autobituary: Shadow Deeds, London: Matt's Gallery, 2006, p. 3.

The 'Re' - factor by Guy Brett was originally presented as a talk on the occasion of the exhibition and symposium NOTES on a return, 9 May - 5 September 2009, at the Laing Art Gallery, Newcastle upon Tyne, UK, curated by Sophia Yadong Hao. It was subsequently published in NOTES on a return by Art Editions North 2010, edited by Sophia Yadong Hao and Matthew Hearn.

We See Fireworks

Helen Cole

Brian Lobel performs "Hold My Hand and We're Halfway There" at White Night/Nuit Blanche Brighton on Saturday: 8pm-1am at The Basement. Please note: all night performance events are not fun for me. I'm planning on being asleep by 1:15am.

AUGUST 2010

I began We See Fireworks with a small piece of writing in 2003. It was cringingly romantic as it attempted to conjure the ghosts of the shows that still clung to the walls of the deserted theatre space in which I worked. Actually as the years have passed I realise that these ghosts really do exist but they are placeless, playing around instead in my own imagination. These moments are no less vivid than when they were first experienced. In reality they burn even brighter as time passes and their stories are told and retold. And so this is where We See Fireworks begins.

It is a collection or a curatorial programme-of-sorts, yet it resides not in a physical place, but in our cultural sub-conscious, made all the more evocative because it will never come together in real place or time. It combines my own stories with the voices of over 250 strangers and friends, audience members and artists, gathered across 6 international cities. I have met each of the people who donated their memories to this collection. Via modest one-on-one installations, they told their stories to me, each in their own voices, at times stumbling to find the right words, in an attempt to conjure their moments for those that will hear or read them in the future. I have barely edited the transcriptions that follow, wishing to keep the essential truth of the original voices.

As the collection grows, it gathers momentum, carrying its own essence of the contemporary liveness it describes. It brings together people and experiences across distance and difference to explode conventional ideas of theatre and audience, to encompass the outer-edges of contemporary performativity by clashing religious ceremonies with road accidents, lovers' meetings with failed productions, big dance numbers with seminal gigs. We treasure the intense moments of unfolding, but also prove that theatre's essence lives on in the stories that we share from that moment on. These words, whispered by strangers,

Richard DeDomenici is repeatedly asked by big men in matching suits to switch off his camera: http://www.vimeo.com/4934172

sear into our consciousness, to collapse their memories into yours, to locate contemporary theatre as essentially viral, or even as if it were a shared state of mind.

Memory 0011, Anonymous
Bristol, June 09
Some of the small things do it for me. She was just walking around the building trying to put on a pair of shoes that were three sizes too small. And I kept looking at this woman out of the corner of my eye, who looked in real distress, and was just trying to put her shoes on constantly. Finally someone told me it was a show. I think it's kind of the way that she just happened to be there, and I filtered her in my mind, and this skewed the way I look at the world just a little bit, which is always something I find I am fascinated with.

Memory 0015, Anonymous
Bristol. June 09
I think it was this year. I had to go and see my girlfriend to say I was going to be late home. I was in an enclosed space with a piano and a kind of upside down barber's mirror. It was a really interesting space. Anyway I was talking, and they kind of closed the space, and I was stuck in there. And I really did not have any time for live art. I really did not have any time for it at all. I wanted to leave, but I had to stay because it was disrespectful to leave the performance.

And it was stunning.

This guy came in and he moved the full weight of the piano onto himself, and played this gorgeous song. It was quite pointed, not an 'oh-I-love-you' song, but an 'I-am-going-to-miss-you-but-I-will-be-fine' sort of thing. The piano was really heavy, and it seemed to be crushing him, and there seemed to be this kind of struggle that was coming from him holding the piano. But the struggle gave the song much more poignancy. It was actually really positive and uplifting, and I felt desperately privileged to be there. It was beautiful, and I think that for about 3 days, maybe a bit more, the performance was my first thought. It just stayed with me, especially the song. It inspired me to move on. He really got deep inside me. It showed his strength, to hold this piano up. Like it was right on top of him. Every sinew in his body was stretched to the limit, and he had to pause between lines to get his breath back and to sing. I have never forgotten it.

Memory 0104, Anonymous
Adelaide, February 2010
I received a phone call from a good friend of mine, Sean, and he rang to ask for my address, and I thought this was strange because we had been good friends and he lived just round the corner, but then I wasn't offended because I realised that I didn't know his actual address either. And then a week later, when I had completely forgotten, I

Kira O'Reilly
Slumber continues,
falling asleep with
a pig as part of
INTERSPECIES,
produced by THE
ARTS CATALYST at
A Foundation, Rochelle
School, Arnolds
Circus, London, E2
7ES.

received a handwritten letter in the mail, and it had gone through the postal service and everything, and this was particularly special as it was the first handwritten letter I think I had received since Lauren Evans gave me this invitation to her birthday party, under the desk in year 3 or 4. And this too was an invitation, but an invitation to something that wasn't quite explained. My partner Lauren and I were invited to a party that Sean was organising, and we were to get dressed up. All the invitation said was to get dressed up really formally, and to meet at our other friend, Rav's place, at a certain time, and that from there we would be taken to an undisclosed location. And Sean wouldn't give anything away when I spoke to him. It all became very secretive, and we were all really looking forward to what was about to happen.

And the night came, and we were all dressed up to the nines, and we met at Rav's place. Rav's mum and Sean's mum were there, serving us champagne, and we all looked like movie stars, and then we were all ushered outside and into taxis, and the taxi drove about a 15 minute ride to an old abandoned pre-school where we were met by Sean and Rav's younger brothers. We were ushered under the fence of this old abandoned pre-school where they had set up this dinner party for us, and we were all so overwhelmed. My hands are still shaking now when I think about it.

We drank and smoked, and we were told that all the food had been made up of dumpster divings, but it was too late, because I had already eaten it all, but it didn't really matter. There were friends of mine that I hadn't seen for ages, and some friends I don't think I have seen since. None of the chairs quite fitted us, and all these young children's artworks were still plastered over the walls, and the only working bathrooms were kids bathrooms with out-of-proportion toilets. Sean and Rav had decorated the place with found flowers and things. Everything in the building had started to fall apart, and they had tried to maintain it all. There was this funny kind of juxtaposition; of us as big kids, dressed up formally, getting drunk, in something that was really beginning to fall apart. And I suppose what is a party, but a celebration, a memorable event, a transitional event, a rite of passage that looks back and forward? And here we were, in this building that was starting to fall apart. And we got a bit drunk and out of hand. I still have this sign that I found there. I don't know what it was doing there. It's a sign that says 'this is not a shame' painted on canvas. I took that down as a memento of the occasion and I still hang it in every house that I have resided in since. A little reminder of a wonderful party, and a wonderful lead-up, or anticipation to the event, and I wonder if I will ever be able to go to one like it again...

Richard DeDomenici has recreated the censored Google Street View image of the man being sick in Curtain Road: http://tinyurl.com/cxa646

Memory 0110 Anonymous
Sydney, March 10

My moment, well it's not really a moment - it's an extended time - was part of a Sydney Front show in 1993 taken from The Passion Of Christ. It was towards the end of the show, after the crucifixion of Christ. Quite a hilarious and sinister scene in which Nigel Kelleher was faceless and anonymous, and hidden away in this huge clown costume, and bombarded by tomatoes by the audience. And then it went dark. We were all standing or walking around, and there was suddenly this noise up in the roof. We saw a hole, which was covered by Perspex - the only light source shining down on us. And then suddenly there was sand and earth being shovelled onto this opening. The light became smaller and smaller, and the theatre became darker and darker, and you realised that it was basically the burial of Christ, and that we were all being buried there collectively. We just kind of stood there and watched this vanishing of the light above us. And eventually there was no more light, and it was really quiet because the shovelling had stopped, the performers had left, we were by ourselves, no performance happening in a normal sense. And we were left in this very deep silence and darkness. And then suddenly a mist started to descend on us because they had turned on the sprinklers. So this slow and gentle rain came down. We were in this tomb and this rain was falling. It

was just so exquisitely sad and beautiful. And it was an incredible feeling of us, together, in this situation, in this darkness, with the rain falling, the mist descending. It was very, very beautiful. Yes I have never forgotton it. That moment…

Memory 0210, Anonymous
Vienna, April 10

When I was in my final year in high school my friend and I, we used to hang out after school – not go directly home. So one evening, it was dark already and we were in the city, sitting by a monument behind the Opera Theatre. And my friend was, well he still is, a singer, quite a good singer nowadays, but he used to sing in a boys' choir, and they used to do all kinds of things for the City Opera, and he was suddenly saying, 'do you know there is a fire ladder, the fire exit, and you can actually climb up to the top of the building? Lets go and do that.'

And we were quite crazy. We went on climbing, up and along the façade, to the top of the Opera House. And the roof is a little like a pagoda, a little bit leaning. And it led to a hatch, or a kind of entrance. And somehow he knew about it, or he had heard somebody telling this story - that you can actually climb in from there, and then you will be above the stage, where they move the staging and fly the props. You were on these….like bridges, like metal bridges.

And we went in there. And there was

an opera performance going on. It was evening. I think it was Mozart's Magic Flute or something like that. And we were watching it above their heads for sometime. We were really, really silent, terrified that something will drop or someone would find us. For sometime we were just standing there, looking down, excited, our blood rushing inside us.

And so like I said, he had been in the building before. So finally we did not go back out, but down the stairs that the actors use. And of course at the exit there was this old lady behind the desk who registers everyone who comes in and out, and she asked where are you coming from? Basically I think she understood that something was quite wrong but she did not want to dig. We were still only young boys and probably not very scary looking. So that was my experience of breaking in and looking at the grand opera from the roof, high above the stage.

Memory 0219, Anonymous
Vienna, April 2010

I went to this performance in an arts space in the second district. It's kind of an off-space, not really known or popular. But the performance moved me a lot. It was not very nice, not very beautiful. In fact it gave me a really bad feeling. It was about migration, about migrants, and how they feel in a country where they are strangers and are not made welcome. And the performance was

very simple. Just one person going round and round the room, doing circles, and telling of her youth, and her migration to Austria. And then it got harder and harder, and there was a kind of climax when the performer started to argue with people and even react like an animal, biting people and coming close to other people. And I really felt like I don't want to get in touch with that person, I don't want to be part of that performance, and I just want to leave because I cant stand it any longer, but then I realised that this was the moment that was intended. I felt guilty in that moment. And the other people in the room, they didn't want to have contact with her. Some really fought with her and pushed her away, and it really was a visceralisation of what happens in our country with people who come from other places. So in the end I thought it was a really good performance because it gave me this feeling of how someone who is a stranger feels in our country.

We See Fireworks by Helen Cole is commissioned by New Theatre Architects and supported by Arts Council England. Produced by Inbetween Time Productions.

Culture crash

Theron Schmidt

Here's a story. Not a bedtime story, but a story to wake you up. The story of a fleet of jet-black ravens who dive bomb down to earth. Knocking out the power plant outside of town, they keep coming, crashing through the basements, the living rooms, the politicians' corridors, and all the trappings of bourgeois life.

This is one of the dark fairy tales told in Pacitti Company's *A Forest*, an intimate performance for a small audience gathered around a gleaming mound of coins. Three performers co-inhabit the space: Robert Pacitti telling stories from the circle's periphery; Sheila Ghelani serving as hostess, an intermediary between audience and event; and Richard Eton as the stooge, the fall guy, his body a canvas for Ghelani's manipulations. Ghelani circles the space coyly, offering first her breasts and later a pair of pig's feet. Eton burrows into the coins,

dances to exhaustion, and finally becomes a landscape of small trees, affixed with hot wax to the counters of his supine body. And Pacitti tells story after story in a carefully modulated tone that is both demure and gleeful, taunting us to join in an indulgence of depravity and refusal. It feels as if this piece itself wants to be like that hole in culture, the one blown open by the ravens; it wants to transform the round pile of money we are staring at into an empty void, capitalism's hollow heart. It is a deliberately audacious piece of theatre, and its success depends on each individual audience member choosing to go along with it. But then this is spelled out at the very beginning. Pacitti says, 'You have two choices: believe everything is okay. Or drown in shit.'

Pacitti is also the founder and curator of the biennial SPILL Festival, now in its second installation. So if he intends *A Forest*

to be an interruption within culture, then it's little surprise that the works he has selected for the festival also feel like irruptions of culture's dark side. For example, Julia Bardsley's *Aftermaths: A Tear in the Meat of Vision* draws an extended and multi-textured analogy between the current crisis of capitalism and ideas of religious rapture and apocalypse. Bardsley appears on a cross-shaped catwalk as part space cowboy, part revivalist preacher, her teeth gleaming with diamonds and a horsehair tail trailing behind her. The audience stands in four inwardly facing sections, divided by the catwalk and surrounded on the outside by large video projections.

Capitalism can be a soft target, especially when it's already down, but *Aftermaths* digs below the surface to expose primal fears and desires, a craving for accumulation which hopes desperately to forestall annihilation. 'Welcome to the black market,' Bardsley declares, 'I will be the eye by which you see the sight of things hidden.' Her visuals and immersive sound experience are striking, and the glossy, black catwalk is a powerful theatrical statement. But, despite being surrounded on all sides by fleshy, visceral images, and despite the dance-club feeling of the throbbing soundtrack, the experience still feels distant; the piece remains too theatrically self-conscious to be totally immersive. Maybe this makes sense: rather than replacing the spectacle of capitalism

with the spectacle of anti-capitalism, Bardsley leaves her viewers questioning, free to choose, as individuals rather than members of a congregation of converts.

In keeping with the festival's commitment to audience engagement, at its centre was an unprecedented mashup of art, counterculture, and politics: the twelve-hour, dusk-till-dawn *Visions of Excess*. This swirling mix of provocations and performances included Bruce Labruce's troupe of blue-eyed, (fake) blood-drenched, masturbating zombies; Ron Athey's wig-wearing, (real) blood-soaked self-fisting; Samantha Sweeting's one-to-one breast-feeding encounter; and host David Hoyle's sharp-tongued mix of universal bonhomie with strident class and gender militancy. *Visions of Excess* admirably expands the frame of the art festival and the kinds of work to which it lends legitimacy. But this expanding frame also overlaps with other frames. An unsettling coincidence was the fact that *Visions*' venue (the Shunt arches under London Bridge station) placed it next door to the London Dungeon attraction, with its less transgressive deployment of blood-soaked zombies. Inside the event, the atmosphere and audience shared much with London's club scene, bringing its own celebratory sense of community, but also its hierarchies and exclusions. And throughout the evening, I often found myself twice-removed from the events, being unable to directly see what was happening and instead

Brian Lobel thinks the
National Review of Live
Art is like Glastonbury
but with cleaner toilets.

looking through a glowing swarm of digital camera displays. Overall, the event produced a complicated, shifting blend of different forms of community: we were sometimes consumers, sometimes voyeurs, sometimes engulfed within a collective, and sometimes singled out as intimate partners.

For me, the works which were most effective in this context of expanding and overlapping frames were those which attended to their circumstances, creating or commenting upon their own frames. In Zackary Drucker's interactive performance, crowded onlookers, hungry for spectacle, were twisted into unwitting accomplices. Pushing forward to try to glimpse his reclining, hermaphroditically posed body, we were invited to help 'perfect' the image by plucking all the hairs from his body with individual tweezers. And Franko B's *I'm Thinking of You* featured first Franko, and then a series of volunteers, each sitting naked on a gilded swing for an hour. The idyllic, beautifully lit scene was a point of constancy through the evening: mesmerising, unsettling, innocent and provocative, its simplicity worked subtly under the skin amidst an orgy of complex images.

The festival also saw the premiere of Forced Entertainment's *Void Story*, in which the famously risk-taking company try out a radical new direction: narrative. The piece depicts the awful misadventures of a hapless couple who through an endless night are shot, evicted, chased through sewers, knifed at a fun fair, and harassed by ghosts. The story is presented through two elements: four seated actors who, as in a radio play, read from visible scripts and manufacture sound effects; and a backdrop of projected black and white illustrations of the narrative. The images are crude photo-collages, filled with glitches and artefacts and the same set of recycled images. They are beautiful: stark and deliberately imperfect, obviously handmade, a welcome refusal of the seamless computer-generated characters and landscapes that have become ubiquitous in mediatised culture. In contrast, this is work in which the seams are very much visible, flaunting its status as make-believe.

And yet, despite everything, I start to feel something for these two characters. When one has his leg caught in a bear trap, the sound of breaking bone is only electronic crackling, and the projected image is just a picture of a trap pasted onto a photo of an actor, and the howling actor is not feeling any pain; and yet my stomach turns anyway. This discomfort is part of a wider pleasure, which is the reality of being told a story. It's like something the narrator says in Tim Etchells' 2008 novel, *The Broken World*, which describes an immense and unending computer game. Rejecting those who question the reality of the game, he asks, 'Is it reality to be even asking if it's reality in the first place? [...] In the end *The BW* is just a part of reality. It is

Richard DeDomenici
Tate have improved
their website's video
streaming, so, for those
who couldn't locate
it before, here is the
direct link to me trying
to give a paper on the
topic of Post Avant-
Garde Activism at Tate
Modern last year: http://
channel.tate.org.uk/

in the world – a part of the world. That's all there is to say.'

The final theatre piece of the festival is another Pacitti Company piece, *Intermission*, a mesmerising solo performance by Sheila Ghelani. Ghelani alternates between nine microphones, each labelled with a mode of performance: fact, fiction, high horse, karaoke. The piece appears to set itself up as the chance to tell it like it is, once and for all, on a series of controversial topics: abortion, death, religion, cannibalism. But as Ghelani shifts between topics and modes of address, what emerges is less a strident, coherent manifesto, and, more interestingly, a complicated overlap of different voices and contradictory beliefs. As with the storytelling in *A Forest* or *Void Story*, as with the theatricality of *Aftermaths*, as with the overlapping audiences in *Visions of Excess*, *Intermission* foregrounds the fact that there is no place outside culture from which to stage an intervention. Any intervention into the way things are will always be made out of things that already are – readers, actors, witnesses, places – just twisted, made strange, spilling out of their boundaries.

Spill Festival, London, April 2-26, 2009

Culture crash by Theron Schmidt first appeared as *Culture crash: things as they are* in RealTime 91, June-July, 2009 and is reproduced with the permission of the writer and the publisher, Open City Inc; http://www.realtimearts.net/article/issue91/9444

A Rebel Form Gains Favor. Fights Ensue.

Carol Kino

http://www.nytimes.com/2010/03/14/arts/
design/14performance.html

This link was active as of February 2011. This article was submitted for the Almanac and the editors were eager to include this piece for its coverage of Marina Abramovic and her exhibition at the Museum of Modern Art, New York. Although the New York Times granted permission for its inclusion, the level of fee involved was unfortunately prohibitive in relation to our budgets. We do hope you are able to access the writing online.

Push and Pull

Lizzie Muller (ed.)

Hi Live Art Almanac Folks

I'd like to recommend extracts from a blog that documents the re-creation of Allan Kaprow's "Push and Pull: A Furniture Comedy for Hans Hoffman", by Lucas Ihlein, Nick Keys and Astrid Lorange. The re-creation took place at Locksmith Gallery in Redfern, Sydney in May 2009 as part of *There Goes the Neighbourhood*, a project exploring the politics of urban space and the forces of gentrification.

http://www.pushandpull.com.au/

In case you don't know the work, *Push and Pull* is one of Kaprow's "environments", and was originally presented in 1963. It is a participatory installation in which visitors arrange and re-arrange domestic objects and junk. It was originally conceived as a parody of, or homage to Allan Kaprow's painting teacher, Hans Hoffman, who often

used the phrase "push and pull" to describe the dynamics involved in two-dimensional composition. Kaprow expanded Hoffman's concept of compositional strategy, moving it beyond the canvas and into social space. It is a powerful, but light-hearted study of participation, negotiation and the emergence of social rules.

From the perspective of contemporary debates in live art, the 2009 version is part of the current interest in re-creating and "re-living" the live art events of the past. The project was led by Lucas Ihlein who has an established practice of re-creation (having previously re-created numerous Expanded Cinema events as part of the collaborative group Teaching and Learning Cinema - see www.teachingandlearningcinema.org). Lucas argues that recreation has a particular significance in the Australian context, as

there is a sense of a double separation - both of time and of distance - from a fabled avant-garde.

During the re-creation of *Push and Pull* Astrid, Nick and Lucas kept a collaborative blog that documented the progress of the installation, and their own experiences of it, over its 9-day duration. All three artists are known as writers, and all three are interested in experiential aesthetics. The blog is more than documentation – the artists' accounts and reflections are insightful, lively and profound. In many ways it is an artwork in itself as well as a compelling critical investigation of the nature of art and participation. The entire blog is too long to include (in fact I wish they would produce it as a book), but here are a couple of short extracts to give you a flavour.

Regards,
Lizzie Muller

Pushing it…(some thoughts before we start)
Posted: May 27th, 2009 |
Author: Lucas Ihlein

[This is an extract from the introductory post to the blog, in which Lucas charts the course of the installation through its various historic re-creations, and ends with some observations about the work's relationship to everyday life]

Push and Pull is not about making objects strange (transforming them like Yves Klein), but rather about setting up a situation where one's own tendency to order things, or move

them towards disorder, is brought to light, and set in tension against the tendencies of other people.

When it's set up away from the sanctity of the museum, *Push and Pull* has the potential to operate as a kind of mini laboratory of what goes on when we re-arrange the living room, plant a garden, or argue with the next door neighbour about how much of that tree should be lopped. The piece gives us an opportunity to actually see our hitherto unacknowledged ways of doing things in a safe environment.

And the work has the effect of making that awareness contagious! It leaks into the rest of life.

As Keg [Keg de Souza - the curator of There Goes the Neighbourhood] said to me recently - "I go into the kitchen - filthy pots and pans everywhere. I shove them to one side to make myself a sandwich: *PUSH AND PULL!* … I go downstairs to find my bike buried under a pile of greasy rags. I dump the rags on Lucy's bike: *PUSH AND PULL!*" (NB: Keg lives in a warehouse with 8 flatmates).

complexity, weather
Posted: May 31st, 2009 |
Author: Nick Keys

The space is marked with traces of the previous nights' frenetic movement. Like waking up the next afternoon after a wild house-party, the mess is pleasant memory,

ghosts of the movements that made it. Zoe's giraffes, Astrid's letraset poem, Hilik's knives, Simon and Keg's cardboard ladder and the gaffer soup can. With the traces linked up to the creator-ghosts who left them, you get this sense, if you think about it as a composition, of anarchic harmony. Anarchic harmony is something Astrid once wrote, or perhaps she got it off John Cage, but in any case it reminds me of a wonderful etymological distinction that was pointed out to us one day by the great artist and teacher Ross Gibson. He talked about how the word *complicated* comes from the Latin *plicare*, which means to fold, and that *complex* comes from *plectere* which means to plait. So a complicated thing is a single thing that is folded, for example, an origami swan is complicated from one piece of paper. A complex thing is something that is plaited, that is, has multiple interlaced strands that form a kind of network, like a Turkish carpet. So the anarchic harmony of the room is complex rather than complicated, because it is composed of many strands, without a master plan or single piece of paper that organises it. And I suppose for this reason many people would see this *Push*ed *and Pull*ed space, as we found it on the day after the opening, as disorder, as mess. But complexity is not chaos or anarchy in the usually (and wrongly) understood sense of the terms. Chaos and anarchy are not total disorder, complete lack of relations, but are rather the order of

relations themselves, just as in ecological systems. And Push and Pull *is* an ecological system. Ecological systems are not just what happens in the wilderness, untouched by the evil hands of humans, they are everywhere, where humans and non-humans exist side-by-side, in complex relations.

Objects of experience: Stein meets Whitehead meets Olson [meets] Kaprow, you & me
Posted: June 9th, 2009
Author: Astrid Lorange
[These are the last paragraphs of a long post that Astrid wrote connecting Push and Pull to Gertrude Stein, Alfred North Whitehead and Charles Olson]

The objects in Push and Pull are mostly domestic miscellany, like in *Tender Buttons*. And, like Stein's poetry, the exact histories and identities of the objects are largely unknown or forgotten or obfuscated. They behave as indexes: each object might refer to any other thing or event. The spatula has been taken up in countless occasions of play and re-arrangement – it has been used to push, pull, lever, scrape. It has been hung and draped and wedged and given centre-stage in temporary sculptural installations. It has suggested a kitchen scene, a flyswat, a sword or a building. It has been held in the hand of participants just for the pleasure of cold, flat metal slapping the heel of the palm. As an object it indexes the infinitude of its

Richard DeDomenici
is trying to make love
to a Dyson Airblade.

own potential usefulness. In this sense the objects of Push and Pull might be imagined as 'quasi-objects', a term from Michel Serres. The 'quasi-object' is an object that 'attains' objecthood through active engagement and movement, literally in the moments of being taken-up, as in play. For example, the ball in the game 'kill the dill with the pill' has little weight until quick, fierce play begins: when the ball moves from person to person, its objecthood becomes electric, frantic with meaning. Its movement and location are known so *intensely*. It is a *quasi*-object because it exists only in this relational intensity – between two terrified players.

It's this non-representational (indexical?) play that is so key to Push and Pull, and that constantly reminds me of a Steinian poetic. The experience of reading *Tender Buttons* is similar to moving through the gallery space. Objects are recognisable but are unknowable or uncertain in terms of a meaningful or static configuration. At first their uncertainty is unsettling, perhaps even slightly unnerving. Until there is an engagement – poking through the wires of a TV's intestines, sketching onto a wall with a blue pencil, stacking smutty manga into neat milk-crate shelves – the objects remain 'dumb', in the Serrian sense. They become charged with temporary meaning in the passing between players. They are pathogens, parasites, vectors, electrons. They move and are moved. Each iteration indexes a thousand

more. And they're not just the objects that have been brought into the space, that exist as concrete somethings. They're also the objects of sense-awareness: the flickering of light from a backlit Botany Road traffic stream, the yellowness of the room half-filled with chairs, conversations, smells of the Locksmith crew cooking lunch, small desires and fantasies being birthed and expiring during people's visits. These are Whitehead and Olson's 'actual entities,' as real as the ladder or massage table, as real as the timelapse compositions, as real as Kaprow's crushed strawberries.

Push and Pull is a collection of writings by Lucas Ihlein, Nick Keys and Astrid Lorange first featured on www.pushandpull.com.au and subsequently edited for this Almanac by Lizzie Muller.
The original writings are as follows:
Pushing it…(some thoughts before we start) by Lucas Ihlein.
http://www.pushandpull.com.au/2009/05/27/pushing-itsome-thoughts-before-we-start/
complexity, weather by Nick Keys.
http://www.pushandpull.com.au/2009/05/31/complexity-weather/
Objects of experience: Stein meets Whitehead meets Olson [meets] Kaprow, you & me by Astrid Lorange.
http://www.pushandpull.com.au/2009/06/09/objects-of-experience-stein-meets-whitehead-meets-olson-meets-kaprow-you-me/comment-page-1/#comment-977

In Memoriam: Ritsaert ten Cate (1938-2008)

Mike Pearson

At the centre of the screen is a small wooden structure with an elaborate, tiled roof, set on a four-legged plinth against a grey concrete wall that shows traces of blackening: a shrine, bird table, garden ornament perhaps that hints at Japan…The soundtrack seems to mix street noise and Buddhist chanting.

He enters from the left, bald pate familiar, body thinner than some will remember, in blue short-sleeved shirt, arm naked, back towards us, face – his serious face – in profile. Eight times he extends his arm with great delicacy and precision to place objects, flowers in the main, into the interior. He withdraws. We wait.

A jet of billowing flame, orange and yellow, suddenly fills the frame. As it subsides, the structure is revealed on fire, crackling. At times the conflagration almost disappears, drawn up into the roof space, then emerges again, curling around the eaves. Pieces of debris begin to fall. It demands our attention – it's only a matter of time. The shadow of a bird passes. And then it collapses, catastrophically. The roof topples, the finial falls. All that remains is the smouldering plinth.

He enters again from the left. In the charred remains, with great delicacy and precision, he places fruit and flowers that suggest, in their composition, a Dutch still life painting. He withdraws. He will not return, ever again.

The video lasts seven minutes twenty-three seconds. It is entitled 'The Offering – a Meditation'. It is credited as collaboration with Catherine Henegan and Eric Hobijn. How typical that he should chose to work in these dying moments with a South African video maker who studied at DasArts and a Dutch pyrotechnics artist whose reputation was assured after his performance of self-

immolation at the Touch Time Festival. Typical too that it is to be found on YouTube, on the latest platform of performative exposition. How extraordinary – and typical – that he had the prescience to make this, with the same mix of resignation and creative hope that he brought to the dramaturgy of his own funeral, an event that ninety-year-old Ellen Stewart would travel from New York to attend.

It is the final work of Ritsaert ten Cate, made in acknowledgement and embrace of his illness and the inevitability of his own passing. He has the last word and typically – though nothing was ever typical about Ritsaert – it is a question: What does this mean? A metaphor. But for what? His own life; his career trajectory; the restorative power of art; the fate of the US? Maybe he's just burning down the house, the house of institutionalized art anyway. Reminding us: Do It!

His achievements are a matter of record. In the early 1960s he and his first wife Mik purchased a farm at Loenersloot outside Amsterdam with money inherited from his textile-manufacturing family. In a converted barn, they started a theatre club that opened in December 1965 with a production of Johnny Speight's *If there weren't any blacks you'd have to invent them*, closely followed by an evening with Nina Simone. Touring companies quickly reached Stichting Mickery Workshop; in this earliest period, Traverse

Theatre were frequent visitors. Then in 1967 came Stewart's La Mama, in the first of many appearances, with *Tom Paine: Part One*, and Bread and Puppet Theatre with *Fire*. In 1969 The People Show arrived as harbingers of the nascent British scene, to be followed by The Freehold Company, Moving Being, The Ken Campbell Roadshow and many others. Thus began a programming policy that would see Mickery become the pre-eminent locale not only for staging alternative theatre but also for producing such work, particularly after the move in 1971 to a former cinema on Rozengracht. It became the first port-of-call for work new to Europe, introducing Dutch and other audiences to Mabou Mines, the pre-Wooster Performance Group, Robert Wilson, Peter Sellars, Tenjo Sajiki from Japan, Squat Theatre from Hungary. Ritseart developed long-term relationships with a number of directors including Pip Simmons, who created several productions at Mickery, and with John Schneider from Milwaukee-based Theatre X.

I first met him in May 1973 at the World Theatre Festival in Nancy, where he saw us perform. That December he invited RAT Theatre to his theatre, and although I had already left the group he persuaded me to return, them to allow me to. It wasn't difficult: to perform at Mickery was already a cherished ambition. I'm not sure he liked our rough-hewn style but he appreciated our seriousness. I still possess the 'justification'

of RAT that he wrote for press and public, clear in his responsibility to nurture a critical framework for and popular understanding of emerging practices. The following year, he arrived at Nancy with all the major Dutch critics in tow.

Mickery was the place to be, to be seen; there was even a rumour that the Arts Council regarded it as part of the English touring circuit, so crucial was its role in fostering radical approaches. At that time Ritsaert favoured Anglo-American work, and whilst his internationalism and Anglophone predilections did attract criticism in the Netherlands, he himself grew in stature as arbiter and advocate.

It was not all import; Mickery continued to make its own productions. In the 'Fairground' series the audience were moved around on seating units that floated on compressed air. And in a suite of multi-media works directed by Ritsaert himself under the rubric 'theatre beyond television' that included *Rembrandt and Hitler or Me* (1985), he presaged the outset of digital modes of apprehension using analogue means – through the overlay of different orders of mediated material, viewed by dispersed audiences in the theatre's various spaces, each group party to different interpenetrations of projection and action.

By the mid-1980s the scene began to change. New companies and directors emerged – in Belgium, Jan Fabre, Jan

Lauwers and Needcompany – and Mickery became a crucial venue for those practices that came to constitute the 'post-dramatic'. Ritsaert was instrumental in promoting these young theatre-makers, and a key player in that group of European producers whose preferences began to define the field. But by the time he staged Brith Gof's large-scale work *Gododdin* in an ice-hockey stadium in Leeuwarden, I think he had tired of the business. In 1987 he left the building to others; in 1991 he decided to leave Mickery altogether, concluding with one final flourish – the state-of-play Touch Time festival that included the Wooster Group with *Brace Up!*, LAPD, Bak Truppen, Station House Opera…

He placed his hopes in education. In 1994 he launched DasArts, an interdisciplinary post-graduate school housed in a former gasworks. The syllabus was organised as four-month blocks, each with a particular theme and a prominent artist – Ping Chong, Stuart Sherman – as curator. I was invited by a student to present a trilogy of solo performances *From Memory,* which commences with the death of my father, simply as a contribution to her own studies. Social engagement here was crucial for Ritsaert: I remember one student working with those who see the world through glass – a prisoner, an elderly woman, a prostitute; and another making sculptures for the city cleaning department from their discarded besoms.

Kira O'Reilly
FORTRESS UK: A
MANIFESTO CLUB
AND ENGLISH PEN
EVENT, SUPPORTED
BY FREE WORD
CENTRE: The Home
Office's new points-
based visa system
has meant thousands
of international
students unable to
start their courses
on time, cancelled
performances artists'
residencies and talks,
the growth of suspicion
and surveillance on
campus and art hosts
being required to spy
on their guest artists'
movements.

In 2000 he moved on again, leaving DasArts to concentrate on his own art works, for which he famously received a grant as a 'young artist'. They, and much else, can be viewed at <www.touchtime.nl>

And off the record? Many will attest to Ritsaert's importance in their lives and careers as mentor, councillor, teacher…Two of the first obituaries to appear were by Mike Figgis, who made his first film *Redheugh* at Mickery, and publicist Mark Borkowski, who writes: 'He always seemed at peace; maybe that was because of the triumph of his principles.' Many will tell of his great humanity, of his love for his partner Colleen, and of his lack of patience with time-wasters.

In the month before his death I was fortunate to meet Ritsaert on two occasions. When he heard I was working on a book on the Mickery he was full of admonitions to write my own version, and to have fun. As Marijke Hoogenboom noted in her funeral oration, his final words to her were: 'Take care of yourself. Make every effort to find your limits. Have fun. And if you are not having fun, shift position.' Towards the end, I asked him to list the ten most significant moments at Mickery; he compiled instead a list of ten people to speak to. Maybe he was just tired; maybe they have some version of events that he approves of; maybe I've become his envoy in a round of unfinished business. Difficult to escape the feeling that some of us at least are forever part of

Ritsaert's unfinished story; certainly, many of us would not be doing what we do without him.

He has left me a book. Aware of my interest, and as a reminder that there are worlds beyond theatre, it is a large volume on birds.

And the blackened wall? Perhaps a hint this has happened before, will happen, continually. Our only option, to go on…

In Memoriam: Ritsaert ten Cate (1938–2008) by Mike Pearson was first published in Contemporary Theatre Review, volume #19, issue #1, pp. 133–35, 2009 by Taylor & Francis Ltd, http://www. informaworld.com. Reprinted by permission of the publisher. Mike Pearson is Professor of Performance Studies, Aberystwyth University.

Disgust, Integrity, Solidarity

Jane Trowell

Brian Lobel had an absolutely astonishing, beautiful night at Duckie. Thank you to everyone who made it such a special time. It was a night that was described as "Edgey" "Hard" "Soft" "Abrasive" and a "Bag of Fun".

Introduction

24.08.10

The text below is from a blog written in February 2010. It reflects on reactions to PLATFORM's 50-day live exhibition and season of over 70 events on art and activism at Arnolfini, Bristol, called "C Words: Carbon, Climate, Capital, Culture". This took place in October and November 2009, in the context of the run-up to COP 15 talks on climate change in Copenhagen.

For 25 years, PLATFORM has worked between art, politics, activism and research, aiming to catalyse social change and to challenge power. In response to Arnolfini's invitation to "do our work", we decided to fill the galleries with our networks, through events, teach-ins, performances, and specifically to commission 7 artist-activist groups to make work for C Words. Just as PLATFORM has rarely sited its work inside gallery spaces, Arnolfini had rarely seen such an infestation of social processes within its walls, let alone comprising artist-activists and campaigners. The hubbub was big, the galleries were crowded, and the fit with "contemporary art" was often deeply uncomfortable and troubling.

For more critique, visit the blog for pieces from the gallery's stewards, and "It was doomed from the start" from Gary Anderson of the Institute for the Art & Practice of Dissent at Home...

http://blog.platformlondon.org/content/c-words-ripples-continuing

For details of C Words programme visit

http://www.arnolfini.org.uk/whatson/exhibitions/details/416

www.platformlondon.org

Richard DeDomenici
Uranium from
decommissioned
Russian nuclear bombs
accounts for almost
half the fuel used in
American nuclear
power stations.

Disgust, Integrity, Solidarity

Nearly three months have passed since C Words closed and I've been re-reading the blog entries, my and others' copious notes and records, the heaps of rich and mostly positive feedback we've collected on paper, in emails, interviews on video, audio, and anecdotally.

This compensates for the tiny art-critical response: one interesting and thoughtful review by David Trigg in an (Artists Newsletter), a mention in Gavin Grindon's great article in February's Art Monthly, regular tracking and comment on the RSA's Art & Ecology website (C Words is 9 out of 21 "Highlights of 2009"), quoted in a piece by Madeleine Bunting in the Guardian on the rise of art & climate change...

http://www.a-n.co.uk/interface/reviews/single/584767
http://www.artsandecology.org.uk/magazine/features/2009highlights
http://www.guardian.co.uk/artanddesign/2009/dec/02/climate-change-art-ea...

Then there was the rather Daily Mail-like piece in the Guardian "Artists use public money to fund Copenhagen summit protest"

http://www.guardian.co.uk/environment/2009/oct/23/copenhagen-protest-art...

But the art world at large, it seems, did the three-monkey act with C Words: we won't see it, hear it, or talk about it. We did get lots of hearsay transmitted to us mostly via Arnolfini's Director, Tom, such as "X told me he liked our "piss-take" of a climate change exhibition". Or, "some of the stewards are embarrassed by the work". Or "But this is THEATRE!", (said critically of the opening weekend's events). One steward said to us, thoughtfully, "PLATFORM clearly doesn't want to be reviewed in Art Monthly." Much later in the run, a member of staff said to us about the art world, "If you'd been to Goldsmiths* and were referencing the right art theory, you'd be fine". All very interesting, potentially, about power structures, the role and aims of art and activism, and certainly needs thinking through if PLATFORM wants to do more of this.

In the opening event for C Words "Who's Recuperating Who, Pt1", writer and academic Wallace Heim spoke with anticipation about what she hoped for in C Words. She said that the work would and should cause disgust. It should disturb and offend. It should make us recoil. If the work did not, then it would have failed in the context of activism and art. This was a bit hard to hear with my campaigner hat on - surely, given our aims, we are trying to lure and bring people in, not alienate? But, I believe Wallace was talking about a particular category of response, a response from a certain quarter, the quarter that believes it "knows better" about art, the quarter that believes it has the power to decide what art is.

She explained: "There is a situation in theatre that is analogous – loosely – to

Brian Lobel is thankful for the Netherlands and their progressive views on scholarship and pornography.

bringing an activism into the art gallery. This is when activism, direct action or especially environmentalism is represented onstage, when it's acted out under the conventions of building-based theatre. However good the production, it can be difficult to watch. It can be embarrassing. The response to it can be almost physical – you want to turn away... the feeling that something is in the wrong place, it's exposed, or doing the unseemly thing.... An aesthetic judgement is being made, which is visceral – emotional – and then intellectually justified...
But I think the feeling of something like disgust, if it happens, is significant, and almost to be welcomed. It's an uncontrolled response that says some tacit rule or historical procedure is being unobserved. Differences haven't been smoothed out, already negotiated or sidestepped...."

She then went on to speak about integrity and solidarity - that the season was a form of public movement-building, with its guts exposed. More on this another time...

Back to disgust. It was a funny old schizophrenic business, working daily in the galleries. The weekends were stuffed with events, encounters, and people. A real hubbub of excitement. Many diverse views, much exchange, a great deal of commitment. People who had deliberately come to the events mixing with people who had stumbled across them and had chosen to stay. Collisions of people from finance, art, direct action, research, education... We had dozens

and dozens of conversations and rarely came across anything more negative than sceptical curiosity, or sometimes bafflement. It seems the disgust lay more with the specialists.

This comes into relief right now, partly because I've got to write the Arts Council report (specialists!), but more than that, PLATFORM needs to make sense of what we did and consider how - and in what direction - to move forward with work of this kind, and in relation to the art world and its norms. To present our practice in a gallery on this scale was a massive experiment, and one we undertook after months of discussion, and in the face of some serious misgivings from some colleagues. The Arts Council has project-funded us pretty loyally for over 18 years, recently making us a Regularly Funded Organisation. None of this support has been about working within the world of galleries. All of it has been because of our interdisciplinary work, made in places selected for their social, economic, geological, political possibilitiies, their potential to provoke real change. Sites which 99.9% of the time are other than "art". There is a long and rich tradition of artists working in this way. Some of these artists work in relation to galleries and the art world, and many not.

Given that, our question was, what should we do with this bold invitation from a leading gallery, this huge opportunity? "Do your practice!" said the director of Arnolfini, who'd invited us. So, we did. We moved into the gallery for two months with groups

and allies whose work we find important, political, and provoking. We did what we do, but in a public gallery, which is to enable conversations, skill-shares, trainings, performances, installations, poetry-readings, screened films, hosted walks, and meals. We spoke to 100s of people. We worked closely with Arnolfini staff on a very stretching timetable. We improvised, got things wrong, got things right, made new colleagues, fostered new networks. We publicly listened and reflected on everything in the weekly Critical Tea Parties and elsewhere.

Towards the middle of the C Words season, we realised that of all the staff at Arnolfini, only the stewards were really witnessing C Words in anything like its entirety. The office and programming staff could only really pass by, their responsibilities being to get on with the next programme. This presents some problems for our kind of work. With a conventional exhibition, you select, promote, install the work, have an opening preview, the artists go home, and the programming and planning team largely move on to the next show. With a season of over 50 live events, and PLATFORM in effect in residence in the gallery, for C Words the artwork is the whole thing: the live events and static exhibits or installations, from beginning to end, and beyond. But actually, very few people in the institution were seeing it.

This was also the same challenge for audiences and participants, and other colleagues in PLATFORM. A member of the audience may come on one or several visits, deliberately or as a passer-by. The sense of the totality unfolding over time may elude that visitor or participant - this was one area which we would definitely address differently next time. Yet for locally based and other people who engaged regularly with C Words, we received a lot of positive feedback on the sense of excitement, the fluidity, the sense of making something happen in real time, which they felt from each event, each visit to the evolving galleries.

Sarah Warden, who looks after Live Art programming at Arnolfini, understood this when she said that we wouldn't be able to judge or make sense of C Words til Day 50, and even then, it would only be a beginning. But our programme was hosted under "Exhibitions", not Live Art, and herein lie the interesting tensions, delicious frictions, and monstrous aggravations. (By the way, only some fraction of these came out in the blog, I notice. Was it too tender and difficult to raise at the time? Maybe. But also it was such a rollercoaster, time-squeezed experience that to try to describe something very tricky and yet also hackle-raising on the fly could have risked some almighty blunderings that might have backfired. So it's only now that we can get our heads around it, slowly. Some might say we should have blogged warts and all. Not only might this have increased interest in the work, but also "outed" the issues, been more transparent, more confrontational.

Brian Lobel hopes
this purple sky is filled
with purple rain.

Maybe, but that would have upped the institutional tensions dramatically; and that was not needed by anyone. That would be a different artwork.)

Anyway, as a result of our realisations about the stewards' exposure to C Words, we proposed to them that they become critics, and write some responses for us. A kind of "What the Stewards Saw". Four of them did this and we are going to publish their often critical pieces very shortly on this blog.

Looking back, I can't help but think that this one is a slow-burner. A massive intense outburst of production for those involved during October and November, but the harvest is only just beginning.

We've been to see so many art & climate change exhibitions/seasons in the last year or so: FACT's Climate for Change, Radical Nature at the Barbican, Earth at the Royal Academy, 2 Degrees by ArtsAdmin, Rethink shows in Copenhagen... What's certain is that mainstream culture is attempting to grapple with climate change. This is arguably a Good Thing, as many people felt about the election of Barack Obama to President in terms of race issues. A good thing? But, as with the question of Obama, the devil's in the detail, not the principle. What are the dangers of a kind of inoculation? Of an anaesthetic reaction, encouraging us to feel better, to pat ourselves on the back, to sense, to engage, but not to act. We consumed that exhibition, we voted for that President, so our work on the issue is done. We sense, feel, think about the issues, but in the end we can be numbed and separated from the most useful - the most hopeful - kind of pain: the pain that can make us act.

What does all this contribute? In whose interest is it made? Who is it talking to? Who cares?

Questions that C Words has to answer too.

Parting new thought: the critique over the aesthetic in C Words - an overtly activist project - can end up as another anaesthetic. A shield of affronted reaction to an aesthetic deemed out-of-place in a gallery, in order to avoid something even more uncomfortable?

"But I think the feeling of something like disgust, if it happens, is significant, and almost to be welcomed. It's an uncontrolled response that says some tacit rule or historical procedure is being unobserved. Differences haven't been smoothed out, already negotiated or sidestepped...."

*part of University of London, famous for its fine art and curating courses

Jane Trowell works in Education and Outreach at PLATFORM.
Disgust, Integrity, Solidarity was originally featured on platformlondon.org 19 February 2010.
http://blog.platformlondon.org/content/disgust-integrity-solidarity

Art in the age of parochialism, protectionism and terrorism

Manick Govinda

Kira O'Reilly is tussling with how to fit a show, enough pairs of footwear & a toothbrush into her suitcase. This is second only to packing for retreats. Undaunted & determined, mathematicians specialising in multidimensional spatial organisation may be consulted before the night is out.

Chelsea Programme invited me to write an essay on the effects of national border regulations on artistic production and relationships in October 2009. At that time we were under a dominant New Labour government, having been in office for over 12 years. Within that period, New Labour's rule brought in unprecedented levels of state surveillance, ID databases, and counter-terrorism laws, as well as ridiculous bureaucratic regulations.

Nearly 12 months later from my writing of this essay, we have undergone over a 100 days of a new Conservative-Liberal government, who embrace the notion of freedom far more than the authoritarian New Labour regime did: ID cards for British nationals have been scrapped, the new government has pledged to review the UK terrorism laws, a suspicious tactic that was being used to stop and search photographers

and many Muslims, including artists; the brakes have been put on vetting adults who work with young people – a paranoid New Labour initiative that deterred many artists and academics from working with under 18s. So, the Con-Lib coalition are making right noises on civil freedom and rolling back over-intrusive regulations that have interfered with our civic and social freedoms.

However, with regards to immigration and the points-based system the new regime is hell bent on reducing immigration to the UK with the introduction of a new immigration cap. While certain areas of the immigration points-based system is being reviewed, the area (Tier 5) where many international artists come to the UK on temporary visits to take up residencies, performances, collaboration is not being reviewed. In fact, a feature in The Guardian indicates that the granting of visas to non-

EU overseas students (Tier 4), contrary to our fears, increased over the last 5 years. This does seem to indicate that the input of foreign students into the national economy is a necessity. It would be interesting to see how the immigration cap, when it comes into full effect, might damage this economic contribution. However, the number of temporary visas (tier 5) entries has practically halved over the last 5 years. This is where many invited overseas artists would be affected, which reinforces the current political outlook that temporary overseas workers (which includes creative artists) are of less economic importance.

The essay called for a review and scrapping of the points-based system, and this recommendation is of more importance than ever. If the new government is serious about less state interference in social and civic life, then this divisive, bureaucratic and controlling technocratic system must be ditched, as it continues to damage our desires, and cultural will to engage and work with international artists.

Manick Govinda
31 August 2010

Borderline is a multi-part project focusing on utilising artists' projects as a means of questioning how emerging European artists and designers are engaging with ideas around borders, nationhood, alternative methods of social organisation and collaboration.

The project also aims to explore the role of art in framing these ideas, particularly in relation to the current state of European politics and increasing social unease within many rapidly changing populations.

Concept
Many parts of the EU are undergoing a period of rapid social change due to non-European migration, and migration from Eastern Europe, as well as continued prejudice against Romany / Traveller communities. We are also witnessing the mainstreaming of far-right politics, as a reflection of unease amongst sections of the wider population. With this project, we aim to create a space for artists' commissions, web content and public discourse concerning the challenges being faced by artists wishing to propose alternative visions of contemporary Europe.

Borderline is funded by Arts Council England and Chelsea Programme, Chelsea College of Art & Design. Borderline is a Chelsea Programme project.

Essay
Chelsea Programme has invited Manick Govinda of Artsadmin to give his take on the current relationship between artistic production and borders.

His provocative essay can be found below. We welcome comments, thoughts and any provocations of your own, please log in to

Brian Lobel and
Annette saw Sister Act
the Musical tonight.
And yes, they loved it.

have your say.

Art practice is now operating under a constraining force of parochialism, amidst a European fear of terrorism and foreign immigration. If you're thinking of inviting an artist from say Russia, China, India, Brazil, Iran, Pakistan, the African continent or indeed Japan, America, Canada or South Africa to collaborate on a project in the UK, think again, because on 27 November 2008 the Home Office's UK Border Agency (UKBA) introduced a points-based system for employers, universities, arts institutions, commercial galleries, publicly funded charitable organisations that wish to invite non-EU migrants into the UK. The UKBA website describes the new points-based system as 'the biggest shake up of the immigration system for 45 years.' In order to invite a non-EU professional, organisations in the UK will have to sponsor that person.

To become a sponsor, companies and charities will have to complete an online application on the UKBA website. Various certified documents will have to be submitted, and there is the compulsory fee to pay the UKBA of £400 for charities, and £1,000 for non-charity organisations. Should you want to invite a skilled worker, under Tier Two of the system, this will set you back an additional £170 for each certificate of sponsorship (required by the migrant) or £10 if s/he is a temporary worker, under Tier Five.

It is at the discretion of the UKBA

regarding the number of certificates that they will allocate to an arts organization or university. So for example, Paul Heritage, Director of People's Palace Projects informed me that as a Grade A sponsor, they have been given less than half the certificates of sponsorship that they need for the year. "No explanation. Thus the cultural industries are decimated - this new legislation makes it impossible to do our job."

Impact on artists and programmers

Artists, musicians and writers have been detained, deported and refused visas, many have refused to come after humiliating and insulting treatment from British consulates and embassies, including: Dmitry Vilensky (Russian), Abbas Kiarostami (Iranian), Cristina Windsor (USA), MP Landis (USA), Anriban Mitra (India) and countless more. Kiarostami was asked for a deposit by Britain's visa office, to guarantee that he would not become a refugee. The regulations are wreaking havoc for curators and their artistic programme. Andrea Schlieker, Curator of Folkestone Triennial has said: "We are looking forward to inviting a number of artists from non-EU countries to the 2011 Triennial. Current Visa restrictions will unnecessarily hamper this process and endanger their participation."

So, the British Government is dictating who, and how many non-EU artists we can invite to the UK and charging us a

considerable amount of money over and above the project costs and making us go through tedious and meaningless bureaucratic hurdles. My own arts organization, Artsadmin has been given only 5 certificates of sponsorship to dispense to invited non-EU artists.

Guidelines

The UKBA guidelines are a turgid, opaque 190-page-long document that prospective sponsors have to plough through. But it's not just the tedious bureaucracy that's a hurdle. Should you decide to read the document you will also notice that the language reveals a massive degree of control on skilled and temporary migrant workers (that includes artists and academics) that polices and regulates their day-to-day activity. For example, all sponsors would be required to hold photocopies or electronic copies of passport and ID card details, recruitment practices would need to be submitted and the migrant must be qualified at the equivalent of S/NVQ Level Three or above – que?!! Try explaining that to members of AfroReggae, who grew up in the slums or favelas of Rio de Janeiro. Furthermore, if the visitor does not turn up to their studio or place of work, or their whereabouts is unknown, the organisation is legally obliged to inform the UK Border Agency. A further erosion of our freedom is the introduction of Biometric ID cards, which are now required of non-

EU overseas students, visa-national invited artists and academics, and non-visa nationals if they intend to work here for longer than 3 months. ID cards will have a photo of the individual carrier and list basic details such as name, date and place of birth, gender, and immigration status. Each card will have a microchip linking that basic information to centralised databases containing biometric information - what the Home Office calls a 'biometric footprint' - such as fingerprints and face recognition data or an iris pattern scan.

Police, immigration officers, and other state functionaries will be issued with scanners to check an individual's identity. Shops, banks, pubs and other businesses will not, but they will be given access to a 'special helpline' to call if they get suspicious about an individual's identity.

Nothing to fear?

So, what's the harm? As my campaigning colleague and Oxford academic James Panton states: "the biggest problem with the introduction of ID cards is that they represent a further and profound erosion of freedom and privacy - in particular, the right to live our lives beyond the glare and scrutiny of the state.

"But surely if you've nothing to hide, there's nothing to fear?" This mantra underpins the growing state impulse to regulate, intervene and certify almost

Richard DeDomenici
just heard a tannoy
announcement asking
for 'Inspector Sands'
as he exited Liverpool
Street tube.. http://
en.wikipedia.org/wiki/
Inspector_Sands

every aspect of our lives in contemporary society. It assumes that we are all potential miscreants until a state-sponsored certificate or biometric ID proves otherwise. This idea only makes sense if we think other individuals are at best untrustworthy, at worse a constant threat to the stability and security of our individual and social lives. ID cards, and the interventionist ideology which underpins it, are much more an expression of a government's sense of insecurity and isolation from the public than a real solution to the risks and uncertainties of our everyday lives."

As a member of the civil freedom group, The Manifesto Club, I've been leading a campaign against the Home Office's restrictions on invited non-EU artists and academics since February this year. Our petition has over 7,500 signatories including 1,000s of artists, musicians, writers and amateur enthusiasts of salsa, tango, belly dancing and religious music. Together we argue that these curtailments and restrictions reinforce a parochial outlook and is an infringement of our right to invite people from overseas from whom we wish to gain new insights, new experiences and with whom we wish to collaborate. I would urge everyone who believes in this principle to sign the petition and get involved.

Protectionism?

We live in an age of protectionism. In economic terms, protectionism is a strategy of restraining trade between nation states. In cultural terms it operates within many creative industries. So, for example Film London's FLAMIN awards, a production fund for artists working in film and video, stated in its criteria that all aspects of film production must take place in the UK. Why? Is this a strategy to combat the recession by forcing artists to employ a British creative team? Again, doesn't this lead to a parochial outlook and what about artists who make work about the narratives of those who are excluded from the cultural privileges of the UK? If that were the case, Danny Boyle would have been prevented from making Slumdog Millionaire.

The acclaimed theatre director Tim Supple could be prevented from having an international cast of amazingly unique performers for his forthcoming epic production of The Arabian Nights, which he anticipates being performed in Arabic, English and Hindi. He says that the production could be anything from 2 to 8 hours long. An Indian female actor who was part of his previous British Council-commissioned version of A Midsummer's Nights Dream was twice refused to come to the UK to work under tier 1, which is the highly skilled workers category of the Home Office's points-based system. Her

performance received great reviews, but alas we may not be allowed to see her talents. Her application to work here was turned down because she didn't have a minimum qualification of an MA degree and was unable to prove that she earned at least £20,000 per annum as an actor. This is an example where a protectionist bureaucratic state has gone just a little bit Kafkaesque. To earn the equivalent of £20k in India would mean that this actor would have to be in India's top earning bracket.

The Musicians Union has also taken on a protectionist stance, chanting the clichéd phrase of having to safeguard British jobs for British workers. Steve Richards, a leading immigration specialist in the arts and entertainments industry made the following comment in his blog: "It is regrettable that these [UKBA] Officers seem to think that promoters, booking agencies and record labels 'hire' bands to tour here by popping down to the Job Centre and putting an ad in the window; "Wanted – Popular rock band to play London O2 Arena; must be Metallica". It's so gormless that, frankly, it's insulting."

So, will curators have to put an advert in the job centre: "wanted – famous artist to exhibit at Tate, must be Bruce Nauman"?

Top economists have always pointed to the dangers of a protectionist policy. Alan Greenspan, former chair of the American Federal Reserve, has criticized protectionist proposals as leading "to an atrophy of our

competitive ability. ... If the protectionist route is followed, newer, more efficient industries will have less scope to expand, and overall output and economic welfare will suffer."

The recession has been used as an excuse to curb innovation and entrepreneurialism on an international scale. But the recession is not simply a national problem, it's worldwide. Surely now is the time to allow the free flow of talent and excellence across the globe?

Embracing talent

Rather than encouraging collaboration with creative professionals overseas, the Design Council seems to be worried that UK design is being threatened by the growth economies of India, Russia, China, and Brazil. 'What is impressive – and worrying – about the emerging economies is not where they stand today but how they are positioning themselves for the future', Design Council chairman, George Cox has said. I detect a tone of British anxiety here; perhaps it's time for British culture and industry managers to start reaching out to embrace the dynamic talent emerging from, and developing in other countries, which could be of mutual benefit to the UK and other countries as partners, not enemies. But more immediately let's scrap this divisive points-based system, which is damaging relationships with our international invited guests and professionals.

Manick Govinda is head of artists'
advisory services and artists producer for
Artsadmin. He is also campaign co-ordinator
for the Manifesto Club's visiting
artists petition.

Relevant Links
Visiting artists petition link:
http://www.PetitionOnline.com/MCvisit/
petition.html
Manifesto Club campaign site:
http://www.manifestoclub.com/visitingartists
Read Henry Porters excellent blog piece:
http://www.guardian.co.uk/commentisfree/
henryporter/2009/jul/11/artists-...
Read Phil Woolas MPs response:
http://www.guardian.co.uk/commentisfree/2009/
jul/14/phil-woolas-border-c...
James Panton on ID cards:
http://www.cherwell.org/content/8788
Work permit specialist's perspective:
http://www.tandsimmigration.co.uk/news.html
Protectionism: http://en.wikipedia.org/
wiki/Protectionism

Manick Govinda's essay *Art in the age
of parochialism, protectionism and terrorism*
was initially commissioned as part of *Borderline*, a
Chelsea Programme project, in 2009. An updated
forward to the essay was added in August
2010. http://www.borderlineproject.org.uk/

Hoyle's Humility

Gavin Butt

Richard DeDomenici is having trouble orienting himself in Manchester city centre due to the preponderance of triangular glass architecture: http://dedomenici.blogspot.com/2009/07/richard-is-having-trouble-orienting.html

Performance artist David Hoyle talks to Gavin Butt about his recent public spat with transsexual media personality Lauren Harries, about the risks of self-exposure in his queer cult show *Magazine*, and about the importance of not taking yourself too seriously.

I meet with David Hoyle the week after his fractious exchange with Lauren Harries at his weekly show *Magazine*. Already something of a cult hit for the unpredictability of its live encounters between Hoyle and his guests, *Magazine* frequently showcases discursive interactions for which neither the words 'discussion' nor 'interview' are particularly appropriate. This is because Hoyle tends to favour something more like a 'heated debate' (to quote Mrs. Merton) rather than the polite etiquette of liberal intellectual discussion or the staid respectful conversation of, say, a celebrity

media interview. This was particularly evident in the fiery exchange of views between Hoyle and Harries, which stayed very rarely on the 'right' side of insult; and in the boisterous interventions of audience members at the Royal Vauxhall Tavern in London. Some people simply shouted expletives, at both host and guest, whilst others made impassioned and angry political points. Tempers ran so high that at one point security was forced to eject someone from the building to prevent a fight breaking out. Hoyle tells me that he'd never felt more "vulnerable to physical assault" than on this occasion. "The energy was unbelievable", he says. And it didn't stop there. Virtual exchanges continued on websites between variously affronted spectators long after the show had ended. Some bloggers made the claim that Hoyle had 'bullied' his guest, whilst others counter-claimed that it was

Brian Lobel is
deeply suspicious of
text messages with a
three act structure.

Harries who was guilty of impoliteness and of being ill-informed (i.e. of not knowing what she was talking about).[1] In short, the show generated much talk about both what, and how, things had been said. In many ways, this is Hoyle's metier: to use the medium of performance to make controversial spectacle out of such ethically troublesome exchanges. And the point? According to Hoyle, it is to keep it *real*. To embrace, not airbrush, the uglier side of *Magazine*'s participants - of guests, audience members, and host - and to demonstrate that when we *really* engage with people and their differences, the results might not be pretty.

Harries is the latest amongst a long motley line-up of guests who have graced Hoyle's stage since *Magazine* began its three-season run in 2006, including an octogenarian recovering alcoholic called Peter, the artist Maggi Hambling, sex worker 'sleazy' Michael, and human rights campaigner Peter Tatchell. Such people have been invited to discuss various subjects, from God, Debt and the Trades Union Movement, to Gender Dysphoria, America, and the Internet. They take their place alongside the show's other regular features including videos, live painting, the performance of so-called 'abstract shapes', and Hoyle's own particular brand of warm, yet simultaneously sneering stand-up comedy. Hoyle appears particularly keen on maintaining a stage for rather humble and popular human performances,

upon which people avow their necessarily partial and limited views, alongside their moral inconsistencies and impurities. Arrogance, bombast, and superiority are qualities clearly frowned upon at *Magazine*. "I'm interested in questioning and betraying my own ignorance and prejudice rather than sounding learned and PC-ed up to the eyeballs. I think it's more interesting to say (adopts modest, unassuming tone) 'Oh well I thought it was like this ...'". Such a performance ethics may, at least in part, be rooted in Hoyle's newly found faith in a more reparative, therapeutic approach to life. This results from his recent stint in the performance wilderness between 2000 and 2006, when he took time out to deal with his personal demons and depression. Since his return to the performance circuit he has been noticeably mellower, and has embraced the healing and empowering effects of avowing one's fears and vulnerabilities. This mellowing is evident, perhaps, in Hoyle's personal demeanour, which is warm, courteous and respectful when we meet over a pair of posh chip butties at the BFI Southbank. But this is not to suggest that he's completely lost the edginess – either on- or off-stage - which brought him a certain notoriety on the 1990s queer performance circuit as the manically charged 'Divine David'. He still can be brought to the limits of his tolerance, and be publicly scathing, even provocatively offensive, to those with whom

Kira O'Reilly No
mobile phone, still
sick. Cloistered away
at home. Haven't
seen anyone since
Friday apart from
pixel people on
Skype. Strangely
enjoying it.

he disagrees – to which the recent encounter with Lauren Harries was testament.

Harries – formerly *James* Harries – was a precocious child TV star and antiques expert in the 1980s. Now, after having had gender reassignment surgery in 2001, Harries is a struggling transsexual media personality. Hoyle tells me: "I have lots of admiration and understanding for people who seek gender realignment because I know it's a massive decision and it's not an easy process to go through." This sympathy had led Hoyle to invite Harries back onto the stage at *Magazine*, and to give her another chance to put herself across to an audience after a previous gin-soaked appearance ended up with the transsexual 'star' too drunk and insensible to take part in any engaging exchange. But, in the event, the return appearance – though less fuelled by booze – was just as unruly a meeting between the two, if not more so, than the first time around. The views (or insults, depending upon your point of view) which were exchanged are perhaps too much to print here in *Dance Theatre Journal*. Suffice to say Hoyle variously accused Harries of being a "right wing cunt", and of transitioning into a stereotypically glamourised embodiment of respectable womanhood, whilst Harries counter-accused Hoyle of being mean, and of being too afraid to own up to his own transsexuality.

Away from the melee of the evening, and after having had some time for reflection on what took place, I find Hoyle in unforgiving mood. "When someone has gone through that journey, and has had gender realignment surgery, you'd think that the process would instill a little bit of humility. But I detected none which got my back up. My natural sympathies just went out the window really. I just thought this person is very reactionary and, god love her, not a particularly well-informed person. I know it sounds very schoolyard to say she started it … but she did." Indeed it was Harries having the temerity to venture that she was 'disgusted' by a previous performance at *Magazine*, which made Hoyle see red. He stills rails at what he sees as her superiority. "Lauren's very into herself, presenting herself as a character, a caricature, a sweet little dairy maid or something." Indeed she appeared on stage dressed very much, as Dawn Right Nasty has suggested, like Heidi or something right out of *The Sound of Music*.[2] "Was that a trans manifestation or does she sincerely think she was dressing as a woman? You can detect chauvinism in a lot of drag and transsexuality because the way people choose to manifest is very often at the more glamorous, bimbo end of the market. Very few are, say, modeling themselves on Andrea Dworkin."

Of course, Hoyle does have a (feminist) point here. There *is* a conservative strand in trans culture which places great value upon a gender transitioning which assimilates the trans-person into hetero-normative society.

Brian Lobel has attempted to write the most obnoxious facebook status ever: "While waiting for the red glitter on my nipple to dry, I read some Judith Butler".

But to reduce all transsexuality to this reading, I suggest, is unfair. I mention, by way of example, the Los Angeles-based actress Calpernia Adams who recently described herself as a *'radical* assimilationist' (my emphasis) to signal her paradoxical desire to *both* pass as a normative woman *and* be visible as a trans MTF. I wonder if the same could be said of Lauren, especially as she made much on Hoyle's stage of wanting to be visible as a transsexual media figure? Hoyle is having none of it. "Aspects of her personality were just like a coarse Liverpudlian drag queen. I said to her transsexuality is not the same as being an uncouth drag queen and yet there you are representing yourself in exactly that way." Hoyle seems so resolute in his position I wonder if he learnt anything new about trans issues that night? "What it taught me was even though transsexuals have a shared experience it doesn't mean they're going to come out of it the same. You know they've all got different personalities, different levels of education, different levels of interest in contemporary politics or the avant-garde. And some are completely uninterested in art." He gives me a knowing grin.

We go on to talk a little about how we both *felt* that evening. I say - without wanting to sound like the usual liberal - that I'd left with split loyalties; that I'd felt both sympathetic to, and affronted by, both Hoyle and Harries in more or less equal regard. But perhaps my response wasn't typical that night as many more rooted vociferously for Harries. "I felt like the pantomime villain" Hoyle tells me. Being vilified by his own audience was, he says, a "horrific feeling" but "I also knew there was an integrity to it. If I wanted to maintain where I was coming from it wasn't going to be an easy ride for anybody, me included, because I was bringing elements of northern stand-up, and northern brusque, and being very direct with the questions. But I did find it difficult." He impresses upon me the importance of taking such risks, of even being prepared to lose his audience. "I think it makes it livelier. When we're grown-up and mature we realise that not everybody is going to like us. And that's OK. I think some people might have thought I was heavy-handed but best to be that rather than be patronising or condescending."

Talk of a northern, brusque directness (Hoyle has more recently referred to Harries as "that cock-hacked-off cunt") raises interesting questions about *Magazine*'s indebtedness to traditional working-class pub entertainment. Hoyle is "proud" to hail from Blackpool, and calls the north of England "his bedrock." There's more than a whiff of regional belonging and class consciousness here, which makes sense of his broadly trailed socialist politics. But it's the *cultural* differences Hoyle seems to hang onto here perhaps more than anything else, especially in the midst of cosmopolitan, politically correct London. He relishes telling

me that, in his view, "Bernard Manning is the ultimate avant-garde artist." This I take to be only partly ironic, and partly genuine, and provocative, clue to the vernacular derivation of Hoyle's own brand of avant-garde performance. But in many ways, I suggest, *Magazine* is perhaps less like Manning and rather more like the contemporary forms of working-class entertainment which have replaced such 1970s pub and club entertainers: namely, chav-baiting reality TV shows like Jeremy Kyle's. What's the difference I wonder between the kind of bust-ups we regularly see on these kinds of programmes and the bear-pit scenarios, such as between Hoyle and Harries, at the Royal Vauxhall Tavern? "Maybe there's not a lot of difference. We're all putting people in the spotlight and asking questions trying to get to the bottom of things. But I think I'm more inclined to be aware of socio-economic reasons for why people are like they are - which they never go into on Jeremy Kyle. They don't analyse why people behave the way they do due to chronic poverty and under-education. Judge Judy I find the most disgusting person on earth. If you had a bit of kindness, humility and a sense of responsibility to wider humanity you wouldn't be so condemnatory and punitive. You'd be a bit more understanding. But I think there are elements (in *Magazine*) which are played for spectacle and for laughs."

And this, lest us not forget, is what makes Hoyle such a successful performer: that he is so funny and able to make *laughter* out of it all. In conversation Hoyle is quite philosophical about the role of humour in his shows. "I look at a lot of the things we do, either singularly or collectively, as a constant displacement activity as we wait to die. To me life is all very comedic. The things we concern ourselves with, and get ourselves in a lather about. So what? You're not meant to laugh at certain things because they're serious. But they're not. Humour is wonderful. It is my balm. I go from the perspective that we've all been hurt and that we're all pretty damaged. I see humour as the salve which will take away some of the pain, for some of the time." This tragic-comic view of life is evident in Hoyle's particular take on camp humour, which is often laden with darkness in his shows. "We all love a camp laugh, don't we?" is a near catch-phrase of his at *Magazine*, usually delivered after reminding his guffawing punters at whose expense such queer joviality is bought. On the children in Iraq he has been know to quip, "Surely they could make more of an effort for the cameras?" Hoyle quite reasonably tells me during the course of the interview that "you can give camp a weight or a lightness." Sure, he's right. But this either / or understanding of camp (*either* weighty *or* light) seems to me to miss what makes Hoyle's camping so remarkably funny: namely, that it solicits laughter that is *both* grave *and* flippant at the same time.

Kira O'Reilly is experimenting with using mobile smoke signaling devices and carrier pigeons.

I say that camp seems to be under attack at the moment in contemporary academic queer studies as a privileged white gay male thing. Hoyle, I am happy to say, disagrees. "I think its open to everybody. A lot of people could camp it up. I mean members of gangs could camp it up. In Los Angeles there's the phenomenon of the 'crumping' community. When they manifest with the clown make-up they look sensational. It would be nice to think that the old reality of being a man, of 'You've got to look like a man, and hate art and have no imagination, and have five pounds of potatoes between your legs, and be really serious, etc.' is on the way out. I hope that people like that do lighten up, and start wearing Pucci prints and enjoying life. No wonder a lot of people are stabbing themselves to death otherwise. A lot of heterosexual men should be thoroughly ashamed of themselves. They're not suitable role models." And, smiling conspiratorially, he adds: "In fact, it would be nice if some of them were publicly executed."

Finally, I turn to ask him about the importance of collaboration, not only to his performance practice, but to his moral view of the world more broadly. This was thematised at *Magazine* by, amongst other things, the campy recycling of a 1960s civil rights anthem 'We Shall Overcome' by Joan Baez. Played each week by the resident DJ Father Cloth, Hoyle knowingly resurrected it as a hymn for today's apathetic times. Its perverse appeal, I take it, residing precisely in how the song's collectivist spirit jars so obviously with our individualist and consumerist present. "We've got to be very aware of divide and rule" he says. "When as human beings we keep going on about how different we are […] You know you're really not that different. You're just a human being. Like we all are. And neither better nor worse than anybody else. So get over yourself and work together for the common good. If we can't get on, if we refuse to collaborate and work with each other then we're making ourselves into these tiny satellite states which really don't mean anything. Yes everyone wants to be seen as an individual, but it's not really going to change the situation, say, of migrant workers, or people who make our clothes for next to nothing. It's whether or not you put yourself before being part of a more massive organic form." Of course, he could have Lauren Harries in his sights again here; his credo of the importance of collective political agency trumping the vanities of any narrow personal ambition. But, he adds, if we *can't* get on with one another then perhaps "we should all be armed, all be as selfish as possible, and just go round killing each other." So watch out Lauren. David Hoyle is nothing if not a glorious and unpredictable performance of contradictions.

Notes

1. See Dawn Right Nasty's blog http://
 redhairedqueer.blogspot.com/ You can find
 numerous posts here by Lauren Harries
 'fans', responding to Dawn's defence of
 Hoyle. See 'Lauren – Round Two' and
 'Shout, Shout, Let it all Out'. Thanks to Kate
 Pelling for alerting me to Dawn's site.
2. Ibid.

Hoyle's Humility by Gavin Butt (based on
an interview with David Hoyle) first featured
in Dance Theatre Journal Vol. 23, No. 1, 2008.

Published by the Live Art Development Agency (London, UK) and produced
in partnership with Live Art UK, Performance Space 122 (New York, USA) and
Performance Space (Sydney, Australia). Financially assisted by Arts Council England.

www.thisisLiveArt.co.uk
www.liveartuk.org
www.ps122.org
www.performancespace.com.au

Editors, Lois Keidan, CJ Mitchell and Andrew Mitchelson for the Live Art
Development Agency (UK); Vallejo Gantner and Morgan von Prelle Pecelli for
Performance Space 122 (USA) and Daniel Brine for Performance Space (Australia).

Production Assistant: Jonathan May.

Design by David Caines Unlimited. www.davidcaines.co.uk

First published 2011.

ISBN: 978 0 9561342 1 9

The first Live Art Almanac was published in 2008 by the Live Art Development
Agency and is available through Unbound.
www.thisisUnbound.co.uk

Live Art
Development
Agency

with additional financial support from

Lightning Source UK Ltd.
Milton Keynes UK
UKOW010512210312

189304UK00002B/34/P